# Art and Politics

# Art and Politics

## Psychoanalysis, Ideology, Theatre

Walter A. Davis

Pluto Press

LONDON • ANN ARBOR, MI

First published 2007 by Pluto Press
345 Archway Road, London N6 5AA
and 839 Greene Street, Ann Arbor, MI 48106

www.plutobooks.com

British Library Cataloguing in Publication Data
A catalogue record for this book is available from the British Library

Hardback
ISBN-13   978 0 7453 2648 1
ISBN-10   0 7453 2648 X

Paperback
ISBN-13   978 0 7453 2647 4
ISBN-10   0 7453 2647 1

Library of Congress Cataloging in Publication Data applied for

10   9   8   7   6   5   4   3   2   1

Designed and produced for Pluto Press by
Chase Publishing Services Ltd, Fortescue, Sidmouth, EX10 9QG, England
Typeset from disk by Stanford DTP Services, Northampton
Printed and bound in Canada by Transcontinental Printing

*To*

*CHRISTOPHER SHINN*

*For the plays he has written*
*and*
*the plays he will write*

*Proletarian revolutions...criticize themselves constantly, interrupt themselves continually in their course, come back to the apparently accomplished in order to begin it afresh, deride with unmerciful thoroughness the inadequacies, weakness, and paltriness of their first attempts, seem to throw down their adversary only in order that he may draw new strength from the earth and rise again, more gigantic, before them, recoil ever and anon from the indefinite prodigiousness of their own aims, until a situation has been created which makes all turning back impossible.*

Marx, *The Eighteenth Brumaire of Louis Bonaparte*

*From a certain point onward there is no longer any turning back. That is the point that must be reached.*

Kafka, *Diaries*

# Contents

# Preface

On February 27, 2006 the New York Theatre Workshop, which bills itself as one of the leading progressive theatres in the United States and with a special interest in the "exploration of political and historical events and institutions that shape contemporary life,"[1] announced the cancellation of its upcoming production of the play *My Name Is Rachel Corrie*, citing political pressure from the "local" community as the reason for this decision. Two months later I completed this book. What began as my response to a disturbing situation took on a life of its own.

The Corrie controversy was irresistible to me because I've lived most of my life in two worlds that I think should be one. The first is that of a cultural theorist who uses psychoanalysis to develop a critique of politics and ideology. The second is that of an actor and playwright trying to advance the cause of serious theatre against the dominance of "the entertainment industry;" i.e., against the belief that the primary purpose of art is to please a mass audience by offering them works that will not challenge any of their beliefs nor ask them to experience any painful emotions. Safe, happy, reaffirming experiences are the order of the day in keeping with the drift of American society toward a state of collective self-delusion.

I was never able to choose between my two "careers" because I always felt that they also were one; and were so in a necessary relationship that required me to immerse myself in many disciplines and issues that appear initially to have little to do with theatre. At the same time, the antitheoretical stance taken by so many of my colleagues in the arts is as limiting as it is self-serving. For we will develop the kind of theatre we need only when we've cleansed ourselves of all the ways that dominant ideologies exert a near total control over all areas of our experience. "To cleanse the doors of perception," the goal Blake set for literature, one must examine in depth all the ways in which ideology operates to obscure them.

As the Corrie controversy reveals, theatre is a social institution that by and large reflects the ideological assumptions and beliefs of the dominant order. Any genuine change in that situation will come about only when we become fully aware of the comprehensive force ideology exerts over every aspect of our experience. Developing a

theatre free of ideology depends on developing a consciousness free of it. This is the sense in which my two worlds or projects have always been one. Only by developing the most radical and comprehensive critique of ideology can we create the kind of theatre that will offer audiences concrete experience that will shatter the hold ideology has over them, that will make it difficult, if not impossible, to accept the limits that ideology imposes on the heart as well as the mind. I would argue, as I have elsewhere, that theatre is that public institution ideally dedicated to the public representation of secrets and lies, of both individual and collective life, and thus of everything a society does not wish to know about itself. As such, theatre offers a striking contrast to the function of other public institutions—such as the church, the media, politics, and political discourse—which are dedicated to indoctrinating subjects in the acceptance and celebration of dominant ideological beliefs. But unless or until the general foundations of ideology are exposed, there is no way for most playwrights to avoid falling back into every ideological trap they wish to escape. Such is the far too common fate of so many works of theatre that claim to seek to do something radically new, either in form or in content. Like the end of an Arthur Miller play, ideology exerts a subterranean force calling us to toe the party line of some ideological pathos or guarantee.

A book should be a drama that immerses readers in a process of discovery in which we learn much that we had not anticipated, not just about its subject but about ourselves. A book, as Kafka says, must be an ice-axe to break the sea frozen inside us. This book constitutes such an effort, but because it asks the reader to take with each chapter a new and more radical step outside (and beyond) ideology, I want here to set forth briefly the argument and structure of the whole.

The first two chapters consider the Corrie controversy in order to reveal the primary ideological assumptions made by all parties to that debate. The result is a discovery of the dubious assumptions not only of the right but also of the left with respect to the relationship between art and politics. To forestall misunderstandings, let me note here that I use the term *the left* broadly. And do so on purpose, since my goal is to show that at the level of shared ideological assumptions the various lefts—including traditional liberal, progressives of the Democratic Party in the United States, dissident voices such as one finds in *CounterPunch*, *Progressive Voice* or the *Daily Kos*, and doctrinaire Marxists—have a good deal more in common than any of them imagine. That commonality—and its contradictions—is what

I here identify and subject to critique. Chapter 3 then offers, as a corrective, a manifesto for a radical theatre, outlining all of the ways in which such theatre must break with dominant ideologies.

Such a break can be sustained, however, only through a further inquiry into the deeper roots of the hold that ideology has over us. This is the function of Part II. And at this point the book becomes a critique of the basic assumptions and beliefs that, I will show, underlie the contradictions that currently make it impossible for us on the left to develop a critique (and a politics) adequate to our historical situation. Such a critique is the purpose of Part II. Chapter 4 takes up the primary political illusions of the left, with specific reference to the current split between those committed to a paradigm based on reason and science and those attempting to recover a role for religion in leftist thought. As I'll show, this split is itself a primary instance of ideology, which has as its inadvertent result the exclusion of the existential and psychoanalytic way of thinking that I establish in this chapter as an alternative to both views.

There is no way, however, that an existential psychoanalytic way of thinking can gain a hearing unless we push the investigation further and examine the ultimate philosophical and rhetorical bases of ideology. Such is the purpose of Chapter 5. It constitutes an attempt (1) to lay bare the ultimate assumptions on which the traditions of rationalist and humanistic thought are based and (2) to offer a point-for-point contrast of these beliefs with a way of thinking that, I will argue, should supplant them. The existential–psychoanalytic framework introduced in Chapter 4 is thus here concretized in a number of ways. (For these reasons some readers may wish to begin with this chapter.)

Chapter 5 thus clears the ground for Part III, which offers two distinct concretizations of the position that the book has developed. Chapter 6 argues for a new understanding of the tragic and a recovery of the tragic as the only perspective adequate to the actual complexities of experience. A cautionary clarification. Forget or bracket every idea you have about tragedy. My goal is to develop a radically new understanding of this category by overcoming the rationalistic and humanistic defenses and guarantees that have, since Aristotle, been imposed upon tragic experience in order to blind us to what we begin to understand—and value—only when we move totally outside those frameworks. To say more here would be counterproductive, since developing this new understanding of the tragic—and why the left needs to ground itself in it—is the primary purpose of this book. For

too long the left has lived in fear of the tragic, offering in its place various quasi-religious guarantees in order to assure us of the eventual triumph of all that we hope for and believe. This triumph hasn't happened. It most likely won't. And it is time that we moved beyond such articles of faith. Indeed, the belief in the eventual triumph of "the good" is perhaps one of the primary reasons why we have so often failed. Tragic understanding offers us the best hope of attaining a more accurate if more austere standpoint. The purpose of Chapter 6 is to make this standpoint possible by outlining the fundamental *structure* of tragic thought as a paradigm that can then be applied to a number of issues and fields. A concrete experience of the position developed in the book depends, however, on another kind of effort. And thus in Chapters 7 and 8 I return to the theatre in order to offer the reader examples of the kind of drama we must create in order to make the theatre again that dangerous and uncompromising art form; one that, as these chapters dramatize, abides within the very space of traumatic experience, refusing every aesthetic and ideological pressure to sacrifice the tragic in order to protect audiences from what they must experience so as to know and feel the demands that reality places on us.

A final word here about the role of psychoanalysis in my argument. Psychoanalysis in America today is little more than a servant of ideology—the mental health wing of capitalism. The radical implications of Freud's central discoveries (and those of his most radical followers) have been sacrificed to a feel-good-happy-talk adaptation of psychoanalysis to what most people in this society want to believe about their identity and their ability to live lives centered in love, mutuality, and service to fundamental human values. My purpose, in contrast, is to show how psychoanalysis remains true to itself only when, as critic of its society, it explores that society's disorders, especially those centered on compulsive reassurance about our individual health and the ethical value of our institutions. Understood properly, psychoanalysis, like theatre, is the most dangerous threat to all of our collective illusions. Our job is to restore it to that dignity.

In developing its argument, *Art and Politics* completes what constitutes a trilogy of books on ideology. *Deracination: Historicity, Hiroshima and The Tragic Imperative* worked out a new psychoanalytic approach to history and the writing of history, an approach centered on a rethinking of *thanatos* as the category required to understand the modern world.[2] *Death's Dream Kingdom: The American Psyche*

*Since 9–11* applied that theory to what has been happening in the United States during the Bush years; i.e., to the analysis of a collective psychosis tied to what is now clearly a fascist agenda.[3] The present book focuses on the example that enables me to dramatize the dialectical connection at the heart of those two works. Namely, the idea that art, and especially theatre, is an independent and primary mode of cognition. Moreover, the knowledge it makes possible is not peripheral to politics but central to the primary effort that must today define it: the ideological critique of the ideas, beliefs, values and practices that blind us to our historical, political situation. The term *politics*, of course, refers to many things and so a final cautionary note is here in order. Politics for me is about power in its many manifestations. And about the ways we can connect those many manifestations in a single dialectical understanding. That, after all, is the true and lasting legacy of the revolution in thought that Hegel and Marx initiated. What happens in the national, public, social consciousness as a result of government policies is reflected in the family as that institution that bears and transmits dominant ideologies in a way that binds the psyches of individuals to collective fantasies and beliefs. Politics is thus a term we should never confine to government actions, the platforms of (say) the Democratic and Republican Parties, or the social agendas and public issues of various interest groups. A far more concrete way in which politics impinges on and determines our experience thereby escapes detection. Fortunately, this is something that theatre has always known. Since the Greeks, theatre has focused on the family, because this social institution is the one in which power and its contradictions can be investigated in a way that offers audiences the deepest insight into the larger political order by dramatizing the conflict and suffering it imposes on its subjects in their most intimate experiences.

Theatre, as I'll show, works at the very foundations of the formation of consciousness. In doing so, it exceeds and overturns ideology by revealing all of its contradictions and showing where, in our own lives, those contradictions operate. The human psyche in conflict with itself, struggling to untangle itself from the chains that bind it to ways of being that poison interpersonal, familial existence—it is here that ideology reveals its claws and the tragic suffering entailed in the effort to get free of it. In representing this struggle, moreover, drama submits an audience to a process that awakens them to a psychological and existential experience of all that they don't want to face about themselves and their world. In doing so drama, "gets

the guests," thereby creating nothing less than the possibility of a revolution in thought and a transformation of the very terms of perception and feeling.

So much for my overarching purpose. What this line of thought has sought for years is the example that would enable me to begin with a topical issue and proceed *dialectically* to uncover the full range of complexities implicit in it. Thereby a wide audience could discover that a comprehension of complex theoretical ideas about ideology is in their interest and well within the range of their understanding precisely because the example would enable them to see that ideology is the very air we breathe; not something abstract and applicable only to certain ideas and commonplaces. As conscious, thinking beings, ideology is the true source of what we think, feel, and say on the most concrete and specific issues. If we want to know ourselves or, better, question and free ourselves from the deadweight of ideological determinations, we need ways to discover concretely how the positions we take on particular and apparently circumscribed issues are really a function of underlying assumptions, dichotomies, and ideological beliefs that predetermine and control thought in general. In taking what at first appears a simple issue and drawing out all its implications, this book attempts to offer a concrete illustration of what Hegel meant by notional or dialectical thinking and why it alone is, as he argues, adequate to any subject matter. To understand a single phenomenon, one must understand the entire system of relationships that determine its intelligibility. Which is another way of saying that to understand something like the Corrie controversy, one must understand how it exemplifies the central contradictions of our current historical situation. But having said something this "grand" I immediately want to unsay it by offering it to the reader as process. A process of discovery that will grow with each of the following chapters as you simultaneously experience two things in their necessary dialectical connection: (1) the complexity of the issues implicit in the Corrie controversy and (2) the inner complexities that each reader will have to plumb in your own psyche in order to develop those implications. Such an interior process of complex change is the primary reality that this book endeavors to effect by engaging you in a drama of self-discovery. As always, my work has only one subject—the effort to create a drama that will enable you to know yourself in a new way, a way that will engage your psyche in depth in a voyage of self-discovery.

# Acknowledgements

This work benefited from the advice and support of the following theatre professionals: Herbert Blau, Lonnie Carter, David Cote, Alison Croggon, Stephen Davis, Garrett Eisler, Jason Grote, George Hunka, James Kozicki, and Christopher Shinn. Without their encouragement and their criticisms it would not have been possible. I also want to thank several friends outside the theatre for reading the work and offering me their critical reflections on it: Howard Beckwith, Hannah Berkowitz, Matthew Biberman, Robert Boldt, Robert Dotson, Todd McGowan, Sukla Sen, James Scully, Lois Tyson, Shahram Vahdany, and Philip Weiss. I want to add two other notes of thanksgiving of a less palpable order. My musical ear usually does not run to the Romantic period but for some reason for the past month while working on this book I haven't been able to stop playing Jorge Bolet's recording of the complete version of Franz Liszt's *Transcendental Etudes*. What started as background became part of the very fabric of this work. It is also my good fortune to have completed the book on the one holy day of obligation in the international calendar of the human family. One of Karl Marx's most radical—and largely forgotten—ideas is that labor can be an act in which we express, discover, and revolutionize what he called our "species being." Or as Sigmund Freud put it, "Love and work." Sometimes they are the same.

May 1, 2006

# Part I
# The Corrie Controversy:
# A Drama in Three Acts

# 1
# The Play's the Thing:
# Censorship, Theatre and Ideology

...I have heard
That guilty creatures sitting at a play
Have by the very cunning of the scene
Been struck so to the soul, that presently
They have proclaim'd their malefactions.
<div align="right">*Hamlet*, 2.2</div>

There is nothing political in American Literature.
<div align="right">Laura Bush</div>

## THEATRE AS A SOCIAL INSTITUTION

The purpose of serious theatre can be stated simply—to challenge the audience to examine everything that they don't want to face about themselves and their world. Theatre is that public space with a unique purpose: the public airing of secrets. Other public institutions (churches, political forums, the media) are dedicated primarily to something else: the celebration and perpetuation of ideology, the programming of a mass audience with the beliefs, ideas, and feelings they need to internalize so that ideology will secure its grand function. That function: the creation within subjects of the conditions that make it impossible for them to understand their historical situation. Freedom, if there is such a thing, depends on overcoming the vast weight of ideological beliefs that have colonized one's heart and mind.

The artist is the bad conscience of a society who calls ideology into question by representing all the ways in which it poisons our lives. The role of serious drama is to represent the disorders of its time not in order to relieve or "cathart" our dilemmas but to make it impossible for us to ignore them any longer. Rilke's "You must change your life" is the "message" that any great drama delivers as a blow to the psyche of its audience. To appropriate a phrase from Albee, the purpose of serious drama is to "get the guests." And not, I add,

primarily by getting them to change their ideas about some current political and social situation. Serious drama strikes much deeper. It is an attempt to assault and astonish the heart, to get at the deepest disorders and springs of our psychological being, in order to effect a change in the very way we feel about ourselves—and consequently about everything else. Going to the theatre can be a dangerous act. One risks discovering things one doesn't want to know about oneself in a way that makes it impossible to remain the person one was before a play eradicated one's defenses and shattered one's identity.

To get the full brunt of this argument one must avoid any narrow definition of the political and of political drama. Serious drama since Aeschylus has focused primarily on the family because the family is that social institution in which the contradictions of a society are lived out as psychological conflicts tearing apart the relationships of those who should love one another. The family is the primary agent of ideological transmission, the process whereby social norms and contradictions become internalized as psychological pressures. It is also where all the contradictions and conflicts rise to the surface. To dramatize the truth of the family is to reveal the truth of a world. And thus among the classics of political theatre: *The Oresteia, Hamlet, King Lear, Ghosts, Three Sisters, Death of a Salesman, Buried Child.*

I have developed this theory of drama and politics at length elsewhere.[1] It serves here as prelude to what I want to say about the recent actions of the New York Theatre Workshop in canceling (or "postponing" as is now claimed) plans to produce the play *My Name Is Rachel Corrie* and what this event reveals about our historical situation.

As an actor, playwright, and cultural critic I am particularly concerned about this event. But I also hope to show that it reveals— with uncommon clarity—the new ideological situation that defines post-9–11 Amerika.

### THE ONLY THING WE HAVE TO FEAR

Just the facts. The play *My Name Is Rachel Corrie* was developed in the United Kingdom by Alan Rickman and Katherine Viner. Every word of it is derived from writings and tape recordings of the late peace activist Rachel Corrie, who was killed on March 16, 2003 when crushed by an Israeli army bulldozer while trying to prevent the destruction of the home of a Palestian doctor in the Al-Salaam neighborhood of Rafah city in the south portion of the Gaza strip.

Ms. Corrie was clearly visible to the driver of the bulldozer, who ran over her and then backed up over her body. She was 23 years old. (For some readers the above sentences identify me as a foe of the State of Israel, an anti-Semite, and even a supporter of terrorism. On which see "The Cartoons Made Me Do It", below.)

The play based on Rachel Corrie's life had an extremely successful run in 2005 at London's Royal Court Theatre. Plans for a production of the work at the NYTW beginning March 22, 2006 were well advanced when the artistic director of that theatre, James Nicola, announced on February 27 that he had decided to "postpone" the production indefinitely. Mr. Nicola's reasons for this decision—which continued to evolve over the following few days from naïve frankness to semantic obfuscation—are well worth examining because of all that they reveal both about the state of supposedly serious theatre today and the impact of ideological and religious pressures. Which no longer have to speak in order to be heard and obeyed.

As always, contextualization is essential to understanding. The NYTW is an off-Broadway theatre that prides itself on producing challenging and controversial material. Here is what it says about its special interests in the 2004 issue of *Dramatists Sourcebook*, the publication playwrights consult to determine where to submit their work. "Special interests: exploration of political and historical events and institutions that shape contemporary life." NYTW in short is atypical. Indeed, it proudly identifies itself as one of the few places left where radical, challenging works will gain a hearing. It thus claims independence from those factors that force theatres on Broadway and throughout the United States to eschew controversial and challenging material. Three reasons inform the policies that consign most American theatres to mediocrity and conformity. First, the general ideological assumption that any play one attends should be easier to digest than the fancy dinner one ate an hour before. Talk to most people today about a play or film and the first thing they want to be assured of is that the work won't contain anything troubling. Art can only have one purpose—entertainment, the relieving of life's cares and woes. Second, any theatre that consistently produces challenging material soon finds that corporate sponsorship and season ticket sales have dried up. The powers that be insist that theatre is another one of the things that they own, an institution that must support and celebrate ideological beliefs, especially about the irrelevance of art to anything but entertainment. Third, we in the theatre have ourselves forgotten what serious theatre is. Much written and produced under

that label is no such thing. The reputation of NYTW as a cutting-edge theatre is a case in point. A study of their seasons from 1995 to 2006 provides a good index of how little is radical or challenging in theatres that try to carve out that identity for themselves as their part of the theatrical pie. NYTW has given us some of Caryl Churchill's fine work, but it has also given us *Rent*, *Dirty Blonde* and a number of other plays that are hardly radical or controversial. This third factor is the most revealing aspect of the Corrie controversy. Mr. Nicola is, supposedly, a serious director with his finger on the pulse of controversial, radical theatre. That is why the explanations he offers for his decision are so revealing as signs not just of bad judgment in this case but of systemic problems working against the possibility of serious theatre in America today.

## THUS SPAKE NICOLA

Mr. Nicola latter insisted that the whole controversy was the result of a semantic confusion (and the intemperate response of Mr. Rickman, who did not appreciate what he termed "censorship.") Moreover, in hopes that everything would blow away, efforts were soon under way to patch things up with the Royal Court Theatre in London so that NYTW could secure the chance to produce *My Name Is Rachel Corrie* at a later date. (After all, why waste all the free publicity on what now promises to be a sell-out?) Money is always a factor in such negotiations, but the ethical responsibility of the Royal Court in this matter is clear. Namely, to refuse to allow the play to be produced in America by NYTW! By the same token, the responsibility of the American theatre community is to see that this play *is* produced here as soon as possible. The worst thing that could happen would be for this all to be swept under the rug and a face-saving compromise reached. Actions should have consequences. And once an issue is out in the open it should be discussed with the thoroughness it demands. If we do anything less here we should all go to work for Mr. Bush. After all he is now desperately in need of something we understand better than most. That language was invented so that we could lie.

But to the heart of the ulcer. Mr. Nicola's explanations of his actions rest on two assumptions, both erroneous and destructive of the very possibility of serious theatre. One is that time was needed to prepare the community for the work. The other is that in the current climate the work could not be appreciated as "art" but would be seen in political terms.[2]

(A) With respect to the first. A work of art is its own preparation. How does one prepare an audience for a work? By calming its fears? By telling it that the work isn't really a threat? By persuading the "community" that they can appreciate it as "art" and should not see it in political terms? Such efforts prepare the audience by depriving the work of everything that might make its performance truly daring. Preparing people for a work of art is and can be nothing but an attempt to blunt the work's power. Preparation is, in short, the construction of defense mechanisms and thus itself a form of censorship.

Moreover, there is only one way that a work of art prepares its audience for it: by being the provocation that the audience cannot resist or deny. If a work is truly radical the community will never be prepared for it. The work will be a scandal to them—a shock and a wound that produces afterthought and forethought. (If the audience had to be prepared first we would not have Greek drama, the tragedies of Shakespeare, the plays of Ibsen and Strindberg, the work of Beckett and Brecht and O'Neill and Shepard.)

The hidden assumption in Nicola's position is that the community has a right to insist on what amounts to veto power. His view that the beliefs and values of the community must be served inverts the very relationship that makes art the conscience of its community. Mr. Nicola states that he made his decision after polling local Jewish religious and community leaders as to their feelings about the work. Why was this done? The first thing any serious theatre must do is proclaim its autonomy—especially from religious and political leaders. There is a simple way one does so: one does not poll anyone. Moreover, the minute one feels the temptation to do so one knows one thing for sure: the play one is thinking of producing is something that the community needs.

There is of course something disingenuous here. One can imagine the travails of running a theatre in Peoria, Illinois or Columbia, South Carolina. But here the community is no less than the Big Apple itself—one of the three major theatre centers in the world. Or is it? Mr. Nicola says he was less worried about those who would see the show than by those who would not. This is a fascinating development. Shows now are and will be canceled not because the people who come to the theatre don't like them but because the people who don't attend won't.

(B) With respect to the second. The deeper error derives from Mr. Nicola's second assumption, the belief that some way must be found to separate art and politics. By his own account, his initial assumption

that NYTW could present this play "simply as a work of art without appearing to take a position was a fantasy." But the separation of art and politics is a bogus one and part of a reactionary ideology that wants to reduce art to an aesthetic formalism. It is thus strange to hear it cited as the official policy of a theatre with the stated mission of NYTW. Mr. Nicola bewails the fact that he didn't have time to create an environment "where the art could be heard independent of the political issues associated with it." It is hard to imagine a clearer case of wanting to have one's cake and eat it too; i.e., of wanting to proclaim that one's theatre is politically daring while assuring oneself that one will never face a situation where one's daring isn't safe and acceptable to the community.

For Nicola, presenting the work "with the integrity it deserves" requires removing it from the political context that is essential to it. This play is, after all, about how and why Rachel Corrie lived her life and died the way she did. By falling back as a defense on an aesthetics of preserving art qua art, Nicola has allowed a bulldozer to be dragged back and forth across his theatre, but he is too blinded by an archaic aesthetic to realize it; or at least to admit that separating art and politics is antithetical to a theatre dedicated to exploring the "political and historical events and institutions that shape contemporary life." At the very least, NYTW should remove this statement from the next edition of *Dramatists Sourcebook*.

I'm sure that Rachel Corrie would be glad to hear that the artistic quality of her words is being preserved from the taint of politics and that the beauty of her prose transcends the political context that informed her impassioned commitment to an ethic of human responsibility.

In fairness to Nicola, we must include reference to the particular events in early 2006 that he cites as the reasons why production of this play was deemed inappropriate at this time. Those events: the electoral victory of Hamas and the illness of Ariel Sharon. One can of course always find current events that warrant postponing or canceling a production, but the ones cited by Nicola are especially significant. Let me see if I have this right: *My Name Is Rachel Corrie* must be postponed because the Palestinian people exercised their democratic right in a way that "we" find repugnant and did so coincidentally at about the same time that the career of one of the primary architects of the apartheid conditions under which they live ended. If this is the wrong time for a play to reexamine the issues here, one wonders when the right time will be.

Whether he knows it or not, Nicola has defended his decision by embracing a theory of art and its relationship to politics that has been refuted by virtually every literary theorist since the demise of the new criticism in the early 60s. The split between art and politics is, in fact, the primary gesture whereby ideology tries to impose limitations on art. Fortunately, since religion is behind this whole fiasco, the best example of this fallacy comes to us from religious quarters. Many college and university English departments feature a course called *The Bible as Literature*. Such courses—and the textbooks such as Alter and Kermode's *The Literary Guide to the Bible* (Harvard University Press, 1987) that provide their theoretical rationale—rest on an impossible dichotomy. The idea, you see, is that it is one thing to believe that the Bible is the revealed word of God and to read it in that spirit. But one can also supposedly read the Bible in a purely literary fashion, paying attention to all the aesthetic qualities found in the great march of biblical prose. Belief has nothing to do with this "reading." In fact, belief is precisely what must be bracketed or put aside in order to perform this operation. Contra right-wing pundits, we need have no fear that such courses will undermine the faith of our children nor that those who teach such courses will be deluged with in-class proclamations of student's religious dogmas or (perish the thought) their desire to question what they've been forced to believe. All that is conveniently put aside as out of place when we discuss the Bible as literature. The larger ideological purpose is thereby served. The Bible can never be discussed in the way it should be—as a work full of psychological disorders that need to be confronted as such.

## THE CARTOONS MADE ME DO IT

Religion is, of course, what the suppression of *My Name Is Rachel Corrie* is all about. Nicola's decision can in fact be seen as the first fallout from the fiasco regarding the publication in a Danish newpaper, in September 2005, of certain cartoons offensive to Islamic beliefs. The failure to do the right thing and publish the cartoons in all our newspapers and other media now reverberates in the suppression of a far more substantial work of art. As Art Spiegelman (the Pulitzer Prize-winning author of *Maus*, the cartoon narrative about the Holocaust) noted in the latest issue of *The Nation* (March 6, 2006), the cartoons should have been published widely or, failing that, our media should have admitted their cowardice. Moreover, Spiegelman takes the correct position in anticipation of the forthcoming anti-

Semitic cartoons: "There has to be a right to insult. You can't always have polite discourse. I *am* insulted (by anti-Semitic cartoons). But so what?"

The cartoons—most of which are frankly stupid; one (that of Muhammad with a turban that is a bomb) is well within the tradition of provocative editorial cartoons; and one (that of the Prophet saying "Stop the jihad, we've run out of virgins") an instant comic classic—were not disseminated, however, because doing so would have challenged the primary ideological assumption of our time. Thou shalt not criticize religion! Religious belief is supposedly so precious and inviolable that the mere possibility of giving offense to anyone's religious beliefs demands censorship of the offending idea. How better secure the ideological hold of religion than by prohibiting any criticism of it? (The religious reader will note that I have now criticized both Judaism and Islam. I thus hasten to remind the reader of my far harsher critique of Christianity in my recent book, *Death's Dream Kingdom*.)

Thou shalt not criticize religion. Thereby the thing most in need of criticism today escapes critique. And thereby the secret that the three great religions of Judiasm, Christianity, and Islam share is protected from a critique that is today more necessary than ever. That secret: that their current fundamentalist incarnations are not aberrations but revelations of the truth—that these three "great" religions are psychological disorders rooted in an apocalyptic hatred and fear of life and dedicated to the infantalization of the hystericized subjects that they create.

Like the cartoon fiasco, the NYTW event is primarily about religion; and, significantly, about the connection between religion and the state, a problem that has grown to alarming proportions in the rise of Christian (including Catholic) fundamentalism here in America, of Islamic fundamentalism in the Arab world, and among Jewish fundamentalists a fatal equating of Judaism with unquestioning support of any and all actions taken by the State of Israel. There is no way to prepare such communities for anything that will question their beliefs or the fanatical attempts to which they will go to prosecute anyone who dares do so. The banning of *My Name Is Rachel Corrie* is really the command to deny what happened to Rachel Corrie. In our time as so often before, religion is the enemy of art.

But an even more disastrous assumption makes it well nigh impossible for us to know this. Consider for example the predictable charge that the argument of this essay implies unquestioning support

for the Palestinian cause. And that the author must therefore be an anti-Semite who is sympathetic to or in league with Islamic fundamentalists. This kind of argument is inescapable today—in fact peremptory for far too many people—because we labor today under the ideological assumption that one's religious allegiance is and should be the ultimate source of everything one thinks, feels, and does. The position one takes on any issue and the reasons one gives in support of one's stand are merely ideological functions of the core religious beliefs that form the very basis of the only identity we can retain in the postmodern world. Thus, a good Jew must be against the production of *My Name Is Rachel Corrie*. A good Muslim must revile the cartoons of Muhammad and persecute those responsible for them. And a good Christian must be moved to an equally fanatical extreme when experiencing a sadomasochistic piece of sacred snuff porn such as *The Passion of The Christ* or regress to the appropriate stupidity when applauding the fear and hatred of sexuality that informs Pope Benedict's first encyclical. The notion that one can get free of all this religious hysteria, let alone subject it to the psychological critique it so richly deserves, is the last illusion of those who labor under the idea that we can combat the psychological disorder that defines our times. But in a world ruled by religious ideologies, there are only ignorant armies clashing by night. Armies of the saved marching in goose-step to the orders given them by fascistic fanatics.

There is a further irony here that we should not miss. Preventing the production of *My Name Is Rachel Corrie* proves that the great Iranian ayatollah who plans to sponsor a contest for the best cartoon ridiculing the Holocaust is right in his basic contention. Not only do we refuse to permit any cartoons that represent Judaism or Christianity in "offensive" ways. We take the proscription one better. We have our Holocaust deniers too; among them those who would deny what was done to Rachel Corrie out of their mistaken belief that allegiance to Judaism means that the State of Israel can do no wrong and that any and every blemish on its history must be whitewashed. Among the stakes in the Corrie controversy: the possibility of making memory what the Holocaust has taught us it must be—an act of mourning in which facing the truth is the agent of genuine change. That possibility too must be banished from our stages. And apparently from our movie houses, as in the current campaign against the Palestinian film *Paradise Now*, a film fraught with doubt and anguish that in no way "condones terrorism."

## SELF-CENSORSHIP: THE TRUE HAVEN OF IDEOLOGY

However, getting outside ideology depends on the most exacting critical self-consciousness, the willingness to examine one's most cherished beliefs and ideas. It may also be an impossibility, since detecting the ways in which one is operating within ideology is so difficult. Thought itself and the self that thinks may be no more than reflections of ideological formations that have not and cannot be detected.

This points to what may be the deepest lesson we can begin to learn from the NYTW fiasco. Perhaps there is not and never was anything radical or controversial about the operations of this theatre nor of many of the other theatres that appropriate terms such as radical, daring, controversial, and cutting edge for themselves. Maybe such labels are yet another way in which we in the arts delude ourselves that we are radical when we're not. (As Marx said, "to be radical is to go to the roots; but the root is man himself.")

Ideology is not primarily the system of beliefs, values, and feelings that are shoved down our throats by the powers that be. It's the prior and deeper ways of having a "self" that one must deracinate in order to cleanse the doors of perception. Serious art begins only after that effort has become one's innermost imperative. Ideology is primarily the way we regulate our relationship to ourselves and our experience. It operates habitually as that which goes without saying and therefore cannot be questioned. For to do so is to *exist* in an anguished recognition of the massive contingencies that define existence. Ideology is first and foremost an activity of self-censorship. The reason that fact goes undetected is that most of the time we aren't presented with material that really challenges us. It is easy to think one is radical when the material one praises as radical never really disrupts one's psychic constitution. As Herbert Marcuse demonstrated long ago, even our tolerance is repressive. We tolerate things that reinforce the ideological economy on which our self-identity depends. We are intolerant of and censor whatever fails to conform to it. This is as true in the theatre as it is everywhere else. In the theatre, however, it presents itself to artists as something that must be overcome! That is what radical art does.

## A THOUGHT EXPERIMENT

There is a censorship prior to the censorship of *My Name Is Rachel Corrie*. And it is far more devastating, pervasive and difficult to

combat because it limits the very possibility of theatre performing its social, political function. I want to try to illustrate the point by a thought experiment. Picture yourself as the artistic director of a (supposedly) left–liberal theatre who wants to stage works that explore the "political events and institutions that shape contemporary life." From that perspective, consider the following sketch of a play submitted for one's consideration. (The play described here does not exist though one can imagine something like it coming into being soon.) At what point or points does this sketch describe a work that goes too far? In identifying these points does one identify what must be rejected or at least postponed—indefinitely or in perpetuity? Or, in making that judgment, does one discover one's complicity in ideological assumptions that as artists, thinkers and theatregoers we must interrogate and then reject as historically outmoded? (Each individual reader may thereby find the point or points at which they conclude that art has gone too far.)

## SKETCH FOR *ECOTERRORISM: A TRAGIC FARCE IN THREE ACTS*

### Act one—the conclave

Set in a bunker. A meeting of leading U.S. and international CEOs with the President of the United States and major members of her administration along with key representatives from the media. (For reasons that will become apparent, the CEOs treat the latter two groups with contempt.) The background situation: a number of CEOs have been assassinated in isolated hits in a number of cities in the United States and in the "colonies." All efforts to pyramid information and thereby track down the leaders behind this "terror" have failed. A Nobel mathematician presents a meticulous analysis of the data in order to demonstrate the only possible conclusion. There is no group behind these actions. They are spontaneous acts by isolated individuals who have no contact with one another. There is no group behind the terror. And yet it continues. New hits are now taking place every day. Corporate America no longer has any safe haven. The deliberation in the bunker focuses on how to put a stop to this. The conclusion reached: the need to arrest and put on public trial the nonexistent ringleader behind the terror, the notion being that this will break the back of the movement while enabling the powers that be to regain control of a media that "has for too long indulged the populace in images of violence and terror."

## Act two—show-trial

Setting: a public trial being televised; O.J. out of Orwell. A key figure in the act will, in fact, be a foxy female reporter for FOX who will offer asides to the audience in the form of newsflashes and commentary as the trial proceeds. The central actor is the philosopher–activist on trial, a man who has published a great deal of "leftist" thought on culture, history, and politics. The act focuses on the questioning of him by the lead prosecutor. The drama lies in the way the accused responds to baited questions. Following the model of Brecht when he testified before HUAC, each response will be an ironic attempt to turn the question back against the questioner in order to reveal its ideological agenda. In the process virtually every assumption both of right-wing and of liberal discourse will be exposed. The audience is thereby put in the proper theatrical condition: all of their ways of thinking and responding are turned back against them. The theatre has become a place of interrogation—and anxiety. Which does not prevent the forseen result: the philosopher–activist is convicted and sentenced to death. The act concludes with the TV reporter describing this execution, one that compares favorably with the execution of Daumier as described by Foucault.

## Act three—inside the mind of a suicidal terrorist

This act presents the monologue of a woman as she waits to assassinate a group of CEOs at an emergency conference they have called. She is situated throughout in a closet of the room where the conference will soon begin. One key difference distinguishes hers from the many acts of isolated terror that provide the starting point of the play. She has no plans to fade into the background after her deed. On the contrary, she plans to die with it. Such is her ethical nostalgia—and she knows that nostalgia as such. It is the through-line of her monologue. The monologue begins with an evocation of the Smoky Mountains the way they were years ago contrasted with the way the trees there now look as a result of acid rain. She has struggled against the conclusions on which she is about to act. That struggle continues here as she moves once again from the Thoreauvian love of nature that has defined her life to the rage that informs her coming deed. The monologue thus takes the audience deep into a consciousness that will at times appear insane and at others prophetic. Such is perhaps the "deep ecology" of one who has suffered and internalized the horror of our time. For two allusions

repeatedly mark her monologue: one to Hamlet's soliloquies (the parent text of theatrical monologue as practiced here); the other to Faust's effort at the end of Goethe's play (Part 2) to reclaim land that was ruined, this project in service to Gaia being the only thing in life to which a restless spirit of existential self-overcoming can say "Stay, thou art so fair." Theatre here thus takes the audience inside the tortured conscience of our time and refuses to offer them any exit from that space. The space of theatre has become the space of a tragic questioning that has rejected all humanistic and religious guarantees. Theatre here takes on a different, darker duty. As Rilke revealed, "What is Beauty but the beginning of terror?"

# 2
# Mendacity: The Prospects of Progressive Theatre under Capitalism

## YOU DON'T NEED A WEATHERMAN BECAUSE THERE'S NO WIND

Mendacity is the system we live in. Liquor is one way out and death's the other.

Brick in *Cat on a Hot Tin Roof*

Chapter 1 offered a critique of the decision by the New York Theatre Workshop to cancel a planned production of the play *My Name Is Rachel Corrie*. My effort in that chapter was to contextualize this controversy so that we won't fail to comprehend the large ideological issues it raises. The present chapter supplements that effort with an argument that will surprise many readers of the earlier piece. The Corrie controversy continues but it has now largely become an example of how easily we get trapped by ideology in simple alternatives, false dichotomies and fatal assumptions. Many of them are illustrated by the current rallying around this play and the lionizing of it as a model of progressive theatre; an examplar, to the shame of the NYTW, of precisely what it calls for in identifying itself as a theatre devoted to the "exploration of political and historical events and institutions that shape contemporary life."[1] Extravagant claims on behalf of this play are now a matter of course on the liberal left. The fact of its cancellation apparently offers all the assurance many people need that this play must be something truly daring and remarkable, the cause célèbre for those of us who want to stand up in support of serious theatre. This has become an axiom of PC thought on this controversy. As a result, when the play opens in New York and elsewhere it will be hard for anyone to attend without feeling that one has indeed experienced precisely the kind of thing that "progressive theatre" is all about. But as the song goes, it ain't necessarily so.

Ideology sets its traps for those on the left as well as on the right. Those who have condemned the play sight unseen for its incendiary content are mirrored by those who will laud its theatrical brilliance and daring. The desultory result, as I'll show, is the "censoring" of

genuinely serious, progressive theatre—the kind of theatre we need if we are to break the hold that plays such as *My Name Is Rachel Corrie* have not only over our political thought but over our very ability to think and feel in the complex ways required for experiencing anything theatrically radical. Here too we are so often lemmings salivating on cue when told that the kind of daring theatrical experience we crave is available to us in a play that, I'll show here, offers no such thing.

## WHERE HAVE YOU GONE, MARAT/SADE?

Audiences know what to expect, and that is all they can believe.
      The Player–King in *Rosencrantz and Guildenstern Are Dead*

Art begins when a traumatic experience seeks an aesthetic form adequate to it. Average writers find a form already extant in some set of generic conventions. They pour their material into it. Significant writers realize that writing is *sui generis*. For them the search for and creation of new forms is the essential act. Thereby an experience that would otherwise be subsumed under the operations of ideology breaks free of it. A new way of thinking and feeling is born. Art has become part of political struggle in the richest sense of that term. Old forms, conventions, and genres offer, in contrast, yet another recycling of the same. New subjects may be treated in them but the same old structures of feeling remain in control with the same predictable reiteration of the same old humanistic platitudes. Stoppard's Player–King's point holds because the kinds of play we are repeatedly offered by our theatres create in us the emotional and ideological needs that determine what we desire and are able to experience. Finding a principled way to challenge this situation formulates in a nutshell the task of any theatre that would earn the labels progressive, radical, controversial, bold, cutting edge, daringly experimental.

On those rare occasions when a play succeeds in preserving the conditions of genuine art, it offers its community a challenge that goes far deeper than controversial comments on a political topic. For such works cleanse the doors of perception, thereby transforming our relationship to ourselves and the world. We feel and experience everything in new ways, ways fraught with anxiety but also with the pulse of transgressive discovery. Ideology no longer retains its habitual and automatic control over our minds. It is in this sense that *Hamlet* and *Marat/Sade* and *Three Sisters* are *political* in a way far more radical than *The Permanent Way* or *Guantanamo*, or, to strike closer

to home, the confused messianic (and non-Benjaminian) aesthetic of *Angels in America* or the self-congratulatory sexual posturing of *The Vagina Monologues*.

In transforming the very terms of our experience, radical works of art expose their audiences to the pervasive ways in which we are prisoners of ideologies that severely limit our possibilities of thinking and feeling. Plays that perform such a function need never directly address a political topic in order to be political in the deepest sense, by making it impossible for us to experience the world the way we previously did. The popular concept and practice of political theatre, in contrast, severely truncates this possibility. It offers us no more than a quick ideological fix on some current issue. As a result we are more the slaves of ideology—be it liberal or conservative, religious or secular, or whatever—than we were before. All such dramas do is incite the faithful so that they'll fall into line the next time they're polled on some issue or asked to contribute cash to some politician campaign.[2]

Such are the general criteria that could be used to judge the merits of any play or theatre declaring itself "progressive." As we'll see, by such criteria *My Name Is Rachel Corrie* does not fare very well. It has already, however, become the rallying cry and the model of what supposedly constitutes "progressive" theatre. Such is the power of ideology to predetermine what audiences will eventual experience when seeing this show. But there is only one way to illustrate this point. By a consideration of *My Name Is Rachel Corrie* as a work of art.

### AUTHOR! AUTHOR!

*A plague on both your houses.*
Mercutio in *Romeo and Juliet*

Alan Rickman and Katharine Viner do not claim authorship for the play *My Name Is Rachel Corrie*.[3] They list themselves as the *editors* of the *writings* of Rachel Corrie. There is something misplaced and finally disingenuous about this modesty. Selections from the 184 pages of journals, writings, and emails that Rachel's parents made available have been arranged by them to form the dramatic structure of a play. That form (and its relative merits or defects) is not Rachel's doing. There is no way to know what she would have done with these materials nor what she would have thought of the play that Rickman and Viner have fashioned from them. Alan Rickman claims

that Rachel's writings are evidence that had she lived "there would have been novels and plays pouring out of her."[4] We can't know what those works would be, though; as I'll show, there are signs that they would have been far different aesthetically and politically from the work that Rickman and Viner have fashioned in determining the artistic integrity of a work for which they bear the primary artistic responsibility.

For example, the play concludes with a video of Rachel aged 10 speaking at her school's "Fifth Grade Press Conference on World Hunger." In context, this speech increases the pathos of Rachel's death, which was reported in the immediately prior scene via the transcript of an eyewitness account played over a television set. (This speech is one of the few passages in the play not written by Rachel and the only one not spoken by her. It is a gruesome, horrifying account that moved this reader to tears. I too was thus perfectly positioned for the young Rachel's final words to work their theatrical "magic.")

Drama is structure. Feeling is a function of that process. The audience is positioned for the effect these two speeches are intended to have by the long scene that precedes them. It is based on an email that Rachel sent to her mother shortly before her death. Dramatic placement thus identifies these words as a final summing up by Rachel of what she's *learned* from her experience. This "message" finds its culmination in two paragraphs in which Rachel both reaffirms and questions "the core assumption" from which she's been operating "for a long time;" namely, that "we are all essentially the same inside" and can thus (no matter how bad things get) sustain our "fundamental belief in the goodness of human nature." Rachel's words here recall Anne Frank's from the end of her journal, as read by her father at the end of the play that bears her name: "In spite of everything, I still believe that people are really good at heart."[5] Placed at this point in the drama Rachel's words perform the same function Anne's did. The audience is bathed in the waters of an essentialistic ahistorical humanism, which once again provides the comfort and the guarantees that cleanse us of politics and history.

Never is the need for ideology more acute than at the end of plays. Whatever a drama may put us through it had better end with a nice "catharsis" that reaffirms transhistorical values so that audience members can feel that collective embrace that blossoms in the applause that drenches the stage with the warm fellow feeling that ripples through the theatre. Such is what we've been trained to expect and demand from even the most "serious" plays—bathos,

pathos, sentimentality and nostalgia; and nobody does it better than those who know how to end their plays—as Arthur Miller for example always does—by reminding us that we all participate in a humanity that transcends our historical conflicts. We're then free to regress to childhood, as Rachel herself is forced to do, as the 10-year-old Rachel proclaims her belief in "the light that shines" from the future. A play purporting to be about a political–historical trauma thus ends by cleansing us of history.

What kind of play then have Rickman and Viner written? At first glance a hodgepodge composed of virtually anything Rachel wrote that they choose to include, under the dispensation that they are offering a "portrait" that will "uncover the young woman behind the political symbol."[6] Anything Rachel says from age 10 to age 23 is welcomed into such a play, which will be as formless as its subject. The title in fact is a misnomer, since there is no identity here, nor should we expect one from the writings of a young person between ages 10 and 23. (This holds whether we're Ericksonians or Derrideans.) Youth: a subject in formation continually changing and deconstructing itself. Or is this the portrait of the artist as a young woman? Recall here Rickman's claims regarding Rachel's future authorship. Or a portrait of the gestation of a political activist? Or all this and more—all the rich and wonderful and silly and naïve and moving and stupid and brilliant things Rachel Corrie was in her brief life. A drama derived from such materials, in keeping with the assumption that controls most of performance art today, need have no concern with *form* or *dramatic structure* because the "portrait" so conceived (and as such the antithesis of what Joyce did) can have none. The trouble with such a play, however, is that it quickly becomes boring, as does reading the diaries of adolescents and young adults. Unless, that is, we constantly remember that the end crowns all, Rachel's death casting a reflected light of sorrow and loss that sanctifies even the most trivial utterances.

It is here, however, that the fundamental problem of this work emerges. For in trying to confer an underlying structure on their materials, Rickman and Viner offer us not one play but three. Each involves a distinct dramatic form with a distinct end or purpose. Moreover, the three forms are incompatible and contradict one another. This contradiction is what makes this play so interesting and revelatory—as a representation of the contradiction that defines the problem of serious theatre today. *My Name Is Rachel Corrie* stages the three distinct options open to us when we try to write serious

drama. It thus presents us with a unique opportunity to confront the hard choices we face as "progressive" playwrights. I know that as good "pluralistic" Americans we think we can have it all. But, as I'll show, we can't, precisely because each of these plays (i.e., dramatic structures organized to realize an informing purpose) *rests on a fundamental choice that excludes the other two.* Making a choice is here not something we can or should avoid, because it constitutes more than the problem of theatre today. It constitutes, as we'll see, the possibility of our own freedom.

One play is about Rachel's political awakening from naïve idealist to one who sees the truth about Israel's actions against the Palestinians (and their connection to the larger geopolitical designs of the United States). Her experience has made her a true radical, who speaks her message in clear and unflinching terms. All theatrical conventions and expectations that would soften the blow must be eradicated from such a theatre. Following Brecht's example, the emotional appeals and manipulations that Rickman and Viner fall back on is the primary thing that such a theatre must eliminate if the audience is to respond the way they must—by thinking clearly, free of emotional needs. The purpose of political drama is to move us from emotional indulgence to historical thought. A play must confront us with hard and inescapable historical choices. The purpose of theatre is to engage us politically by refusing the appeal of every theatrical convention that would release us from such responsibility.

There is, however, a second play here. It is about an idealistic woman who tempers her political awareness with the larger claims of a humanistic vision of human goodness that has the power to lift us above sectarian conflicts. The form of such a play follows the path blazed by Arthur Miller. Any historical conflict we care to dramatize must be subsumed under the universal humanistic truths we impose on it, so that audiences can through drama have their faith in unchanging truths restored. The duty of such a theatre is to reaffirm our assurance (and pleasure) in a quasi-Platonic process that always triumphs over time and contingency. Isn't it pretty to be reminded, especially in dark times, that human nature is good, unchanging, something we all have that cannot be lost? As indicated above, this is the dramatic form and ideology that wins out in this play.

But there is also a third play here. It is far more interesting than the other two and points toward the kind of radical and experimental drama that they cannot contain. This play is about a consciousness awakening to a radical existential contingency that destroys all

guarantees, both political and humanistic. This Rachel sees through what the other two believe. The form of a play dedicated to preserving this possibility would center itself in deepening the break with ideological guarantees that defines such a consciousness, cutting out of Rachel's monologue everything else. This Rachel would move in the directions of Beckett's *Not I* or Sartre's Roquentin; or to think of another young protagonist, Shakespeare's Hamlet. Monologue would become a voice that probes the depths of its own existential contingency. Several such moments in *My Name Is Rachel Corrie* come, like a thunderbolt, to disrupt the tedium of the commonplace. They are not, however, sustained or developed and so the play described here dies aborning. Let the following quotation suffice for now to illustrate the incompatibility of this voice with the guarantees on which the two dramatic forms previously described depend. Written by Rachel on February 6 after two of the six weeks (January 25 to March 16) she would spend in Palestine: "It's just a shrug—the difference between Hitler and my mother, the difference between Whitney Houston and a Russian mother watching her son fall through the sidewalk and boil to death. There are no rules. There is no fairness. There are no guarantees. No warranties on anything. It's all just a shrug, the difference between ecstasy and misery is just a shrug." Admittedly this remains rough but it is also promising. Center a play in the development of such a consciousness. Give it six weeks to let the trauma of that shrug drown the stage, and theatre will begin to recapture the promise of Artaud.

But such a possibility is antithetical to the dramatic and editorial methods of Rickman and Viner. Moreover, the fundamental confusion that defines their effort is evident at the very start of the play. It opens with Rachel lying in bed one morning in Olympia, Washington. Age unspecified, but prior to her trip to Rafah, perhaps even prior to her political "radicalization." Lying there, Rachel is apparently seized by a panic as she imagines the ceiling trying to devour her. This experience is developed for four paragraphs.

What is this? The knock-out image sure to grab the audience and identify what will be the through-line of the work? The perfect image to jump start the dreary work of characterization by giving us an immediate entry into the depth of Rachel's consciousness? What better way to establish the importance of a play that will be one long monologue!

One suspects that Rachel knew better, knew why she wrote these paragraphs and what they signify. Rachel, you see, wants to become

a writer. She has recently read, one gathers, Gilman's *The Yellow Wallpaper* and some Sylvia Plath and is eager to try her hand at imitating their example. That's why this image finds no sequel in the play. It has none because none could be found in Rachel's writings. (Had they found one you can be sure Rickman and Viner would have used it.) Rachel knows what Rickman and Viner don't; that this is apprentice work, essentially about learning how to write and not indicative of any deep experience pivotal in the development of her consciousness.

Rickman and Viner, in short, cannot create anything complex or coherent out of their materials because they are unable to comprehend those materials except in the most superficial ways. As a result, we get the three plays I mentioned before with all sorts of irrelevant asides thrown in to fill out the necessary time. I want to develop this point further now in order to bring out what it teaches us about monologue as an art form and both the possibilities and the pitfalls of plays based, as so many are today, on an extended use of that form.

### The humanistic Rachel

Despite many banal passages, Rachel Corrie emerges in the course of the play as an intelligent, sensitive, well-meaning person who sees the world and her place in it in ethical terms. She is in the process of developing precisely the kind of political conscience that is needed in Bush's Amerika. Hers, however, is a conscience and consciousness *in statu nascendi* that was interrupted by death long before it could develop into anything original, provocative or even politically informed and sophisticated. (The signs here of the beginnings of a global Marxist understanding are only that—signs.) Rachel is no prophet possessed of some deep or original vision. Nor is she a deeply conflicted or complex figure. I suppose the very ordinariness of much that she says can be seen as a virtue. Here's a child of privileged parents who is normal in so many ways and who yet makes the very privilege of her position the basis of a conscience that is troubled by the massive injustices of the world and that then acts on that perception. Is this not something we all want to believe slumbers in the bosom of Amerika? Our young people are not mindless narcissists or fanatical Jesus freaks. As Bush the elder proclaimed, there are a thousand points of light. Young people like Rachel Corrie are still possible. What an uplifting drama to warm our hearts deep in the winter of our Bushian discontents. But to claim more for Rachel is to burden her with a weight or significance she cannot bear. Contra Mr.

Rickman there is no assurance here of a future great writer or thinker. To know that, all one need do is consult what Kafka was writing in his diary at age 23. Rachel has her moments, but they are not part of a sustained awareness nor precursors of that uniquely original experience of the world that leads to great writing. Saying this does not dishonor Rachel Corrie's memory. We fail to honor it when we make claims for her words that they cannot bear. Or when we fail to admit that because Rachel is all potential, a drama based on quoting her words is essentially about loss and the one thing such loss can produce—a sentimental nostalgia that trumps everything else.

### The political Rachel

Rachel Corrie is not a political prophet, nor was she meant to be. In the course of the play, she articulates several important, though by no means original, political ideas, foremost among them perhaps that the term "terrorism" is now the primary label ideology deploys to prohibit examination of historical situations such as the Israeli–Palestinian conflict. (The word "progressive" serves as a similar shibboleth in the current rallying of the "serious" New York theatre community around itself. See below, "Toward a Really Poor Theatre.") But those who think *My Name Is Rachel Corrie* will offer a unique or compelling analysis of the Israeli–Palestinian conflict don't need to go to the theatre, they need to go to the library. Or what amounts to the same thing, to realize that their conception of serious theatre amounts to nothing more than propaganda. Even if its polemics speak the truth, such a theatre is unable to rise above the condition of agitprop, i.e., a preaching to the choir a message in which the complexities of historical awareness collapse under the pressure of ideological certitudes.

Those who want to understand the Arab–Israeli conflict and why it has attained the rebarbative condition that now defines it should read Avi Shlaim's *The Iron Wall* (642 pages.) It'll take you from 1907 to 2000. One can then update things by reading Robert Fisk's *The Great War for Civilization* (1107 pages,) which offers an overview of the geopolitical conditions that define the Middle East. When an issue is historical, there's no substitute for hard, long and dreary work. To seek a quick fix by going to a play is to behave like those benighted souls who bow down every Sunday before what some moron or charlatan tells them the Bible demands. One sign of the situation we're now in, however, is that the conception of political theatre described above has achieved hegemony in the age of PC identity

politics. Each group or cause—each subject position and multicultural identity formation—gets to strut and fret its two hours' message on the stage. Exploration into the deep and dark places of the human soul is proscribed. It can only lead to confusion—or worse.

## The existential Rachel

And then, almost out of nowhere, Rachel discovers her voice and becomes a genuine writer for the first time. Please read again the "shrug" passage quoted earlier. Here is an experience that neither the humanist nor the political activist can contain. Experience here erupts in an existential contingency that eradicates all guarantees. A subjectivity defined by anxiety and dread experiences the world in a radically new way. The result is a voice that shatters all extant dramatic forms by exposing the ontological fallacies on which they depend. But for this to become the through-line of the entire monologue, anguish must be sustained. The beauty of the political choice is that it delivers us from that task. The world seen in the indifference of the "shrug" is sacrificed to the calcifying clarity of political commitment. The beauty of humanism is that it offers an even more thorough deliverance from experience. Contingency and existence are mere moments, mere illusions and no more than the vaguest of memories dissolving into insignificance once we remind ourselves of "the goodness of human nature." That, after all, is what made the play about Anne Frank such a success. The audience got to be horrified by the Holocaust and then comforted by a transcendent essentialistic humanism. Because Rickman and Viner are playing the same game there is no way for the voice that erupts from time to time in their play to sustain or realize itself. That Rachel is consigned to the ashes. And with it the *possibility* that defines and haunts the method that Rickman and Viner use.

## THE ART OF MONOLOGUE

The purpose of acting is to drip acid on the nerves.
Jack Nicholson

Monologue is employed in *My Name Is Rachel Corrie* to warrant a chatty, diffuse procedure wedded to digression and condemned to frequent bathos. Anything Rachel ever wrote is grist for Rickman and Viner's mill. This is not the inevitable way of things with monologue and all we need do to realize that is to recall what Shakespeare did in

*Hamlet* when he saw that exploring the inner conflicts of a psyche at war with itself provided a way to renew and redefine the very nature of drama (see Chapter 6.) One achievement of that masterwork was the discovery of how to dramatize the depth of human inwardness. Hamlet's soliloquies open up places within our own subjectivity that transform our understanding of what it means to be human. Monologue or soliloquy in *Hamlet* transforms the stage into a place of breathless discovery, the kind of discovery that is only possible when anxiety and dread become the driving forces of an attempt by a psyche to probe the darkest registers of its experience. (It would not be going too far to say that it is Shakespeare, not Descartes, who first discovered and explored the interiority of the cogito.) Unfortunately today monologue in theatre has become for the most part a travesty rather than a recovery of Shakespeare's example—i.e., the bearers of different ideologically fixed "subject positions" assure themselves of phantom identities as "selves" by rehearsing a bundle of PC platitudes. The complex and conflicted inwardness that defines a psyche like Hamlet's is shunned in favor of the kind of cutesey assurances one finds exemplified in Eve Ensler. Monologue is here no longer a way of exploring oneself, but of declaring oneself in a way that puts an end to all doubts and fears. Think how different everything would be if a monologue situated itself within a subjectivity traumatized by the "shrug" Rachel briefly discerns or, say, by the trauma of childhood sexual abuse (see Chapter 7). Such a monologue would permit entry only to passages derived from the depths of a tragic suffering. The traumatic development of *character* would be the through-line of the action. Such a voice would terrify and amaze us because it would constantly take us deeper into the heart of everything we fear to know about ourselves. The theatre would become a traumatic space where none of the traditional forms would any longer be of use. Monologue has become exploration, possibility, discovery—the deepening of a depth of subjectivity that eradicates all the assurances of the surface.

Such a possibility is a far cry from what happens in *My Name Is Rachel Corrie*. The beginnings of such a consciousness occur only in isolated moments that are not sustained. Rickman and Viner would of course reply that their commitment to the quasi-naturalistic qualities of docudrama precluded such a possibility, as did the reluctance of Rachel Corrie to pursue what was probably only a passing moment of her awareness. She is primarily a self-assured speaker, not a traumatized existential subject, and with Rickman and Viner's aid she

remains true to her rhetorical task. To preach messages. How different a play we'd have if Rickman and Viner had taken Rachel Corrie's writing as an overture to the truly imaginative act: the creation of a consciousness that would speak from the depth of a struggle to probe its own inwardness through a play that would take us far beyond the bare beginnings found in Rachel's writings. (What, for example, if she became an annihilating voice interrogating her experience from beyond the grave?) But Rickman and Viner are not up to such an effort because they don't know how to interrogate either their materials or the dramatic forms they employ.

The result is what in the present climate may remain the unspoken truth about this play. It is a slight piece, worthy enough for a minor night of theatre if seen in terms of its considerable limitations but profoundly unsatisfying, even retrograde, if regarded as a complex realization of either the art of monologue or the mission of "progressive" theatre.

## FOLLOW THE MONEY[7]

Sometimes the bullshit comes down so hard you need an umbrella.
Ned Racine in *Body Heat*

But of course this conclusion is no longer warranted. And the foregoing analysis is supremely irrelevant. *My Name Is Rachel Corrie* is no longer the play it was. It is now the cultural event it has become. It is what it will "signify" for the theatre that produces it and the audiences who attend it, prepared by the NYTW controversy to experience *My Name Is Rachel Corrie* as the epitome of progressive, challenging, politically relevant, and experimental theatre. Such is the power of ideology as that great a priori mediator that establishes the expectations that lead us to regard as our own the experiences it programs us to have. *My Name Is Rachel Corrie* is now the Pavlovian stimulus before which vast audiences will salivate on cue in order to leave the theatre congratulating themselves on how liberal, progressive and daring they are. A minor play will thereby further a process of commodification that makes it exceedingly difficult for actually bold plays to gain a hearing. What caused Mr. Nicola to back off from this play has now become the very thing that will lead others to produce, imitate, and applaud it. For the contradictions of *My Name Is Rachel Corrie* as a play *mirror* the contradictions of the progressive, liberal theatre community. Neither has a true vision of what serious theatre should

be. As a result, all we get is a further reification of our collective blinding by ideological assumptions about both politics and theatre that go undetected and therefore unopposed. But there is a deeper reason why this is so. It is time it came forward and took a bow.

On January 11, 2006 Mayor Bloomberg presented the keys to six buildings formerly owned by the city to ten cultural organizations that comprise part of the Fourth Arts Block. (NYTW was among the beneficiaries, as their website proudly notes.) The Mayor's Office, the City Council and the Manhattan Borough President's Office also invested over $3 million to assist in the renovation of the buildings and an additional $1 million has been pledged by the city.[8] Let's imagine a fresh production of *King Lear* starring the mayor in the title role and with the parts of the three daughters to be determined later based on auditions by the artistic directors of our progressive theatres.

It now turns out that the "postponement" began when two members of the Board of Directors at NYTW relayed to Mr. Nicola concerns about the wisdom of producing *My Name Is Rachel Corrie*. The infamous polling of select members of the (local) non-theatre community followed. Theatres that want to succeed while carrying out the mission of exploring the "political and historical events and institutions that shape contemporary life" depend, as we all know, on the "advice" and support of boards that are largely composed of financially prodigious figures.[9] When all goes well, the moneyed class lets the "artists" think they're running things. After all, it's useful to have places where the theatregoers of the Big Apple can go to assure themselves how liberal, progressive, even radical they are and how the most richly endowed theatres in town attest to that fact. With commodification in charge, everything becomes a matter of sign-exchange value. But once in a while the truth makes a brief appearance, and we see that theatre is yet another one of the things that the capitalists own and control.

A curious circumstance has emerged in the current controversy that reveals the extent and nature of this control. The other leading representatives of "progressive" theatre have been quick to condemn or express regret over Nicola's decision (thus reasserting their "leftist" bona fides) but just as quick to remind us how "progressive" and daring the NYTW has been under Nicola's long leadership. There is apparently one thing above all that we must all believe. That a theatre such as the NYTW (and other similarly self-described theatres in Manhattan) are, in fact, progressive, liberal, cutting edge, daring,

experimental, etc. Such was the assurance offered by Oskar Eustis, artistic director of the Public Theatre and others at the end of a recent forum on theatre that the Public held at the New School.[10] Talk went on for the better part of two hours before a member of the audience had the temerity to refer to the Corrie controversy as the white elephant in the room. The panelists then tripped over one another with the excuse that they couldn't comment on the matter not yet having had time to read the play. Mr. Eustis then brought things into happy perspective with an encomium on the progressive credentials of Mr. Nicola and the NYTW.

A similar reassurance followed when Tony Kushner finally broke his silence with the statement long awaited by those who were certain that what he said would prove definitive—at least in helping them know what they thought. Following party lines, Kushner bewailed Nicola's decision while reminding all of us (lest we doubt it) that "his [Nicola's] is one of the two most important theatres in this area—politically engaged, unapologetic, unafraid and formally experimental."[11] (Want to guess which the other one is? Or is Tony letting us all play mirror, mirror on the wall?) And so it goes. The theatrical powers that be must rally around one another lest we take seriously the question raised recently by a Dr. Cashmere on Garrett Eisler's *playgoer blog*: "Are there worthy plays out there that can't get a production because theatres are afraid they'll catch hell for staging them?" One hopes this was a rhetorical question. As such it points to the most distressing and important lesson we can gain from this controversy.

*My Name Is Rachel Corrie* will gain production in New York in October 2006, at the Minetta Lane Theatre. It will then come to us trailing clouds of progressive glory, serving as a model of what daring, controversial theatre is. The reductive concept of political theatre that led to the original selection of this play under that banner will thus extend its hegemony. The run of the play will serve something far more important than sparking talk about the actions of Israel in bulldozing Palestinian homes and callously justifying the killing of a young woman. The run will serve as training in teaching audiences what progressive theatre is. Bad money will continue to drive out good. *My Name Is Rachel Corrie* was cobbled together following a set of aesthetic and political assumptions that severely compromise the possibilities of progressive, experimental theatre. It was selected for production because the same set of assumptions inform the judgment of theatres such as NYTW. Now, as a cultural event, it will reify those

assumptions by creating audiences habituated to this sort of play and therefore unable to respond to anything that challenges the artistic and political assumptions on which such stuff is written. The whole event will thus serve to solidify the ideologically closed circle in which we are moving. The hegemony of plays like this necessarily results in the rejection of plays that are truly progressive and formally experimental. You see, Dr. Cashmere, that's the beauty of ideology. It is a self-contained system that excludes anything that challenges it. The perfection of any ideological system is that conscious intention is never required for it to determine all that happens. When Nicola and others who share the dominant theatrical ideology "read" plays sent to them they are already screening out works that don't conform to the model without knowing they are doing so. That's the beauty of ideology. It doesn't ever have to pass before your conscious mind in order to determine what you experience, think, and do.

And that's the pity of it. Our so-called progressive theatres are run by those whose artistic sensibilities (and judgment) have already been so colonized by capitalist imperatives that they can only approve of art that furthers the system. After all, a show has to make bucks, position our theatre for a big slice of Bloomberg's pie, please our corporate sponsorship, and increase season ticket sales. There is only one way to do so: to take care never to produce anything that will really ruffle the feathers of those who exert a silent, paternalistic, yet pervasive control over the whole enterprise. Follow the money.

But that's also the beauty of the Corrie controversy. It has the power to expose the entire institution. And that, after all, is what theatre is—an institution serving the needs and desires of its community. Those of us who think it should be the conscience disrupting the community by standing as that one public institution dedicated to the public airing of all secrets and lies the community doesn't want to confront are asking for a poor theatre indeed. And yet perhaps the most important implication of the current controversy is that we shall only get such a theatre when we reject the model followed by those theatres that so loudly proclaim their progressive character. And not just in New York. The situation described here persists throughout America. At the Humana Festival in Louisville? At Steppenwolf? At the Mark Taper? Etc....

But of course the beat goes on. Whether things can be patched up so that the NYTW produces the play—unlikely according to those in London; deeply desired apparently by most of the theatre community in New York, despite the hypocrisy of this solution—or someone else

here gets it, one thing is sure. And you can take it to the bank. *My Name Is Rachel Corrie* will be a mega-hit. Everyone has to see it now as transgressive ritual if nothing else. Ten days before I began this chapter, the only way I could get a copy of the play was through U.K. Amazon.[12] As I write this, two weeks later, the play is widely available in the United States and its sales a mere precursor to what advance ticket sales for the New York production will be. Moreover, the cancellation here has already led to a new run of the play in London's West End, an unexpected boon on the heels of the end of its two earlier runs at the Royal Court Theatre.

A Pynchonian fantasy is here irresistible. Note: I'm not claiming that the following scenario was consciously planned—especially not by the people at the Royal Court Theatre. It is, rather, the foregone result of theatre as an institution that is shaped by considerations inimical to serious art. So, consider this: What if the whole controversy was cooked up precisely to assure the mega-success of a very minor play? *The Producers* for highbrows! Let's create a media event. There's no better publicity. Everybody wins—even NYTW. Jim Nicola's temporary embarrassment is already being softened by daily testimonials from the other luminaries of progressive theatre and no doubt this vote of sympathy will pay dividends in the chorus of praise that will be lavished on his next production. In the meantime, another New York theatre will be given an opportunity to proclaim its progressive credentials all the way to the bank. Vast audiences will in turn gain the assurance that they support serious, daring progressive theatre and know what it is when they see it!

Ideology does not work primarily as overt censorship, as in Nicola's initial blunder that put us in a position to see the state of the king's clothes. Ideology works as that prior self-censorship that controls the sensibilities of those who run our theatres and those who write the kind of plays those theatres are certain to produce. Liberating oneself from ideology is an enormous task. Art only begins, however, when that liberation is the effort one refuses to compromise. Perhaps today there is only one way we can honor that principle. By refusing any longer to fall into the ideological traps that the Corrie controversy enables us to see.

## TOWARD A REALLY POOR THEATRE

He is condemned to go on forever, knowing the truth and powerless to change anything. No longer will he seek to get off the wheel. His anger and

frustration will grow without limit, and he will find himself, poor perverse bulb, enjoying it.

Thomas Pynchon, *Gravity's Rainbow*[13]

The most destructive censorship is the one that exists as the set of assumptions about theatre under which Mr. Nicola, Mr. Eustis, Mr. Kushner, and so many others operate. For those assumptions are what determines what plays have a chance of being produced. The key point once again is that this is so because these assumptions remain hidden and for the most part unconscious in those who have all their judgments determined by them. That's the tawdry effect of ideology on artistic possibility. Mr. Nicola picks up a play and sees only what the prevailing ideology permits him to see. Anything that threatens or violates that implicit framework must be discarded. That is why a truly progressive a theatre would consist solely of plays that our mainstream progressive theatres can't produce.

Do new plays that are radical, progressive, truly experimental exist? I can think of several but feel it is best not to mention them here so that each reader can examine their own theatrical experience. It would be counterproductive to provide titles here when the question asks each reader to reflect on their own theatrical experience. What kind of play would one have to write in order to make and sustain a break with the assumptions that rule in so-called serious, progressive theatre? If nothing else, this question has the power to sharpen and quicken our perceptions the next time we attend a play. The need for theatre is profound. And it can only grow through disciplined experiences of how rarely we get the real thing.

# 3

# Beyond the Corrie Controversy: Manifesto for a Progressive Theatre

> The Director's first task is to cast the audience.
> *Grotowski*

The previous chapters discuss the central issues raised by the Corrie controversy. I want now to develop these issues further, free of that example. What is the role of art—and specifically theatre—in leftist thought? Why have most social and political theorists and commentators on the left become so estranged from understanding the cognitive status of art that they can see drama as little more than a way of popularizing ideas in order to give an audience a quick fix on some controversial issue? What the left thereby sacrifices of its own history is the understanding of art developed by the most important theorists in the Marxist tradition—Adorno, Benjamin, Marcuse, Raymond Williams, Slavoj Žižek, etc., not to mention Leon Trotsky and Karl Marx. For these thinkers, art is absolutely central, both to our knowledge of history and our struggle, because radical art performs a unique function in exposing the ideological blinders that control the left as well as the right. Art alone perhaps proves capable of this task, because art is a primary mode of cognition or knowing which offers us something unique: a comprehension of history in terms of the velocities of irreversible historical change. As Hamlet said of the actor's art (and implicitly of the playwrights): the task is to show "the very age and body of the time its form and pressure" (*Hamlet*, 3.2).

The following theses constitute an effort to reintroduce this way of critiquing and thinking beyond ideology into leftist political and social thought. As such they offer a prologue to the larger effort of Part II, which will describe and critique the fundamental ideological beliefs and assumptions that underlie the current paralysis of leftist thought. A correct understanding of the cognitive status of literature is the route to such an understanding. Grasp the radical possibilities of theatre and one soon apprehends its power to overturn everything.

## 1

The commercial theatre needs no manifesto. It gets its from season ticket sales: Do nothing that will make the evening's entertainment harder to digest than the fine meal the audience consumed an hour before as prelude to the after-dinner sleep in which they dream their way toward final curtain. Everything passes through the mill of an overriding need: to create those feelings that relieve and resolve whatever is troubling. "That's entertainment." This motive, which has always been the bane of our theatre, became in the wake of 9–11 a national imperative. A traumatized nation called out for healing, and the arts responded with a virtually single-minded effort to produce works distinguished by nothing other than the attempt to bathe the collective psyche in the Lethe of happy talk, heroic posturing, sentimentalism, and nostalgia. Affirmative culture today apes the spirit of Lynne Cheney's NEA in giving us a theatre at home in its *polis*, one that caters to its emotional needs. Such a theatre knows what it is and why it is; and, more importantly, what kinds of plays and productions must be canceled as "inappropriate at this time." Our problem is that we've lost the ability to distinguish ourselves from this theatre. We've lost it because we've lost an understanding of our foundations, an understanding of what the purpose of theatre has been since its origin.

## 2

From its inception theatre has had a unique cultural function. It is the one public forum where people come together to witness the exposure of things that they don't want to know—about themselves. Other public forums exist to celebrate the ideological beliefs that protect us from ourselves. The public sphere is, by and large, the space of ideological *interpellation*; i.e., the hailing operations that tell us what we believe and feel as subjects subjected by the social order to share articles of faith and meaning which have as their primary function the blinding of subjects to their historical situation. The purpose of public forums—the Sunday sermon, the media, presidential addresses—is to offer rituals of pseudo-deliberation that always move to the triumphant reassertion of the unchanging truths that constitute the collective affirmation of who we are and what we value. We come together as an audience in public space to participate in a group psychology in which conflict is overcome and calm of

mind restored. Public space, in late capitalism, is the arena in which we are put collectively to sleep.

Authentic theatre is the exception. A primary constituent of the magic that attends it is the willingness of an audience to sit in rapt attention before the public airing of secrets that expose them to themselves. When a play does its work, the audience finds itself, like Claudius, caught in a mousetrap as the characters on the stage reveal the hidden conflicts of the audience. Such is the true measure of our responsibility and of how deeply an audience can find itself delivered into our hands.

### 3

The purpose of theatre is to move an audience from the comfort of secondary emotions to the *agon* of primary emotions.

*Secondary emotions* (pity, fear, contentment) constitute the defenses that the ego has developed to displace and discharge anxiety. The motives the ego requires for its maintenance—safety and self-esteem—find in secondary emotions the means to resolve conflict in a way that distances and protects the ego from the threat of all disruptive experiences. (I am, of course, aware that Aristotle taught us that pity and fear are the deep, tragic emotions. One may take the continued hegemony of that view as a sign of how far we are from the kind of theatre we must create.)

Pity—the effort to short-circuit anxiety by turning suffering into something one can only experience passively as undeserved misfortune that comes as a result of factors over which one has no control and limited responsibility.

Fear—the effort to externalize anxiety by displacing inner conflict into concern with matters outside the psyche.

Contentment—the feeling of well-being that banishes all sources of anxiety through the obsessive-compulsive iteration of the sentiments that tranquilize the subject's relationship to itself.

*Primary emotions* (anxiety, humiliation, envy, cruelty, melancholia), in contrast, burden the subject with an agon in which it finds its being existentially at issue and at risk. Such emotions are defined by the absence of any inner distance between what one feels and who one is. One is assaulted from within by the force of the conflicts that are central to one's being.

Anxiety—existence as the awareness of responsibility to reverse the control that the other (parents, social and ideological forces, religious authorities) has over one's psyche.

Envy—the need to destroy anything that makes one feel contempt for oneself or that activates the memory of possibilities one has squandered.

Melancholia—Keats' "wakeful anguish of the soul;" the desire to engage the core conflicts of one's psyche in active reversal.

Compassion—love as the refusal to succumb to the appeals of pity and the fixations of desire so that one may conduct one's relationship to others on the basis of uncompromising psychological honesty.

Cruelty—the desire to poison what is vital in another's psyche so that one can watch the other bring about their own destruction.

Primary emotion shatters the ego and awakens the psyche. The *ego* is the system of defenses whereby an illusory identity is maintained through vigorous opposition to two things: reality and the inner world. *Psyche* is the agon that is joined whenever that system breaks down and the subject is forced to engage the conflicts of its inner world. Secondary emotion is the system of feelings we construct in order to deliver us from that process. The purpose of theatre is to activate the latter process.

## 4

"The Director's first task is to cast the audience" (Grotowski). Something I want from you is opposed to something you want from me. That is the essence of drama. It is also the relationship between any worthwhile play and the audience. The *theatre event* is what happens *between* an ensemble and the audience as the former work upon the latter to activate a group psychology of a unique kind. A written play is nothing but a score that is only actualized when in performance an audience begins to move as one to the urgencies of a collective psychology. We don't create in front of an audience; we create by working on an audience. They give us their defenses and we give them back to them as primary emotions.

That dynamic is the main difference between cinema and theatre. Cinema is oneiric: the projection of private fantasies by subjects sitting alone in the dark. Theatre is communal: lived and living because it is built in performance out of the responses that the ensemble seizes upon in order to take an audience in directions it fears to tread. At the movies, audience members try to be unaware of one another; in theatre, they desperately depend upon and solicit one another's responses in the effort to evolve a collective psychology. Theatre takes on its inherent danger when the ensemble uses this condition to activate an agon that shatters the ideological beliefs that hold the

audience together. When we cast the audience in ways that flatter their self-esteem and reinforce their beliefs we create a theatre in which nothing happens. When in casting them we seek out the agons that will engage what is buried most deeply within them we create a theatre that shimmers with existential possibility. To bring that about our task is to overturn the wisdom of Stoppard's Player–King: "Audiences know what to expect and that is all they can believe." Most productions, unfortunately, bank on that fact, drawing their mandate from the pleasure associated with repetition of habitual operations, whereas for us the purpose of playing must be to make what happens on the stage become for the audience what the Archaic Torso of Apollo was for Rilke: "For here there is no place that does not see you/You must change your life." The paradigmatic status of O'Neill's *The Iceman Cometh* for an understanding of the theatre event derives from O'Neill's effort in that work to dramatize the essence of this process. Hickey engages the audience on stage in a process that represents the agon that any great play strives to activate in the theatre audience.

## 5

The art of acting is defined by this agon. That art can be condensed into an aphorism: "Something must break within you with each line" (Angelina Jolie). In exploring the inner world, actors don't discover their "true self" and their "true feelings." They discover the inner conflicts that must be engaged in order to uncover what one does not want to know about oneself. When one acts from that place, acting becomes, as Jack Nicholson said, "the process of dripping acid on the nerves." For when something breaks within you with each line it breaks too within the audience who see their world represented in a way that unmasks it. Robert De Niro's great description of acting is only as good as its hidden major premise. To quote De Niro: "Actors are like people. They don't express their emotions. They conceal them. And it is in the process of concealing them that the emotions are revealed." An audience experiences the shock of recognition when they are confronted with action and gestures that perfectly mimic their characteristic ways of fleeing themselves. The question marks that the Brechtian actor places within and at the end of each line are addressed, contra Brecht, not just to the intellect but to the psyche: they plant in the head the time bomb that explodes in the heart as primary emotions erupt from long concealment, engaging the audience in the struggle to confront and reverse their lives. The

purpose of acting is not to entertain, but, borrowing from Albee's George, to "get the guests."

6

Here is a story revealing where drama begins. Recently, by chance, I saw on television a dinner party held by Oprah Winfrey for six members of her book club and Toni Morrison. Among the guests were several obviously wealthy socialites (including one named Celeste). At the end of a bountiful dinner, Toni Morrison reads from the passage toward the end of her novel *Song of Solomon* in which Pilate mourns her dead grandchild Hagar. During the reading, Celeste breaks down and weeps uncontrollably. Comforted by Morrison, that great-souled presence, who holds her, Celeste, still weeping, tells her story. Her first child was stillborn. She never saw the child nor did she ask to hold it. "I was always taught that I should be protected from such things." But now something different has come into being, thanks to Morrison's work. "I never held my baby. I'm so ashamed." A drama has begun. A work of art has put a subject in touch with a depth in her psyche that she did not know existed. One can only imagine the struggle later that night to resume the mask and cover her embarrassment when Celeste returns to her suburban home and, one imagines, the wealthy friends gathered together to watch her on Oprah and celebrate the occasion. She can't go home again—and yet she must. Such is the power, however momentary, of art to cut through our defenses and "make us ashamed of our existence" (Sartre). As Celeste learned, art restores us to the past that matters by revealing that past as the forgotten duties that we bear to our own humanity. Through art they are imposed on us in the violence of the claim they make upon us. And so our anxiety for Celeste is that she will succeed, helped by her group to say what Heidegger says we always say once anxiety passes: "It was nothing." Theatre is the attempt to bring that nothing into being.

7

"An image is true insofar as it is violent" (Artaud). The task of the playwright is to find traumatic images and then create a dramatic structure that will unleash their power, so that the emotional *dynamis* implicit in the image becomes an agon that transforms the audience's relationship to itself. Theatre must preserve the violence of the image, because without that violence nothing happens. Change only becomes possible when an image stays alive and works within the psyche, when

another's suffering becomes one's own and one gains no relief from that suffering through fine thoughts and airy platitudes. Our task is to create a theatre that knows, with the artist R.B. Kitaj, that "reducing complexity is a ruse," that the goal of art is "to create images that will sit in the Unconscious;" for it is there, where nothing sits still, that change begins in psyches delivered over to everything they hoped to keep repressed. Such a theatre can be as grand as Weiss' *Marat/Sade* or as intimate as Chekhov's dream of that actor who reveals his fate (and ours) in the way he lifts his coffee cup or turns the pages of his newspaper. The choice does not lie between an "epic" and an intimate theatre. It lies between exploring the truth of primary emotions and indulging the evasions of secondary emotions. The lesson Artaud taught visits our consciousness daily. It has become what Hegel called the newspaper: "the morning prayer of modern man." On rising, one turns on the television and is awash in traumatic images, such as those of a six-year-old child mimicking the dance and gestures of an adult woman in a "beauty pageant," soliciting our voyeuristic complicity in the illness that tells parents they have a right to do such things to children. And so we look again and see what gives the image its true violence. It's there—in the deadened eyes, and the broken, frightened gestures that rupture the performance from within, giving it a Brechtian function that is one with the ability of JonBenét Ramsey to "signal through the flames." In such images we recover the lesson we most need to recover: that drama is the truth of everyday life; because agon remains the being of the subject. In the image of a child violating herself in a desperate effort to win her parent's love, we are offered a way back into Aristotle's recognition that tragedy has the family as its primary subject, because cruelty is most terrible when we find it where we had expected to find love. For we then suffer the recognition that one sign of our disorder is the pleasure the culture took—and continues to take—from such images. In the traumatic image the suppressed truths of our world assault us in their inherent violence. To articulate their meaning requires a descent into the heart of our collective disorders.

## 8

"Always historicize" (Frederic Jameson). Theatre in its origin is wedded to this principle. The contradictions of its time are its subject matter. That is why the task of theatre is always the same—and always different: to expose *ideology* by creating dramatic forms and dramatic experiences that cannot be subsumed under the guarantees

that ideology superimposes on experience in order to assure us that traumatic realities and conflicts cannot alter or destroy what we desperately need to believe: that we possess an *identity* that is one with the goodness of a *human nature* that cannot be lost and that guarantees the persistence of values that are universal and ahistorical. In combating ideology we face a redoubtable task. For these assumptions and guarantees are not the property of a single ideology. They go much deeper, forming a common heritage. Insofar as we are creatures of the *logos*, the western *ratio*, we structure experience in terms of a *system of guarantees*. They form the a priori frame of reasoning, explanation, and emotional response that we impose upon events so that nothing traumatic can impinge upon the ego-identity that the guarantees provide. The *logos* or *ratio* can be defined, for our purposes, as the system of intellectualizing operations that give experience a structure that is conceptually transparent and that marginalizes—as irrational, neurotic, unintelligible, irresponsible—anything that fails to correspond to reason. Such a system offers us an essentialized identity that frees us from contingency and that provides a way, especially in times of national crisis, to transcend particular political and factional differences and unite as subjects on the basis of a shared, universal humanity.

We discern here the true reason Plato banished the poets from the perfect state. The agons drama explores and the primary emotions it engages exceed the forms of mediation that the *ratio* provides. Drama offers knowledge of ways of being that are lived concretely by agents who act from principles of psychological and existential self-mediation that exceed reason and its founding desire—to submit experience to that which can be rationally conceptualized. Drama is our way of representing and apprehending all that exceeds that framework. In that effort reason is no more than the cutting edge of passion and oversteps its bounds whenever it presumes to legislate over that which it must humbly serve.

## 9

Fortunately there is a concrete way to pursue this theme, a way that dialectically connects history and drama. History under the *ratio* is the explanations that are constructed to deprive events of their contingency. History thereby becomes the *parousia* of *Geist* (Hegel), the story of liberty (Croce), the triumphant march of the essential ideals that constitute the American experience, etc. History is that which is written so that the past will not be known; or will

be known only insofar as it finds fruition in the future. Traumatic events that would enervate the national consciousness—Hiroshima for example—are justified by explanations invented after the fact. History is the narrative written retrospectively to wash the blood from our hands. And as such it is a discourse whereby a collective ego-identity is forged through the banishment of nagging doubts and fears—a melodramatic allegory play, rife with resentment, whereby a collectivity triumphs over time and contingency. Plays that offer resolution and "catharsis" perform a similar function, by creating structures of feeling that cleanse the psyche by bathing it in the pleasure and release provided by secondary emotions. Aristotle's famous distinction between poetry and history misses the main point. Within the system of guarantees, history and drama are *fictions* that perform the same function in different ways. As the two arts dedicated to the exorcism of existential contingency, they give the metaphysical need that informs the *ratio* with a "local habitation and a name." That name is *humanism*: the set of essentialistic beliefs about human nature that we use to assure our transcendence of historical, existential, and psychological contingency.

Drama is the agon that erupts whenever those guarantees are shattered. One then exists in the knowledge that conflict is the essence of being human, not the temporary departure from the essence. Psyche is its conflicts; nothing within protects us from the need to *act* and through action to submit ourselves to a world that estranges us forever from the paradise of the guarantees. Humanism is that wing of the *ratio* that is of most concern to us, because it is the application of the *ratio* to our psyche and our experience. Once we have internalized the humanistic *ethos,* conflict can only be experienced as the movement *from* and *to* the recovery of an identity that we cannot lose, an identity fitted with the added benefit of assuring our goodness, our psychological health, and our correspondence with fundamental, unalterable values. Such is the experience that theatre within the system of guarantees offers its audience. It does so by violating the essential thing that theatre incarnates. *Representation exceeds intention.* Any halfway decent play engages conflicts that exceed the guarantees. Unfortunately, the latter then far too often come to impose themselves upon the emerging drama so that it can end—as every play of Arthur Miller's does—with the reassertion of every belief the play has thrown into question. Playwriting within the orbit of the guarantees is the clash of contradictory imperatives. This is so not because we are faint-hearted in the face of experience,

but because the traditional forms and principles of dramatic structure are the aesthetic realization of the guarantees. The pull toward resolution embodied in traditional dramatic forms is one with the underlying ideological and emotional guarantees that are thereby satisfied. Genuine experimentation and newness in the theatre thus begins only when we write and perform in ways that *deracinate* all conventions and artistic principles that wed us to the guarantees. Arthur Miller argues that "every drama is a jurisprudence." The law of drama however is not the translation of abstract thought into temporal terms. It is the submission of guarantees to their reversal and the liberation of what emerges when experience is represented cleansed of their intrusion.

## 10

*Against catharsis.* Historical explanation within the system of humanist guarantees, and catharsis within the emotional dynamics of form are two different ways of fulfilling the same metaphysical need. Aristotle was Plato's apt pupil in one regard. He knew that the disruptive power of drama had to be contained. What better way than to impose secondary emotions (pity and fear) upon it and then argue that the *logos* of dramatic structure was the movement of those emotions to their purgation. He thereby invented tragedy in order to banish the tragic. The limit of theatre is the limit of our will to explore agons that will not be bound by the need to produce catharsis. But to get there we have to become aware of all the ways in which we remain bound to that desire; as, for example, in messianic aesthetics and the belief in the redemptive power of art. To know history we must experience our situation without deriving succor from the aura that the desire for redemption casts over it.

*Against irony.* But to achieve our goal we must overcome something that is for many of us far more binding than the guarantees. We must overcome our misplaced confidence in the postmodern exaltation of irony and the "death of the subject" as the last word in liberation. A theatre of free play sounds experimental and historically liberating only if one forgets that the last word on irony was pronounced long before the aporias of the self-ironizing sensibility began to strut and fret their hour across the stage of culture in an effort to conceal an underlying despair.

Irony. Don't let yourself be controlled by it, especially during uncreative moments. When you are fully creative, try to use it, as one more way to take

hold of life. Used purely, it too is pure, and one needn't be ashamed of it; but if you feel yourself becoming too familiar with it; if you are afraid of this growing familiarity, then turn to great and serious objects, in front of which it becomes small and helpless. Search into the depths of Things: there, irony never descends. (Rilke, *Letters to a Young Poet*)

Nor does the cant offered by a slew of ideologues that 9–11 marks the end of postmodernism and the return to "reason and moral clarity." What we need, in opposition to both dogmatic deconstructionism and moral posturing, is to press on and constitute what has long slumbered in the postmodern condition as its true contribution to our historical awareness—the supersession of irony by the tragic and with it the recovery of a genuinely existential way of thinking about concrete experience.

*Incipit tragoedia.* For it is in a frank opening of ourselves to despair that we find our way back into an authentic relationship with the grave and serious things, a way to live in the temporality of the fundamental questions, not as prisoners of nostalgia, but in the confidence that such a relationship alone gives us the courage to once again explore agons that derive from the depth of human inwardness. Being a subject will then become again what it was for Hamlet—not an illusion to be deconstructed in the deferral and delay of endless signification ("signifying nothing") but the agon in which "the human heart in conflict with itself" (Faulkner) endures the existentializing claims that tragic experience makes upon us: "for I have heard / That guilty creatures sitting at a play / Have by the very cunning of the scene / Been struck so to the soul, that presently / They have proclaim'd their malefactions" (*Hamlet* 2.2). Our task is to do everything in our power to make that happen.

## 11

Drama has a unique cognitive and ontological status. Freud said "the tragic poets knew it [the unconscious] first." We can now see that they also know it best; know it in a way that goes beyond the limits of other ways of knowing. Authentic drama is that representation of concrete, lived experience that comprehends what happens when we are delivered over to ourselves. In destroying those structures of feeling that protect us from ourselves, drama opens the psyche to an order of self-mediation that becomes possible only when traumatic conflicts are sustained in agons equal to them. As C.S.Peirce said, "experience is what happens when our ways of knowing break down." Drama

is that happening. It is what breaks within us when all ideological blinders, all rationalistic guarantees, are submitted to an agon in which we exist as at issue and at risk in the struggle to mediate the burden of primary experiences. The proper relationship between the image and the order of the concept is thereby established. The world of the image, of concrete experience, is our way of apprehending realities that exceed the limitations of the concept. The cognitive power of literature subjects Plato's argument banishing the poets to a complete reversal. "Poets are the unacknowledged legislators" in a world that reason knows little of, a world in which traumatic images are sustained in agons that prove equal to a representation of experience engaged at a level that is visceral, primary, and existentially exacting. Literature is not the translation of abstract concepts and themes into temporal, narrative terms; it is the world as it is lived existentially in structures that are prior to reason and beyond its range of comprehension.

## 12

Here is a task for a dramaturg of the future. We don't need censorship, we have interpretation. The history of dramatic criticism from Aristotle to the present is a monument to the effort to superimpose the guarantees upon drama by constructing theories and interpretations that take the tragic, explorative energy of great works and bend them to our needs. Thus Aristotle: offering us the catharsis of emotions that are themselves a defense against the tragic. Milton: "calm of mind / all passion spent," so that we can leave the theatre assured that nothing will change. And in our time, the many varieties of ritual theatre (Burke, Girard, Frye, etc.) that turn drama into a group psychology in which social conflicts are transcended through the imposition on experience of patterns that are held to be universal and ahistorical. By and large, the history of dramatic criticism constitutes so many conceptual shields before the Medusa, ways of letting us get close enough so that we can slay what we can't look upon directly. What we need is a dramaturg who will reverse that tradition by exposing all the ways that the guarantees are sequestered in interpretations. We need a method of interpretation that will prepare the way for radically new productions through concrete demonstrations of how great works undermine the interpretations that have been foisted upon them. Scholarly research would then itself become a drama of Heideggerian *a-lethia*, i.e., of wresting from concealment. We'd thereby learn, for example, that virtually everything that has been

written on *Hamlet* constitutes an attempt to avoid the play. Despite different frameworks of meaning, the interpreters of *Hamlet* share an identical goal: to turn the most radically open-ended and emergent exploration of the tragic in our literature into something cabined, cribbed, confined in the narrow house of our needs and desires.

## 13

And of course we need a theatre of the oppressed, a theatre that will be feminist and gay and multicultural, for these are the places where the contradictions of our historical situation are most apparent. We need a theatre that honors every subject position. But in liberating such voices our purpose cannot be the celebration of diversity as an end in itself. For we live in one world—now more than ever. And so our task remains *dialectical*—to apprehend the contradictions that define the social order as a whole and thereby discover the necessary connections that bind us to a common task. No subject position can be excluded from this search, for we can never know when the contradictions of the whole won't become apparent and assault our psyche in a way that tears our world to tatters: as in the eyes of JonBenét Ramsey and what they reveal about our most cherished institution, the American family.

And of course we need a theatre that is grandly experimental. But all experiments must derive from a single rationale: to shrink the space between us and the audience so that the audience is forced to become a participant in the performance. Thus I envision a theatre in which every device is exploited to make actors and audience inseparable. As when, for example, the actors, with the play in some way already begun, would form a queue the audience must join and move along in order to get to their seats; or when at points during the performance the lights would go up in the house so that audience members would become painfully aware of one another; or when perhaps they would at intermission find the doors of the theatre locked and a discussion of the work already begun among the cast and actors planted in the audience, a discussion they would be invited to join. What has become one of the most deleterious conventions of recent theatre—the post-play discussion—would thereby become the itch of an anxiety felt at the time it should be. We have only begun to explore all the ways we can break the fourth wall through experiments that will be disciplined because they serve a single end: to activate an agon in the audience. That is the purpose of playing, the concern that informs everything we do from the moment we

first begin to write or read a play and search for ways to activate the most radical of encounters.

**14**

Here, then, in summary, is an ideal realization of the action that a great drama performs on the audience. (1) Social identity is maintained through the public legitimation rituals through which shared ideologies are celebrated. Drama reverses that process by exposing those rituals: by blocking their function and turning them back against themselves. (2) As group psychology, the agon thereby engaged has the following structure. The audience, as group, tries to resolve conflict by coalescing around a shared need (laughter, pity, etc.) which offers a collective identity. The ensemble's task is to destabilize this structure. Defenses must be activated; the sores of discontent rubbed raw; projections turned back against themselves. (3) The collective psyche then regresses to a more primitive state in an attempt to ward off deeper underlying conflicts. With the fragmentation of group identity each individual is delivered over to the drama of primary emotions. As in *King Lear*, "close pent-up guilts" break loose in an audience confronted with the return of buried conflicts. (4) The miracle has happened: an audience has been transformed from a group seeking pleasure through the discharge of tensions and the affirmation of common values to anxious agents existentialized in a solitude that has arisen, in the midst of others, as the space of a fundamental concern. Tragic recognitions ensue, destroying the possibility of regaining the psychological identities that existed prior to the play. (5) The audience now experiences in the characters on the stage the fundamental truth: that what we don't know about ourselves is what we do—to the other. They experience it in sufferance as the imperative to deracinate everything that hides one from oneself.

(6) The purpose of authentic drama is to destroy the ego in order to awaken the psyche. The ego cringes in the theatre because it witnesses the staging of its informing motive. Flight from inner conflict is its reason for being. (7) Our job is to reverse that process; to represent an audience to themselves so that they will, in the shock of recognition, see and suffer what they want to deny. Thereby the smooth functioning of secondary emotions gives way to an agon of primary emotions in subjects who now find themselves in fundamental conflict with themselves. (8) Once that has happened, the task of the ensemble is to bring that audience to the recognition that there is only one

choice: radical change or the extinction of consciousness; persistence in inner paralysis and the deadening of affect or the effort to reverse oneself totally through the struggle to overcome everything that protects one from confronting one's deepest conflicts.

(9) Theatre has become a place of total exposure, with no "catharsis" available to relieve the audience of the burden that has descended upon it. Aristotle was right in this—reversal and recognition are the essence of tragedy. They are what happens to the audience when they prove equal to the agon that a great play activates within them. When that happens the space of theatre has been totally transformed. The audience isn't looking at the play. The play is looking at them with a look that has the Sartrean power to expose us to our bad faith and re-establish our contact with our existence. (10) The purpose of theatre is to awaken this possibility and bar all exits that would deliver us from it. Theatre is not the space in which a content—a body of themes or pre-existing ideas—is communicated. It is the space in which an action is performed. That action is the attempt to act on the psyche of the audience in order to bring about a reversal in the relationship that they live to themselves.

## 15

"Always historicize." A trauma cannot be resolved until it has been constituted. That is why one cannot write a play that will resolve the trauma of 9–11, for example, without being untrue both to drama and to history. Which doesn't mean we won't be deluged with plays and productions dedicated to healing the national psyche. That has, after all, been the national mandate since 9–11. As such, it reveals the persistence of the root assumption we must deracinate: the assumption that trauma is only resolved through the restoration of guarantees; concretely, in this case, through dramas of pathos followed by a triumphant reaffirmation of the ahistorical ideals that constitute "the American character" and America's unique role in history. Therein lies the ideological formula for pseudo-drama: our innocence, our unexampled suffering, our triumphant recovery. Any representation of 9–11 that does not serve this structure is forbidden. And so here, as prologue to a drama that will not exist, I offer these "fragments shored against" our "ruins"—a primer toward the recovery of what the *image* reveals about history and our collective unconscious.

Image is the native language of the psyche, the language in which the truth of history and the impact of history upon the psyche is expressed in a logic which, like the logic of the dream, establishes

hidden and unexpected connections in which the present speaks to and reawakens the past in the reemergence of everything that ideological consciousness strives to deny. *Ground Zero*. What's in a name? The term now used to designate the rubble of what was once the World Trade Center was the term coined in Alamogordo, New Mexico to identify the epicenter where the first atomic bomb was detonated. It was then used to locate the same place in Hiroshima and Nagasaki so that we could measure with precision the force of the bomb and gauge its effects. Through a grotesque and cunning reversal it now designates what was done to us. But in doing so it also reveals an unwritten history. Hiroshima, a repressed memory deep in the American psyche, returned on 9–11 as we experienced in diminished form what it must have been like to be in Hiroshima city on August 6, 1945 when in an instant an entire city disappeared, abandoning the *hibakusha*, the walking dead, to a landscape become nightmare. For us, however, repressed memory only returns to serve the defense mechanisms of *projection* and *denial*. The term *Ground Zero* thus offers no entry into our past; instead, it gives us a new identity as the innocent victims of a terror we have the temerity to claim is unprecedented and that we demand the whole world acknowledge as such. In doing so we reveal our relationship to history. History is hagiography, the assertion of our virtue through our triumph over the forces of evil. From which follows the parade of heroic images whereby we rise phoenix-like from the ashes, united as a nation that has recovered its essence and thus goes forth to reaffirm the ideals it represents by undertaking the actions needed to cleanse the world of terror. John Wayne lives—and he's been called upon once again to provide the American imaginary with the images it needs to deliver it from images of another order.

For the images blazed into our consciousness on 9–11 are terrifying precisely because they embody anxieties that open up the psychotic register of the psyche. A plane embedded surrealistically in a building; bodies falling from the sky; that great granite elevator going down; the black cloud rushing forth to engulf a fleeing multitude; and then the countless dead, buried alive, passing in endless queue across the shattered landscape of the nation's consciousness. The dark dream of psychosis—of falling endlessly, going to pieces, collapsing in on oneself, losing all orientation, being delivered over to a claustrophobic world of inescapable, ceaseless suffering—found in 9–11 the objective correlative that awakened images buried deep in the national psyche; images of things forgotten, ungrieved, vigorously denied.

For a historical consciousness incapable of agon, however, the only operation traumatic images permit is *evacuation*. And so, for the media and those comfortably seated in the places of ideological power, the projector had already started running and on the screen of the national psyche flashed old, familiar images of a movie full of patriotic sentiment and patriotic gore. Flags a-bursting, the heroic dead of Ground Zero are resurrected in the acts of war we undertake in their name, their image blending and fading into the images of our triumphant military action in Afghanistan, in Iraq, in North Korea, in any place we designate a haven of "terrorism," that term the blank check on which we draw to do whatever it takes to restore us the way we were restored by the incineration of Hiroshima and Nagasaki. And restored we were, as witnessed by another image from the past that flares up here to confirm what Walter Benjamin defines as the mission of the dialectical historian: "Every image of the past that is not recognized by the present as one of its own concerns threatens to disappear irretrievably." Navy Day, October, 1945, a crowd of 120,000 gather in the Los Angeles Coliseum to celebrate a simulated reenactment of the bombing of Hiroshima, complete with a mushroom cloud that rises from the 50-yard line to the joyful cheers of that rapt throng. The first Super Bowl: the new American collectivity as it gains orgasmic release in hymn of praise to the burgeoning cloud that ushers in its hour upon the stage of human history, a collective Hosanna before the image of its inhumanity as it blossoms before them, big with the future.

Einstein said "the bomb changed everything except the way we think." It didn't change that because no drama was written with the power to implode/explode the *fact* of that event in the psyche so that the bomb would be internalized as a crisis for the soul and not just another fact to justify, before capping that justification with the claim that the one nation that used the bomb has the moral right to determine who should have it.

And so the parade of images that echo and exorcise other images creeps on apace. As after Gulf Storm, the Nintendo war, a war represented on TV as a video game. No images of the 100,000 Iraqi dead were permitted entry into the national conscience; nor subsequently any images of the million Iraqi civilians who have now died as a result of our sanctions. (Yes, Saddam bears a lion's share of the blame. So do we!) Instead with victory the proclamation of George H. Bush: "We've finally put an end to Vietnam syndrome"—and so can safely confine that war and its vast body of traumatic images to

oblivion and the dustbin of history. We thus repeat over time the same Pyrrhic victory—a victory over those traumatic images that call the psyche to a knowledge of itself. Which is why such images can only return from without as violent and unwarranted assaults on the "innocence" of a people who refuse to know their actual position in the world.

Five per cent of the world's population consume 25 per cent of its resources—and they do so by exerting control over the destiny of other countries. But that fact finds no image in our consciousness. And in Rio de Janeiro, at the one ecological conference he attended, George H. Bush delivered a proclamation even more chilling than his crowing about Vietnam syndrome: "The American way of life is not negotiable." As long as that dogma remains in place, there will be many more ground zeroes.

And so for some of us traumatic images remain the weight that weighs like a nightmare on the brains of the living. A drama that would be adequate to 9–11 would resolve nothing. It would, instead, deliver the audience over to a history that would reveal the historical, dialectical connection of the pattern of images presented in this section in order to awaken that audience from its collective slumber. For those of us who work in the theatre, Walter Benjamin's great aphorism about the task of culture—"the dead remain in danger"— must be emended thus: the dead remain in danger—of being sacrificed to the needs of the audience.

## 16

The previous sections have offered 15 ways of making a single, complex point. All are different and all are necessary. For they are dialectically connected. It is in that dialectic that theatre finds its rationale and its mode of being. Our first job and our last is to cast the audience. But the only way to do so is by first casting ourselves in a way that deracinates within ourselves everything that stands in the way of the most radical act—the engaging of primary emotions in mediations that remain true to the agon that primary emotions activate within us. For the ability to perform such an action on an audience is only given to those who first perform that action in themselves.

## 17

All our efforts depend on a single circumstance. Kafka at 20 offered this as the task of reading/writing.

If the book we are reading does not wake us, as with a fist hammering on our skull, why then do we read it? Good God, we would also be happy if we had no books, and such books as make us happy we could, if need be, write ourselves. But what we must have are those books which come upon us like ill-fortune, and distress us deeply, like the death of one we love better than ourselves, like suicide. A book must be an ice-axe to break the sea frozen inside us. (Letter to Oskar Pollak, January 27, 1904)

We will get the kind of plays we need only when we have become the kind of audience who come to the theatre demanding plays that perform such an action within us.

# Part II
# Ideology: The Heart of the Ulcer

# 4

# The Trouble with Truffles:
# On the Ideological Paralysis of the Left

## THE LEFT TODAY: A DEFERRED CRISIS

By God you don't need a swine to show you where the truffles are.
George in *Who's Afraid of Virginia Woolf*

The Corrie controversy offers those of us on the liberal left an opportunity we can't resist. A chance to celebrate our identity by railing against censorship. For as we all know, the left is incapable of censorship. Critical self-consciousness is the very foundation of our enterprise. We are the critics of ideology, not those blinded by it. With this article of faith firmly in place, I offer a counterexample that I regard impersonally even though it involves my own work. Its appropriateness here as overture to a critique of the central contradictions of current leftist ideology derives from its connection to the Corrie controversy, which continues to provide an occasion for progressive thinkers with little or no interest in theatre to issue proclamations which feature a denunciation of censorship as clarion call to a reaffirmation of leftist identity.[1]

Since shortly after 9–11 I've enjoyed a working relationship with *CounterPunch*, which describes itself as "America's Best Political Newsletter." First versions of some of the key chapters that went into *Death's Dream Kingdom* were published there. While working on my first Corrie essay I wrote the editor, Jeff St. Clair, asking if he'd be interested in that piece. Jeff wrote back telling me he'd been hoping to run something on it from an interdisciplinary perspective that, as an actor and playwright as well as a cultural theorist, I could provide. (What is now Chapter 1 was published in *CounterPunch* on March 6, 2006.) Jeff expressed similar interest when I informed him that I was working on a follow-up article discussing the larger issues raised by the Corrie controversy. I was thus surprised to receive the following response to that essay, which here forms Chapter 2.

Walter,
   As always there's a lot of interesting stuff here, but don't you think 8,000 words is a bit of overkill for a play that really had no literary pretensions at all? I haven't seen anyone putting this in the same class as Beckett or Brecht, have you? Also, I think Alan Richman [sic] would have been criticized if [he] had tried to re-write or re-shape Rachel's words into a drama. I'm not big on martyr plays either, but I wonder how the Corries, who are devoted readers of *CounterPunch*, would feel about your essay. It's really a political touchstone, isn't it? And as that, it's more than served its purpose.
   Best, Jeffrey

   I wrote back addressing Jeff's concerns and asking him to let me know if his letter constituted a rejection of the essay, a request for revisions, or simply a personal comment. If I was troubled by his first letter, I was alarmed by his second.

Dear Mac[2]
   I just don't think * this * is the time to be leveling a broadside against "My Name Is Rachel Corrie", which was, it turns out, merely an opening act, a dumbshow, if you will, for the political theater which it has unleashed. This is the time for solidarity, not academic carping. I'm not willing to substitute my views of the literary merits of the play for Harold Pinter's (see below). If you really think you must publish this piece now, try Sunil at *Dissident Voice*. The reaction of our readers—those [who] would dare to swim across its oceanic breadth—would range from the hostile to violently hostile, with some justification in my view.
   Best,
   Jeffrey

   Attached beneath this was a reprint of a letter of March 16 signed by Harold Pinter and 20 other Jewish writers expressing support for the Royal Court production of the play and dismay over its cancellation or postponement by NYTW. Nowhere in this statement, I should add, is any claim made about the artistic merits of the play. But that is a minor point. Without apparently realizing it, Jeff St. Clair had performed an act identical in kind to the one taken by James Nicola of the NYTW. Quick to censor censorship on the right, are we on the left unable to detect it when we engage in it? And if so is that because we too are ruled by covert ideological beliefs that override all other considerations?

What I want to suggest is that what we have here is not a simple "failure to communicate," as in *Cool Hand Luke*, but a necessary failure that highlights some of the central contradictions of current leftist orthodoxy. Here, as revealed in St. Clair's letter, are the main ones with regard to theatre and politics.

1.  The role of art is to offer a simplified take on a political issue in order to rally support for a political discourse that has no further need of art. Art has served it's purpose if it popularizes an issue in a way that creates "a mass consciousness" that can subsequently be deployed for political purposes by those who specialize in such matters. Art is valuable in serving that goal if it is easy to understand and produces emotional reactions that readily translate themselves into unqualified support for a desired political program. What art does not possess, according to this view, is the power to challenge or transform our political agendas. For that would entail a far different theory of art; the one, I should add, that underlies the essay Jeff found politically incorrect.
2.  Solidarity trumps all intellectual differences. We can entertain various views but once an issue becomes political, *consciousness* must tailor itself to the party line. Our common duty then is to marginalize or dismiss all doubts and academic quibbles. Political discipline is the insistence on obeisance to a collective mind organized around unquestioning allegiance to certain political positions. Critique or critical consciousness must always bow to the demands of political correctness.
3.  Writers should never provoke the hostile—or violently hostile— reactions of fellow leftists. That is precisely what one risks whenever one says unpopular things about an issue where solidarity has been invoked. Apparently our need for emotional allegiance is even stronger than our intellectual. Like the subjects of Dostoyevsky's "Grand Inquisitor," feeling in common may be for us too a need that brooks no opposition. Emotionally we may in fact have much in common with the fundamentalists whom we mock as emotional infants. Whenever emotional reactions are determined by a religious adherence to shared dogmas, we condemn ourselves to a situation in which we can only feel in extreme and rigid ways.

As we'll see, this issue which appears minor at first will turn out to be the pivotal one. Confining *feeling* within the procrustean bed of ideological correctness is not only what destroys the possibility

of radical theatre. It is what makes it impossible for the left to recover radical psychoanalysis as the way of thinking needed for a critique of ideology that will address the actual way in which subjects are formed and how emotion is the glue that holds the entire ideological edifice together.

4. But because we too are the prisoners of emotional programming— and because the left remains for so many a religion or substitute for religion and thus an unquestioning allegiance to certain immutable articles of faith—dissent is forbidden far more often than we care to admit, especially when dissent asks us to sustain a line of thought critical of dogmas and beliefs that we insist must not be questioned. Our own brand of anti-intellectualism thus labels as "academic carping" any discussion that would ask us to "swim across" the "oceanic breadth" of arguments that can only be of "academic" interest. I recall here the boos that once greeted Herbert Marcuse when he told a group of California student radicals that they should go home and read Hegel and *Kapital* before presuming to think they knew anything about *praxis* or history. Similar considerations apply to dominant leftist beliefs about art and its relationship to politics.

5. Though right-wing commentators are fixated on authority, we have our own version of the argument from it. There are certain people whose opinions count more than others. Thus in artistic matters we must subordinate our own "subjective" response to a play—and our judgment of its literary merits—to theirs. Invoking this principle entails an interesting shift in Jeff's position. His initial claim that the Corrie play has "no literary pretensions" now bows to Harold Pinter's alleged assertion of its artistic merits. Moreover, Mr. Pinter is not required to develop the view imputed to him. A single principle is uppermost when dealing with "academic" questions about art and theatre. *Artistic quality is insignificant.* If a work serves politics its artistic integrity is irrelevant. In fact, mediocre works are the most serviceable because they don't cloud the political function of art with the kind of aesthetic complications that characterize "high" or "elitist" art. Once again the fundamental ideological necessity has been asserted in a way that deprives drama of any independence or significance. As we'll see, this necessity is the fulfillment of larger emotional, psychological, and ideological assumptions that Jeff's letters throw into relief.[3]

But if Jeff's words imply a nest of ideological contradictions, they do so by directing our attention to the issue that almost everyone will agree must be first and foremost. Namely, the question: What is politics?

## WHAT IS TO BE DONE?

### Ideology

By ideology I refer here to the total system of assumptions, beliefs, ideas, attitudes, and emotions that make it impossible for a group (or an entire social order) to understand its historical situation. This definition formulates the essence of Marx's concept.[4] Developing it has led me however in a direction he seldom pursued. To battle an ideology, the key operation is to get at the deepest principles upon which it rests. Overturn them and the rest will follow like a stacked row of dominoes. However, the real forces that determine what individuals and groups believe are not ideas but the psychological and emotional needs that underlie them. For example, to undercut the attempt by the right to recycle Thomistic natural law theory as the philosophical foundation for its politics,[5] it is not enough to demonstrate the philosophic flaws of Thomism. One must tunnel beneath to the fixation on authority and on moral absolutes that fuels it in order to bring into the open the psychological conflicts that adopting this way of thinking enables one to flee. Eventually thereby the underlying truth comes into view: that the right is ruled by an emotional *resentment* that must be projected on anyone who doesn't order their life with a similar obsessional rigidity. (The fear and hatred of liberated women, gays, sexual freedom, etc. derives from the flight from experience that such attitudes defend by sanctifying.) Philosophical ideas that have long since received their quietus, such as Thomism, gain a new lease on life by enabling a psychological disorder to cloak itself in a quasi-intellectual form. The ideational rigidity of conservative ideology draws its force from the psychological complex it both satisfies and displaces from scrutiny. That is why, to put it bluntly, the way to combat O'Reilly or Hannity is to go right after the obedient little altar boy who is still trying to prove to his mother that he's a good boy devoted to the truth.[6]

An ideology derives its appeal from the *conflicts* it enables one to avoid and the *desires* it enables one to fulfill. The emotional and psychological pay-off is the ultimate basis for the whole enterprise.

Every ideology attempts to establish as rooted in human nature and in history the emotional and psychological needs that it satisfies. Faith in progress and hope as the categories defining the future would not, for example, compel the allegiance these beliefs continue to hold were it not for the satisfaction they offer as "teleological guarantees" against the bite of contingency, so that no matter how dark things get we can continue to see a light at the end of the tunnel. Certain ideas remain in force against the overwhelming claims of counter-vailing evidence because they serve emotional and psychological needs without which their adherents would find life meaningless or too hard to bear. Such is the primary role of ideas in the affairs of most human beings. That is why almost every political debate is a pretext doomed to frustration. We think we're arguing about abortion or immigration or the death penalty, concerned solely with the rational grounds of our position, when what's really being satisfied is emotional and psychological needs that make it impossible for us to think except in the ways that they dictate. Intellectual debate is by and large the carnival of psyches playing out their deepest needs while pretending to do something else. And thus the absurdity, for example, of debating Hannity on immigration. His argument that "it is immoral to give amnesty to lawbreakers" is rooted far deeper than his pathos for the "legal means" his Irish forefathers used to achieve citizenship. It's rooted in the pleasure and necessity of abstract moralism not only as a way of denying the complexities of a historical situation but as a way of confirming a psychological identity grounded in rectitude and resentment. The threat that Hannity, O'Reilly, Limbaugh, Falwell must expel is the threat of self-examination; i.e., of having a relationship to their psyches based on anything but flight. Each political issue simply provides the occasion for repeating that operation. The necessity for a moral reading of historical events thus draws its strength from the psychological repression it satisfies.

There is no way out of this situation, for one simple reason. By and large, people are unable to criticize or change their ideas because they are unable to question the psychological fears and desires that have a greater control over them than anything else. To get free of the ideology, one would have to make a break with the system of defenses and needs that hold one's psyche together. Ideology draws its ultimate force by delivering subjects from the threat of psychic dissolution and anxiety. No wonder political correctness proves irresistible. Ideology is that way of thinking and feeling that we

adopt in order to deliver ourselves from the anxiety and burdens of self-knowledge. Theoretically, that is why the Marxist understanding of ideology requires a grounding in psychoanalytic theory for its renewal and development.

## Critique

> This is nothing until in a single man contained,
> Nothing until this named thing nameless is
> And is destroyed.
>
> Wallace Stevens, *The Auroras of Autumn*

Ideological analysis has its charm when applied to the right. But what's good for the goose.... And so consider this possibility: a lone individual undertaking a systematic critique of an ideology to which he or she is firmly committed. Is such an act possible or are we all so much the products of ideology that we can never see outside it?—so that each time we delude ourselves that we are free of ideology, all we do is illustrate another way in which we remain *blind* to *how* utterly it shapes and determines consciousness. However, such deconstructions of the possibility of self-consciousness are also ideologically convenient, because they relieve the apostles of postmodern irony of the need to undertake any genuine psychological self-interrogation. In order to reclaim the value of that act let me suggest a modest and concrete way to address the question of ideological determination. Consider a common experience: how easy it is to see it when someone close to us is projecting and denying conflicts they don't want to face and how hard it is to detect the beam in our own eye. The example doesn't prove the impossibility of self-consciousness; it proves the difficulty of it. Moreover, it identifies the principle on which its possibility rests: a systematic self-interrogation guided by the need to root out every defense one has constructed against self-knowledge. As with Oedipus, self-knowledge depends on a process of detection that turns on all that one doesn't want to know about oneself. Whenever a subject has the courage to engage that process, the dynamic of *reflective self-consciousness* has been recovered at precisely the point where it most intensely activates what Hegel called "the labor of the negative." (To anticipate: this concept is the primary thing that this discussion is trying to recover for the left.) Procedurally, once self-critique begins, everything habitual grinds to a halt. All beliefs must be called into question—especially those that are hardest to detect. No ideological dogma or pathos can be

invoked to terminate that inquiry. The anxiety of being bereft of such shields becomes the principle one must sustain in order to perceive what one can only when anxiety attunes one to everything that habitual modes of cognition and behavior conceal. One then repeatedly discovers existential contingency where before ideology had provided the comfort of necessity and truth. All the defenses on which the ego depends for its maintenance have given way to a process of radical individuation that is informed by trauma as the prime agent of perceptions that exceed the limits that ideology places on thought. One thus attains, at least in principle, ideology's antipode. Critical reflective self-consciousness disrupts the bliss of ideological certitudes and the reduction of consciousness to social determination. There's one principle that gnaws away at all givens. And that principle constitutes the very being of consciousness, or what Kant and Ricoeur term "the subjectivity of the subject." As Hegel said, "thought is essentially the negation of that which immediately appears." Never more so, he should have added, than when that appearance is oneself; or what amounts here to the same thing, the political commitments and guarantees one needs to sustain in order to secure one's "identity" and one's belief in a "meaningful" world.

In Warren Beatty's *Reds*, Henry Miller—one of the historical witnesses interviewed in the film—makes a suggestion worth considering about Jack Reed and other true believers; namely, that single-minded devotion to a cause is a function of the inner problems that one thereby projects and avoids. Contra Miller, that does not invalidate such choices, but it alerts us to what can *bind* us to them in ways that *blind* us to new ideas and possibilities that can be constituted only by a *break* with orthodoxy and solidarity.

Politics is a wonderful way to escape and lose oneself. Success at this however breeds a theoretical reptile: the opposition between social and psychological explanation, between (say) Marx and Freud, as if we here faced a choice rather than the need for a complex synthesis. The grossest example: an assertion such as this—"Women aren't depressed; their oppressed. That's why all psychological disorders will wither away once social conditions are changed. And why wrestling with our psyches is a waste of time that could be better spent advocating on behalf of a political party or social movement." We on the left have been wedded to this way of thinking for so long that it has taken on the status of an ideology in the most vulgar sense of that term—a rigid dichotomy rigidly enforced to expel the possibility of psychoanalytic investigation whenever that threat rears

its head. We thus achieve at the level of theoretical concepts the simplifications required in order to exorcise a self-consciousness that would introduce doubt and complexity where we demand certainty and solidarity.

Which brings us to the essential issue. Is ideology the sine qua non for politics or does it perhaps beget a concept of the political that also requires critical scrutiny?

## Politics

Here are two distinct concepts of the political. Politics is comprised of the actions that certain interest groups and political parties take in order to advance their program on specific issues or general policies. Belonging to the Democratic Party, creating MoveOn.org, editing *CounterPunch* are prime instances of political activity. Political thought is confined to what one finds in books on political and social theory and in policy studies. One's political identity, in turn, is formed by the positions one takes on specific political issues and the alliances one accordingly forms with different organizations. The height of the political is those events, such as a national election or general strike, where a fundamental determination is given to the political direction of a country. Perhaps the most interesting thing about the political so conceived is the amount of certainty that characterizes it. One's political activity gives one a sure grasp on what one stands for, what one is against, and thus who one is, with one's moral character evidenced by the particular positions and policies one supports through the vote, monetary contributions, and organizational activity.

Another conception of the political has a radically different beginning. Politics begins when a traumatic event tears everything apart, exposing the underside of a social order (Katrina) or the psychosis at its core (the Bushian response to 9–11). Uncertainty trumps every ideological belief. Long neglected problems are seen with a new urgency. The impossibility of old solutions becomes apparent. There is no secure ground; no extant political party or ideological system provides meaningful bearings. A radical contingency transfixes consciousness. Everything that is solid melts into air. History has again become a *nightmare* that weighs on the *brains* of the living rather than the quasi-Platonic realm on which we project the certainty of ideological *guarantees*. Those existentialized by such events move in a new medium in which anything is possible, including actions that extant ideologies condemn as immoral. *Politics*

is the effort to sustain such a consciousness as the source for radical discoveries and new forms of association and *praxis* that emerge only when one remains immersed in the situation while resisting the pull of the old guarantees to impose themselves upon it. The new coalescence of the labor movement in America at the end of the nineteenth century, as chronicled by James Green in *Death in the Haymarket*, and, at an ontological level, Sartre's theory of the group-in-fusion, as this dynamic developed in the course of the French Revolution,[7] provide two examples of politics as what happens when events force us to break free of the programs and ruling assumptions of extant ideologies.

Politics in the first case is a perfect example of how a system of guarantees exorcises the possibility of traumatic shocks; politics in the second is precisely what emerges when a trauma is sustained, so that radical contingency gives birth to new possibilities. The signs of the times (Bush's war on terror, the ecological crisis, the effects of globalization, the coming energy crisis) suggest that we are living in a period rife with the possibility of new forms of politics. We can only constitute them, however, by rooting out all the ways that the old ideologies paralyze us, blinding us to history rather than enabling us to find ourselves within it.

The Corrie controversy constituted such a moment for the possibility of exposing the retrograde assumptions behind so-called progressive theatre in a way that could have had a radical effect on both the institution and the kinds of drama written for it. Unfortunately, all signs now point to the failure to seize this possibility. The current leader of the call to conscience is, in fact, none other than the NYTW, which recently conducted an ambitious program of four public "meetings" on the topic of political theatre and "the larger issues embedded in" the Corrie controversy, featuring speeches by 20 prestigious figures.[8] This may sound like appointing Bush to investigate leaks in the White House. But enough glitter will make it all look like gold. Rather than doing some serious reading and thinking about "the larger issues" of theatre under capitalism, guest appearances by some big names in the theatre community will enable everyone to circle the wagons, thereby expelling the suspicions that have so rudely erupted to challenge the hegemony of those who claim to represent progressive theatre. The worst outcome will therefore triumph. As a result of this controversy it will become even less likely that we will get plays different from that soon to be mega-hit throughout the country, *My Name Is Rachel Corrie*, which has

emerged, thanks to this controversy, as the poster child of progressive theatre. That is now the one belief no one can question; the one thing every audience will experience when they attend this play. Everybody wins! An ideology closes around itself because no one can detect how deeply it controls the predictable moves in what we persist in considering as a thought process. As Marx showed, this is how and why history repeats itself as farce.

## NEITHER SCIENCE OR RELIGION

Criticism of religion is the premise of all criticism.
Karl Marx

Jeff St. Clair's difficulties with the relationship between art and politics are symptomatic of the larger ideological contradictions that bedevil the liberal left. To go straight to the issue that will dramatize the furthest reaches of the problem, consider the efforts now under way to reclaim for religion (or "the spiritual") a prominent position in liberal, left politics. This effort, inspired by the success of the fundamentalist right, foregrounds an opposition that the left will remain trapped in until it realizes that there is a position that transcends the terms of what is seen as an exhaustive opposition: that between those who base leftist thought on reason and science and those who want to base it on the older traditions of a theologically grounded humanism.

### The scientistic ideology

On the one hand we have the "scientism" that has in recent years dominated leftist self-consciousness. The Cartesian rationality of a Chomsky, the Darwinian ontology of a Dennett, provide for many leftists the only solid theoretical foundation; one that has the added virtue of liberation from religion. We are the party of reason. Our paradigm, accordingly, must derive today from Darwinian neuroscience as articulated in its broadest philosophic implications by Daniel Dennett and Stephen Pinker and as applied to our current ideological situation by Sam Harris. As Dennett teaches, evolution provides the master code for explaining everything about life. "Darwin's dangerous idea," to cite the title of Dennett's finest book, is that purposeful behavior emerges from a senseless mechanical process. Ontologically that process is all there is. And thus the correct explanation of any phenomenon traces it back to the mechanical

conditions of that origin.[9] What we call "intentional behavior," for example, is no more than natural adaptation to a situation that by selection pressure favored the development of that behavior. Over time, wholly naturalistic processes thus give birth to the illusion of consciousness as a separate realm defined by an "inner theatre" full of deliberative and even Hamlet-like complications. But "consciousness explained"[10] reveals it as nothing but what has evolved out of selective pressure as the best way for one species to survive.

I pause here to note what from one point of view is an irrelevant aside and from another the heart of the matter. Self-consciousness for Dennett can be no more than a replication of the behavioral operations that define consciousness. Any other view of it loses sight of basic evolutionary facts in a maze of poetic imaginings. The position this chapter will develop, in contrast, holds that self-consciousness is the unprecedented act that shatters the continuum. In the upsurge of the questions "Who am I? What does it mean to exist? To die?" there emerges something fundamentally new that cannot be reduced to the laws that obtained for its origins.[11] The negativity of self-consciousness is the goad of an inwardness that constantly transforms the human subject's relationship to itself. An evolutionary explanation for that will never be found, or will always offer tortured, reductive "explanations" that lag far behind the emergent revolutions that this principle produces as its very way of being. And yet so bound are we to the scientistic paradigm that evolutionary theory holds the key to explaining everything human that the concept articulated here is dismissed out of hand as a meaningless nostalgia. The ideology of science demands no less. What physics once offered, biology will now provide: an explanation of everything in terms of certain simple evolutionary principles and laws, because this paradigm now defines the very bounds of sense and must perforce explain poetry, love, etc., no matter how reductive and counterintuitive the resulting explanations. Anything that can't be fit in the circle in which this thought moves becomes of necessity meaningless.

From the perspective of evolutionary metaphysics, all activities of the human subject make sense only when seen from a behavioral, adaptational perspective. As Pinker argues, this is the key to understanding all of our emotions and actions—and thus of giving us the explanations we crave as sworn foes to mystification: explanations of why we love and hate and suffer and rejoice, sacrifice ourselves to causes and develop the sexual—or mating—practices we do. The

evolutionary paradigm is now so firmly in place that it determines what research is proposed and funded. An ideology determines what we can and will know by objective, scientific methods. And the humanities must follow suit. Ethics for Pinker is the simple application of biological imperatives to any and all social and personal questions of value. And thus the grand ideological conclusions: all ways of thinking that retard our adaptation to a scientistic view of things must be eliminated from progressive, leftist thought. We will find no John Stuart Mill reading Wordsworth in the new scientific Utopia. For poetry lacks any adaptive value. As do so many other things. Enter Sam Harris with the predictable argument that religion is no more than the archaic survival of an earlier stage in our biological evolution. We need not trouble ourselves with a psychoanalytic consideration of the complex psychological motives and forces that enter into religious belief. All that's needed is that superior, smug scientistic condescension which Harris indulges at inordinate length in a book that replicates an unremarkable thesis ("religion is irrational") to one religious belief after another, as if iteration and ridicule sufficed as a substitute for an in-depth examination of the phenomena. All we need know—and repeat endlessly as our scientistic mantra—is that Enlightenment rationality wedded to contemporary evolutionary neuroscience proves that there is no place for religion anymore.[12] As leftists devoted to reason, science and political progress we have no choice but to rid ourselves of any remnant of religious beliefs. Only one consequence need trouble our demystified bliss as we wait for the world to catch up with us. It's hard to rally the masses behind such a dispassionate worldview. The current cry for a recovery of religion on the progressive left is a response to that fact.

### The religious ideology

Religion stands at the door. Whence comes this uncanniest of guests? As a corrective to scientistic reductionism and a surefire way back to the Oval Office, supposedly all we on the left need today is a simple act of memory.[13] Religion rallied the troops in the 60s and can do so again. The question of the ontological status of religion need not arise. By the same token religion is insulated from criticism. People need to believe. "There is no God and Mary is His mother." Santayana's ontological atheism is always trumped, as he realizes, by psychological imperatives. Our newfound ideological dependence on religion can thus dispense with what the leftist critique of religion has revealed in a line of continuity that stretches from Hegel through Feuerbach and

Marx to Nietzsche and Freud and from there through almost every major figure in twentieth-century European thought. The briefest summary of the fundamental point developed through that critique must here suffice. As Hegel showed, religion is the way in which we simultaneously become aware of the inner powers and desires of self-consciousness and alienate ourselves from that knowledge by positing them as the properties of a transcendent object. Undoing the alienation brings about the death of God. This is the irony in which religion is trapped: it gives birth to an existential awareness that consumes religion in the fire of a recognition of history in its radical contingency as our duty and destiny. The religious longing for transcendental guarantees constitutes a flight from both historical understanding and historical responsibility.

The attempted reclamation of religion for the left thus entails a regression that begets an insoluble contradiction. Is our newfound religious belief heartfelt or is it the manipulative consciousness of those Grand Inquisitors who give the masses what they need while preserving the truth as the condition of those few who see through the illusions on which religion depends? Is religion a temporary *pathos* the left must indulge for pragmatic purposes; or more cynically, an effort to play the religion card in order to keep the very people we claim to represent in a condition of ignorance? If so, we have a strange revolution dedicated to keeping those it claims to represent in a condition of intellectual ignorance. Or do we truly believe that leftist thought requires religious grounding? If so, how do we establish that position without a violent erasure of our own history? The critique of religion was one of the primary acts through which the left became conscious of itself; i.e., conscious of the insight that the truly "spiritual" force in history is a revolutionary self-consciousness that is grounded in negativity and self-overcoming and that declares itself the foe to any regression to those religious and "humanistic" beliefs that it must uproot in order to constitute itself. The essential task is to liberate oneself from all the supposedly eternal values and desires that prevent us from fully entering history. To put it more concretely, the critique of religion is the act whereby the left established *history* as something that could be known—and acted in—only through a systematic overcoming of all the transcendental guarantees that philosophy and religion impose on life in order to flee it. Religion has always been a primary barrier to historical consciousness—and the hardest one to overcome, precisely because it is able to inculcate in masses of subjects the values and beliefs that lead them to accept

their condition by assuring themselves that its transcendence is guaranteed to them in the beyond. For the disadvantaged, religion has meant acceptance of their lot—as punishment, trial, transcendent justification ("blessed are the poor in spirit") and, when all else fails, as the final, ethical barrier to revolutionary action, since the one lesson religion engraves is that there are certain things we can never do, no matter how evil our oppressors, at the peril of our immortal souls. For wealthy believers, religion offers something even worse: the assurance that they are saved by a God who loves them irrespective of the injustices that their position in the socioeconomic order institutionalizes, since all that is required to prove one's worthiness is the affirmation of certain ethical platitudes that are conveniently confined to the private sphere of one's personal relationships. Indeed, a glut of ethical self-congratulation is the first thing that comes once one has attained sufficient wealth. For all that's needed now is the assurance that one will get all the good things in the afterlife too, and can guarantee that by proclaiming with William Bennett one's deep commitment to moral values.

On a deeper level, the current call for religion represents a *nostalgic* longing for certain ontological guarantees that are craved today precisely because they offer deliverance from a knowledge of the tragic dimensions of our historical situation. Ours is indeed the darkest of times. Once that fact becomes the motive for a return to religion, however, it begets the very thing that makes it impossible for us to comprehend history. Belief in onto-theological guarantees is the "bad faith" of religion.[13] Religion condemns us to live in two worlds, with the ghostly one always there to deliver us from the real one. Until we rid ourselves of the desire for transcendence—and without this desire there is no religion as we know it in the West—the guarantees that the Deity superimposes on experience will continue to block our understanding of history and our ability to act in it.

The left thus appears to be on the horns of a dilemma. But only if science or religion are the only options open to us. A prime function of ideology is to trap us in such dichotomies. Fortunately, there's a way to overcome both positions with a third, which has the added benefit of being concrete precisely where they are abstract. That way is what I term radical psychoanalysis. In order to prevent an unnecessary misunderstanding, a word before turning to it. I share the position of those who think we must find a way to reclaim the "spiritual" values that scientism has lost. My attempt, however, is to show that there is only one principle that enables us to do so, a

principle that sustains a secularism that is far more "spiritual" than religion. That principle is self-consciousness: the human subject in the depth and complexity of that existential relationship to oneself that overcomes all otherworldliness by constantly interrogating and overturning one's relationship to oneself.[14] As Nietzsche put it: "Spirit is the life that cuts back into life; with its suffering it increases its knowledge." I will now outline an argument that psychoanalysis offers the most *radical* and *concrete* realization of that principle.

### RADICAL PSYCHOANALYSIS: A PRIMER

In the destructive element immerse.

Conrad, *Lord Jim*

There are, however, two main barriers to constituting this position. The first comes from Freud himself whenever he gives way to that reductive, "scientistic" mode of explanation, a product of his medical training, that is at war with his far richer clinical sensibility and the literary education that was so central to its development. The second comes from the American psychoanalytic establishment, which is today little more than the mental health wing of *adaptation* to late capitalism, offering its subjects the feel-good "relationalism" they require to assure themselves that their lives are grounded in the bonds of love and mutuality. (One product of this is the "culture of therapy" that has now invaded "progressive" theatre with the notion that plays have to be contextualized before audiences see them and with "talk backs" and other services offered afterward so that the whole experience will be "managed" in a way that deprives theatre of its traumatizing and questioning power. The only mirror such theatres now hold up is to a nature defined by fragile egos needing a superfluity of defenses.)

Luckily there is a corrective to both errors. Rather than following Freud dogmatically or capitulating to the American establishment, our task is to *preserve* and *constitute* what is most radical in Freud's thought—and the thought of the most significant psychoanalytic thinkers after him, a list that includes Ferenczi, Alexander, Klein, Winnicott, Fairbairn, Bion, and Lacan—by reading against the grain. To do so, the first thing to combat is the assumption that to achieve the status of a science everything Freud says must be restated in scientistic terms and then tested by scientific criteria.[15] The question "Is it a science?" is a convenient ideological dodge. For psychoanaly-

sis is something far richer: a *rethinking of the very foundations of what used to be called the humanities*. The true value of Freud—and the primary evidence in support of psychoanalysis—is what happens inside us when we read him in search of ourselves. It is then that one experiences the constant shock of recognitions that burden one with an anxiety unlike any other: the anxiety of discovering all that one has buried in oneself about oneself. To that recognition Freud then adds an even more shocking discovery: how deeply one's life has been structured by the effort to escape the buried conflicts one projects into all situations. Reading Freud is like reading Shakespeare or Dostoyevsky or Faulkner or O'Neill. The task of theoretical conceptualization, accordingly, is to articulate a *system* of concepts that will preserve the fundamental *structure* of a writer's vision; or, to be more technical, the theory of psyche and experience that can be abstracted from a writer's work. Such an effort must necessarily attempt to preserve the radical shock and anxiety of that writer's work, so that in studying the conceptual articulation the reader will undergo an existentializing process.

Here, then, in terms of radical psychoanalysis, is a sequence of propositions that attempt such an articulation, in order to lead us beyond the ideological bind considered in the previous section. Of necessity, the sequence explains psychoanalysis both in terms of the individual subject and the social process, since one of our goals is to move beyond the ideological opposition that the left has far too often embraced in opposing socioeconomic to psychological understanding, with a resulting reduction of the psyche to no more than a passive "reflection" of social conditions.

**The personal**

1. Alienation from oneself defines the primary relationship of the subject to itself. As a result, self-knowledge is a rare achievement requiring a novel method: a systematic attempt to uncover all that one doesn't want to know about oneself. Reflection doesn't confirm a cogito; it reveals a fundamental self-division between the defenses that create and sustain the ego and the *core conflicts* that are thereby "repressed." Psyche, as opposed to ego, is the dynamic we engage whenever we open the crypt of all that we've buried in ourselves.

2. Maintaining defenses is the primary human act. Thereby a system of lies and avoidances comes to control our lives. Except, that is,

when anxiety reveals a rupture in the arrangements. The subject is then assaulted (however briefly) by all that it has tried to deny. One faces a choice in the anxiety that attends that choice: to re-establish the defenses of the ego or pursue the self-knowledge that it forbids. The latter choice only deepens one's anxiety, however, because the world we've buried within us is composed of the *core conflicts* we've fled, the *wounds* that have never stopped bleeding, the *feelings* we desperately want to flee or deny.

3. Anxiety, not rationality, is the principle structuring consciousness. The common assumption that *conscious intentions* determine our actions is the most convenient way to avoid self-scrutiny. The belief that we have an *identity* and with it a transparent understanding of *who* we are and *why* we do all that we do is the fruition of that illusion. Its hallmark is the belief that *rational inspection* reveals the truth of the subject and that *rational deliberation* is the primary cause of intentional behavior. All of the ideas about human nature that derive from these assumptions constitute defenses against another experience of subjectivity: subjectivity as existential engagement in an in-depth self-interrogation defined by an effort at self-overcoming. (On this, see Chapter 5.)

4. These reflections lead to three challenging insights into the structure of our lives.

    (a) Our primary action, the purpose that defines the ego, is to flee and avoid our conflicts.

    (b) Doing so, however, necessarily *projects* them in a particularly troubling form. *What one doesn't know about oneself is what one does—to the other.* Psychoanalysis derives its urgency from the moral imperative implicit in this recognition.

    (c) Not facing a conflict increases its power. Fleeing ourselves we thus create the sequence of events that may eventually bring us face to face with ourselves. The possibility of reversal—and with it recognition—haunts us. For it is when the past catches up with us, when we find that we've brought about the very thing we most feared, that we learn that our true bond with Oedipus is not a single complex but the tragic structure that shapes human experience.

5. The primary lesson from the above: traumatic experiences are the only ones that matter. That event in which everything collapses, in which we experience the bankruptcy of our life and the return

of everything we've tried to escape is the best thing that can happen because it brings us before the necessity to reverse our lives by suffering a self-knowledge that strips away the entire system of secondary emotions we've constructed to protect us from the emotional turmoil that erupt once we engage our deepest conflicts. Knowing oneself requires no less; and once one finds the courage for it, one discovers that the conflicts one has persistently avoided are the portals of the deepest discoveries.

6. Undertaking that effort requires the most difficult revolution. For the primary thing implied by the previous propositions is also the barrier one faces in trying to live them out. *Emotion, not rationality, forms the essence of the human being.* The ultimate basis of ego identity is the structure of feelings we've created so that we can experience the world in a way that delivers us from anxiety. Unlocking all that we've refused to feel about ourselves and those closest to us activates a totally new way of relating to the life of feeling. An agon of primary emotions supplants the defensive reign of secondary emotions. (For an example, see "Always Historicize" below.)

7. The existential significance of Freud derives from this recognition. For what he teaches is a sovereign contempt for all the ways we lie to ourselves and a disgust for our indulgence in those emotions that protect us from becoming honest with ourselves. Self-contempt is the richest possibility Freud's work offers as a gift to our humanity. Once one has experienced his work this way the question of its "scientific" status takes on its proper proportions. As a minor moment in an existential hermeneutic. The lesson of Freud is that only the most radical action is adequate to the problem of the psyche. Our task is not just to know ourselves in the most painful ways but to make that knowledge the basis for an effort at self-overcoming that is only possible if we take up the tragic conflicts that define us. Moreover, the only way to do so is to find a new way to act in those situations we've done everything in our power to escape.

## Political

1. In terms of larger sociopolitical structures, Freud's value is even more disruptive. For what he offers here is an insight into the depth of a collective disorder that in America now slouches toward harrowing realizations. To put it bluntly, Freud provides

the categories we need to analyze the Bush Administration and the social forces it represents in terms of what we may term apocalyptic fascism. To go directly to the heart of such an analysis is to recognize that since 9–11 everything has proceeded from *the psychotic register*. That is the underlying condition that the years since 2001 have brought to the surface.

2. The actions taken by the Bush Administration in response to the trauma of 9–11 embody the trajectory that defines psychosis.

   (a) A traumatic event creates a massive shock to the system. All defenses and illusions are shattered—by a self-knowledge that cannot be borne. We know that "they" don't "hate us for our freedom." Much of the world hates us because it suffers under the rapaciousness necessary to sustain our way of life. That is the guilty conscience that late capitalism cannot tolerate.

   (b) The only possible response is therefore the psychotic one: an *evacuation* of all inner conflict through a massive reliance on the mechanisms of *projection* and *denial*. Such is the function of Iraq in restoring national identity.

   (c) Following the demands of psychotic logic, an object that represents everything we don't want to face about ourselves is submitted to an attack that releases all the aggression that would otherwise be turned back against ourselves in a psychotic fragmentation and self-dissolution. Such processes can consume societies as well as individuals. Even G.H. Bush knew this when he crowed that the first Gulf War put an end to Vietnam syndrome. Only in Bush II, history doesn't repeat itself as farce. It repeats itself as genocidal global aggression.

   (d) The unbound discharge of aggression offers a traumatized psychotic social order the only way it can reassert its identity in terms of what has become its ruling principle. *Thanatos* projected everywhere—at home and globally. This is the principle that has long since achieved hegemony in American society.

3. The eroticization of *thanatos*, in fact, offers the only adequate psychological explanation of the fundamental structures of everyday life in America today.[16]

(a) *Narcissism.* The obsessional effort by those who have no inner identity to reassure themselves that they do by compulsive rituals of self-aggrandizement. The narcissistic quest can get no satisfaction, however, because it derives from the void at the heart of American society.

(b) That is why *panic boredom* is the other primary characteristic of American society, the perfect realization within subjects of the imperatives that define capitalism. We cannot sit still because whenever we do we experience an inner emptiness. In panic we throw ourselves into consumerism and mindless activities that can have no purpose but relief, flight, entertainment. Bored by everything we dreamed would satisfy us, we flee the panic of the inner void by spasming ourselves into the next meaningless activity, in hot pursuit of the next obscure object of consumerist desire. As T.S. Eliot saw, we live "distracted from distraction by distraction."

(c) Keeping the whole engine running requires a *hyperconsciousness* which functions as a sort of inner cheerleader, a hystericized superego that bludgeons every possibility of critical self-consciousness. Thus the endless stream of *happy talk* that produces the self-narcotization of the American subject through public (the media) and private ritualizations of flight. And as we all now know, nobody does it better than Jesus. An endless stream of affirmations ("The U.S. is the greatest experiment in freedom in the history of man") and affirmative sentiments ("I'm an optimistic person and so I always try to see the bright side of things. Like Pat Nixon, I treat each day as Christmas") proclaim a catechism that covers over the massive emptiness at the center of the American psyche.

4. There is, of course, another name for this. Capitalism. For the collective psyche described above is what capitalism necessarily produces in order to realize its imperatives. Subjects formed to value nothing but pursuit of success in the capitalist order necessarily experience their own inwardness as a void. Moreoever, they find that experience unendurable, but without being able to respond except by throwing themselves further into the capitalist way of being. The only solution to unhappiness, after all, is more money, more Jesus. As in D.H. Lawrence's "The Rocking Horse Winner," there can never be enough. And thus the disorder

produces as its necessary result a steady accumulation of envy, self-hatred, and a resentment that must be evacuated in aggressive attacks on others.

5. And so the wheel comes full circle! The psychotic disorders of the sociopolitical order produce the psychotic disorders of the normal capitalist subject—and the ever more rapacious activity whereby both the system and its subjects project and deny the collective condition.

The above offers an abbreviated example of the benefits that psychoanalytic categories bring to the study of collective social and historical processes. One of its primary purposes has been to free us from a false yet persistent concept of *dialectical materialism*; or, more accurately, one that removes the dialectical dimension from materialism. Subjectivity is irreducible. Consciousness is always both the reflection and the suffering of its society. And thus always the possibility of a negative consciousness that overturns everything by deracinating within itself all the ways in which its disorders mirror the disorders of the whole.

<h2 style="text-align:center">NIGHT AND FOG</h2>

Emotion, as we've seen, is the glue that holds the entire ideological edifice together. Consequently, its analysis is where we must go in order to confront the true sources of ideological paralysis. What follows is an example that attempts to go straight to the most fundamental way in which the problem of emotion may be engaged in a way that exposes the ideological ways in which feeling is itself manipulated so that the system of ideological guarantees will police experience.

In a brief but perceptive discussion of Resnais' great film about Auschwitz, *Night and Fog*, Robin Wood suggests that the film (1) attempts to create a feeling of "despair" in the audience and (2) that such a result "is never a very helpful emotion."[17] Such is the emotional effect that *Night and Fog* apparently produces in most viewers; as does the work of Beckett, Bergman, Pynchon, Faulkner, Sartre, Genet and a host of other modern artists. Despair, it would appear, is the message and emotion conveyed by the greatest literary works of the past century. (And, no doubt, the reason why so many today seek a kinder, gentler theatre.) The charge of despair, however, may tell us more about the psychological needs that some audiences place on challenging works than it does about their inherent character or

purpose. There are, in fact, two radically different responses to *Night and Fog* and that difference is central to the overarching argument I'm developing.

*Despair* wants to flee a situation it finds unbearable because of the beliefs and hopes that it cancels. Collapsing under the situation, it projects its resentment upon it. Through despair one *finalizes* what one can't bear to endure. To use a popular term, despair forces *closure* on a situation because the amount of suffering that the situation entails has shattered the emotional economy on which ego-identity depends. For despair, the loss of the old guarantees means that all is meaningless.

*Dread*, in contrast, sustains sufferance as a force that brings about a revolution in thought and feeling. The eradication of guarantees begets for it a Hamlet-like questioning that roots out all the emotional hiding places that the ego has created in order to flee experience. Despair despairs because it can't return to the way things were before. Dread sees in the irreversible passing away of older ways of being the emergence of what we must endeavor to become when faced with a knowledge we can no longer deny. It thus looks to the future in the only constructive way: by confronting a horror as the demand for a new humanity that begins by taking what despair can't endure into the center of one's consciousness. The emotional blow that causes so many to despair is precisely what dread suffers in its deeper meaning: the recognition that everything one believed about humanity is canceled by an event such as Auschwitz. In the face of Auschwitz, dread constitutes itself as the demand for a new understanding of the human being, one that accords primacy to what the system of guarantees insists be seen as secondary; evil, for example, as the fall from a fundamental goodness or the privation of what natural law theory sets down as the teleological ends rooted in human nature. Dread sees the truth that such an ontology flees. Evil is the primary fact. At Auschwitz one view of our humanity ended. Another was born in the question dread poses: Is it possible to replace belief in the fundamental goodness of human nature—the faith that offered Anne Frank some measure of hope right before the end—with the recognition of a fundamental *evil* that we must acknowledge not as an accident but as a *primary condition* that is rooted in the very being of the psyche?[18] Rooted, that is, in our need to project everything we can't stand about ourselves onto others whom we therefore strive to humiliate and destroy. What Auschwitz teaches us is that this is the psychological dynamic that has the upper hand in human

relationships—and in history—because it offers the easiest way to resolve the problem that defines the psyche. How deliver myself from anxiety in a way that makes me feel powerful, secure, and justified? In forcing itself upon us, Auschwitz also offers us a new measure of our humanity; as that rare thing that depends for its possibility on the overcoming of a prior disorder that must be given its primacy in all our thought about human nature, culture, and values. There is one thing that Auschwitz should have put an end to: the ideology of affirmative culture and all the values and beliefs we insist on reaffirming in order to deliver ourselves from experience.

*Night and Fog* is uncompromising in its representation of its subject. No transcendent guarantees are permitted to limit the impact of Auschwitz. Those guarantees accordingly take their revenge on the film through the chorus of viewers who complain that the film leaves them in despair, a response capped in its resentment by the assertion that such an emotion is not very helpful. The question why the needs of the weak must become the standard that judges the courage of the strong is never posed. Despair is the emotion that works of art which reject the guarantees (both in their content and their form) have on those who need to hang onto them at the expense of everything. Their need for restoration is more important to them than anything Auschwitz could ever teach them.

There is another way to state Adorno's ethical maxim "no poetry after Auschwitz." *No religion after Auschwitz.* After Auschwitz the desire for transcendence and any attempt to reaffirm the guarantees it offers reeks of a refusal to face our historical situation. Auschwitz cast all theories that posit a fundamental goodness of human nature on the dung heap of history. To allude to Hume, all guarantees must be consumed in the flames of Auschwitz because they can contain nothing but resentment in the face of it. There is a secret that the religious keep from themselves. They are in despair. One sign of this is the knowledge that flits through their consciousness from time to time: the realization that on their own they are unable to deal with the world. The fragility of their psyche makes dependence on transcendental supports mandatory. Without God everything is, indeed, for them meaningless. Despair as response to *Night and Fog* is representative of a defect they carry with them at all times. That is why each situation in which they cry despair must become for us the source of possibilities which find their origin whenever a situation that awakens the desire to pray or cry out becomes an occasion for the decision to accept trauma and radical contingency as the condition

that gives us the world—and our being in it. This is perhaps the most exhilarating experience an existing human being can have: that we can make the transition from those emotions we feel we must have to those we realize we must choose. For that process is the one that frees us from ideology.

## ALWAYS HISTORICIZE

Anyone setting out today to write a *historical drama* about 9–11, the fundamentalist Christian right, the Israeli–Palestinian conflict, or any other traumatic event that reveals our contemporary condition should bear the following sequence of *artistic problems* in mind. For unless an artistic solution to them is found such dramas will remain inadequate to their intention.

Is it possible to conceive of drama as an original and primary way of *knowing* which is uniquely suited to the representation of traumatic historical events? That is, how might drama be understood not as ideological popularization or mass entertainment but as a mode of cognition that makes possible an apprehension of historical events that exceeds the limitations of other ways of knowing? Moreover, how might a playwright constitute this possibility by constructing a play that would offer historians an understanding which reveals both the limits of their discipline and the need to reconstitute it by following the model that such a play would provide?

These are complex questions, because they challenge ruling assumptions both about theatre and about history as a discipline. The traditional view of both activities and of their relationship goes something like this. Historians establish the truth of events through the use of objective, value-free methods of empirical research. They then represent those findings in narratives, but the act of narration in no way alters or transforms what is known independent of it. Hence, if historical writing is frequently dry, it is because historians know the proper, marginal place of the poetic in their activity. Following this line of reasoning, one also knows the cognitive status of literary works that represent historical subjects: works such as DeLillo's *Libra*, Morrison's *Beloved*, and Hochhuth's *The Deputy*. Such works make events vivid, memorable, exciting, entertaining, but that is really all they can do. Access to the truth of history is prior to them and remains so. Docudramas, for example, make wonderful entertainments, but if one wants to know the truth one turns from them

to the history books on which they depend for whatever "truth" they contain.

Recent work by historiographers and philosophers of history has questioned all of these assumptions, especially those about the role of literary forms of writing in the very constitution of historical fact and historical explanation. The central idea developed from such inquiries is this: history as knowledge and history as literary representation are in no way separable. Moreover, their necessary connection goes to the very constitution of fact and inference. This recognition signals a productive "crisis" in a discipline. If the constitution of fact and inference—and thereby the testing of multiple working hypotheses— is itself determined by the narrative paradigm in which the historian casts the data, history is not (and cannot be) an objective, empirical, value-free quasi-scientific inquiry. It is, from the beginning, a way of writing, shaped by narrative and artistic conventions and the larger ontological assumptions that underlie, for example, the difference between omniscient narration and the use of multiple perspectives and opposed points of view.[19]

The following statement by Hayden White, the dean of American historiographers, is representative of the new directions that beckon to those historians who now know that their ability to apprehend history is only as good as the power of their *artistic competence*. White draws the following bold inference from these developments:

Such a conception of historical inquiry ... would permit historians to conceive of the possibility of using impressionistic, surrealistic, and (perhaps) even *actionist* modes of representation for dramatizing the significance of data which they have uncovered but which, all too frequently, they are prohibited from seriously contemplating as evidence.[20]

Artistic forms are the very basis and first principle of historical inquiry. That is the radical implication of these developments. However, a historian who turns to art for instruction will not find a ready-made palace of forms at his or her disposal. What one finds, instead, is a "crisis" more extreme and more intense than the one within historiography. Twentieth-century art is a story of unending revolutions, the ceaseless development of new forms, techniques, experiments. A single rationale informs what is vital and lasting in them. The artist knows that the primary source of artistic creation derives from art's *immanent critique* of its own forms in terms of their inadequacy to the apprehension of new historical experiences.

Another way to put this: unlike a priori and fixed categorical ways of knowing, art is inherently historical and *sui generis*. The artistic form required to comprehend a particular situation need never occur again. The task of the artist is to create new *forms* as our only way to grasp the new pressures that history puts on the nerves and brains of the living. Art is the most historically engaged activity that human beings have invented. Its task, in Wallace Stevens' words, is to "measure the velocities of change."

The historical imperative that defines art as cognition is especially clear when an artist confronts a traumatic historical event—such as Auschwitz, the Gulag, Middle Passage, Hiroshima, 9–11. For then the task of knowing and the creation of a new artistic form are united *within* the psychological space torn open by trauma. The search for artistic form is thereby tied to a phylogenetic regression in which the artist descends to the depths of the psychological disorder of the time in search of a new beginning that must, in order to constitute itself, deracinate all false, nostalgic solutions and guarantees. This, to cite a frequently misunderstood statement, is the deepest implication of Adorno's imperative, "No poetry after Auschwitz." Except, he might have added, Celan's. For Adorno's meaning is twofold: after Auschwitz it is an obscenity to write poetry in the old ways. The duty of poets as true, dialectical historians is to create the new artistic forms that will constitute words, affects, and representations "adequate" to the "unspeakable" reality of the Holocaust. Art is that way of knowing which evolves forms fit to its historical occasion. It is not, contra Northrop Frye and traditional humanistic aesthetics, a palace of essences—of fixed a priori forms that we can impose on whatever contingencies arise in order to satisfy our persistent effort to exorcise history and time. Art is, rather, an existential a priori that is *sui generis* because its categorical imperative is the immanent critique of its own extant forms as they confront their inadequacy to new historical events. What this idea suggests, of course, is that the history of artistic forms may be the true key to the irreversible course of history itself. Such is the grandest implication of an ontology of aesthetic form as historical cognition.

To focus this idea on the question of theatre, ideology and history I want to call attention to the one certain thing the historian can learn from modern drama—from the example of (say) Beckett, Pirandello, Chekhov, Ibsen, Genet, O'Neill, Strindberg, Churchill, Shepard, Artaud, Brecht, and Grotowski. Nothing remains free from the force of ceaseless experimentation in the creation of new and

striking forms that radically alter the theatre event—the relationship that drama forms to the audience. The very nature of drama is what every significant development in modern drama calls into question. It is as if each time one sets out to write a play one faces the need to interrogate the form itself and create it anew. As Kossuth said of another art, "that is art which changes the meaning of art." And thus perhaps the best advice to the historian stirred by Hayden White's call to tread carefully before undertaking the complex task that artistic mediation entails. The playwright does not have that luxury.

As Artaud says, "an image is true insofar as it is violent." That truth must form the center of any play that endeavors to be adequate to a traumatic event. Rather than resolving a trauma (which is the office of bad writers and pre-existent artistic forms) the artist's task is to *constitute a trauma* so that we will know it whole and from the inside. Radical art is the creation of dialectical images;[21] images that cannot be comprehended by traditional, rational ways of knowing because they take up residence in the unconscious where they bleed a conscience that troubles our sleep with thoughts beyond the reaches of our souls. Image is the natural language of the psyche, the only way it has to apprehend the terror of situations that are otherwise unendurable. Such, Freud reveals, is the revelatory power of dreams, and the reason why, as Delmore Schwartz held, in dreams begin responsibilities. In dreams we exist as artists endeavoring to create images adequate to our deepest wounds and conflicts. The task of the playwright is to do likewise for history.

One of the clearest formulations of this problem came at the dawn of the historical trauma we remain trapped within. Here is how Dwight MacDonald posed the problem of *writing* and of *history* in his 1946 review of John Hersey's *Hiroshima* (a book for which, I hasten to add, we should all be grateful): "Naturalism is no longer adequate, either aesthetically or morally, to cope with Hiroshima. Hersey has failed to find a form adequate to his subject matter."[22] MacDonald speaks to a dissonance that most readers of Hersey sense without being able to give it a name, a dissonance deriving from the discrepancy between Hersey's journalistic style and quasi-objective reportorial method and the magnitude of the events he is trying to record. To accept MacDonald's argument, however, is to take up the project implicit in it: until an artistic form adequate to Hiroshima is found, the psychological and historical meaning of that event will remain unknown.

The challenge MacDonald raises goes to the heart of humanism and the *essentialistic* guarantees it asserts in order to insulate itself from history. Because the artistic forms and emotional needs dictated by that ideology are so deeply ingrained in all our habits of perceiving and feeling, the dramatist finds no easy solution to the limits of traditional historical representation. For the most part dramatists, too, march in step with humanism's cardinal metaphysical assumption: the need to contain and then deny radical contingency by representing experience in a way that gives us the pleasure that comes whenever we feel the guarantees imposing themselves upon events. Once again we've been made safe.

Traditional historians use those guarantees to structure their narratives in one way; most dramatists in another. Most historians fashion structures of explanation in order to contain contingency within the working of a larger progressive or restorative *telos*. Similarly, traditional dramatists draw on the emotional force of the guarantees to create *structures of feeling* that have as their primary function the purging of psychological conflict through the movement of everything to catharsis. Both operations supplement one another in assuring our continued sleep; traditional histories providing "explanations" that cleanse the mind of nagging doubts; traditional dramas providing feelings that cleanse the psyche of painful affects. Explanation and catharsis are thus two forms of the same metaphysical need, partners in a single crime. Whatever one leaves undone the other provides; resolution, discharge, "calm of mind / all passion spent" being the end and the guarantee implicit in the a priori structures and needs they impose on experience. That is why it is as crucial to the project of the left to expose the aesthetic or formal expectations that shape the drama of, say, Arthur Miller as it is to reverse the logic of rational mediation that so many post-Hegelian historians continue to impose on history.

All the issues implicit in the foregoing focus fortunately on the question of the audience. The great Polish director Jerzy Grotowski defined the director's task thus: "The Director's first job is to cast the audience." The same is true for the playwright. The question of dramatic form is always at base a question of the audience for which a play is intended and what the dramatist wants the play to do for—and to—that audience. *Form is ideology as the structuring of feeling.* Unfortunately, in most cases this dooms us to dramas that reinforce those feelings we don't want to give up, reality be damned, because living without them would be too exacting. The forms of

drama constitute the ways in which representation, progression, and resolution may either serve or challenge the emotional needs and desires of the audience. All drama, in this sense, is psychodrama. Dramatic form is the in-depth working of an action on and within the psyche.

Whenever one tries to write in a new way, implicit in that effort is the desire for a new relationship to the audience. Every play is the concrete realization of a particular relationship to the psyche of the audience. To alter one is to alter the other. When one sets out to write a play about a traumatic event that a community has refused to confront, one quickly discovers that traditional dramatic forms are among the strongest ways in which the communal "we" enacts the ideological refusal of history. The problem of artistic form is thus to construct a play that, in effect, puts the audience on stage—and on trial. A play must work *on* and *in* the psyche of the audience by taking the psychological principles the audience has used to protect itself from traumatic events (the defenses and emotions that assure ego identity) and must subject those principles to a radical and complete reversal. The progression of the play must become the process whereby the psychological needs the audience projects are turned back against them. Drama thereby becomes an agon that works in the psyche of the audience without offering them any way to discharge the burdens that the work places upon them. *The Iceman Cometh* remains paradigmatic because it is a play about this process; a virtual metapsychology, in effect, of how the group identity of an audience (the denizens of Harry Hope's saloon) is progressively destroyed by an *action* (written, performed, and directed by that great playwright Hickey) that deprives that audience of all its illusions and defenses. As walking dead men this is what they know when, clutching the last straw of a convenient misinterpretation, they rush at play's end toward a final catharsis of all inner conflict.[23]

Creating traumatic experience is the revolutionary function that the contemporary playwright must perform. For only thereby is the audience offered a way to get free of the ideologies that blind them. A play must be a painful exposure of all the ways audiences try to protect themselves from a traumatic event and a representation of the actions they must take within themselves in order to make the necessary changes in the only way possible; by, as Rilke said, embracing the flame. The psyche of the audience—such is the true subject of drama. Drama as Hamlet's mousetrap: as a process in which defenses are staged in order to be exposed and destroyed, in which

structures of feeling are deracinated. This is the ontological possibility inherent in drama as a unique form of public space. Most forms of public space—church, presidential addresses, news broadcasts—function as scenes of ideological interpellation, their purpose being to celebrate the beliefs and feelings that constitute the public as a mass united in a vast complacency. Serious theatre is the antithesis. It is that public place where people go to witness the public representation of secrets—about themselves. As every good actor knows, "the purpose of playing" is to reverse the situation that exists at curtain's rise: to get the audience to experience the play as something that is looking at them rather than the other way around. When that happens, theatre becomes a place of danger, for the audience then find themselves engaged in a struggle to save themselves from what the play is opening up inside each one of them. When as actors we succeed, they fail.

Properly conceived, historical knowledge and dramatic form coalesce in a single goal: to create an agon that will transform the audience's relationship to history by transforming their relationship to themselves. When that happens, one order of feeling is exposed so that another can come into being. In our time, this means shattering all the guarantees on which the belief in catharsis rests, so that we can constitute a radically different way of living out the *responsibility* that traumatic events impose on us. Once we do we'll discover that this anticathartic function is what great drama has always done; purge the lie imposed to deliver us from it. But to recover such an understanding and thereby supplant catharsis we need to delve deeper into the motives behind the ideological assurance that resolution, restoration, and renewal are the proper and necessary goals of art. To understand the persistence of the ideologies we've discussed we need to comprehend the very foundations and ultimate bases for the entire system of guarantees. Such is the purpose of the next chapter.

# 5

## The Humanist Tradition:
## The Philosophical and Rhetorical
## Roots of Ideological Paralysis

Every philosophy is a systematic preservation of what is sound and a cathartic exposure of what is absurd in competing philosophies.

Richard McKeon, "Philosophic Semantics and Philosophic Inquiry"

I would meet you upon this honestly.

T.S. Eliot, *Gerontion*

### HUMANUS, INC.: HOW THE CENTER HOLDS

Unfortunately, the hardest part of this chapter comes at the beginning. A fairly abstract discussion is needed to set up what will, I think, become a concrete and highly revealing experience. Namely, a discovery by the reader of the core assumptions and guarantees that structure the way most of us think, feel, and experience the world and that are so deeply rooted in us that we are scarcely aware of how deeply we depend on them. My subject is the core assumptions that underlie progressive, humanistic, liberal thought and thus the ultimate bases for the power that this ideology has over us. What we think, feel, desire on particular issues is, I hope to show, a function of our allegiance to these core beliefs, which, though we are seldom if ever aware of them, structure and control our thought and, at a deeper level, our self-consciousness and our experience. Moreover, as I'll try to show, these assumptions are false and need to be overturned radically and completely by the way of thinking and existing that, we'll learn, they were constructed in order to exorcise. Rooting them out is thus the act that will give us a totally new understanding both of the world—and ourselves. Such are the high stakes of this chapter. The attempt, in effect, is to take what most readers will discover to be their deepest assumptions and articles of belief and subject them to a critique that will lead the reader to replace them with a radically new way of thinking and being. My effort in this chapter is to expose the

deepest layer of ideology—the general assumptions and guarantees that underlie all particular ideological ideas and beliefs. As we'll see, the positions taken on particular issues exemplify the control that these assumptions exert over thought—and our inability, even with ardent effort, to break free of them. This is so because these assumptions constitute the very bases of intelligibility, thus determining what makes sense and what doesn't as well as what counts as a coherent experience, a legitimate feeling, an appropriate action. As such, these underlying assumptions and guarantees are—or should be—both the primary and the ultimate object of ideological critique, because they are determinative in the first instance and in the last. Distinct discourses in distinct fields serve but to illustrate the binding power they have to determine what counts as intelligible, rational, real. As a result, the core ideas developed in different disciplines, for all their apparent concreteness, simply provide instances of the same set of underlying assumptions and guarantees. Thus, for example, belief in the inevitability of historical progress, the necessity of catharsis, the stability and coherence of self-identity, the primacy of reason, are distinct ways in which distinct disciplines come to the same general conclusions about "human nature" in support of the same general goals.

By the same token, no revolution (in thought or in praxis) can take place unless these underlying assumptions and guarantees are overturned, precisely because their primary function, as the general framework of intelligibility, is to rein in new possibilities and developments in thought, so that eventually what may look initially like a break ends up providing yet another illustration of the eternal veracity of the underlying system of assumptions and guarantees. Contra William James, this process is perhaps the true history of apparent revolutions in thought: what began as different ends up being another example of the same.

In their breadth and depth, these principles transcend the work of any one thinker, discipline, or field. At the same time, their omnipresence, as foundation, makes them the controlling force one discovers at work everywhere. Interdisciplinary thought, in fact, provides yet another instance of their power to form the set of underlying shared assumptions and concepts that make possible those larger patterns of connection and agreement that interdisciplinary thought establishes. In making its particular contribution to the overarching project of determining what will count as knowledge—and legitimate inquiry—each particular discipline illustrates how

deeply it is wedded to the underlying and overarching assumptions that will shape and control its contribution. Another proof of this condition is the prior act wherein the discipline purges itself internally by rejecting any work within it that won't contribute to that goal.

Two empirical observations are crucial here. First, few thinkers, whatever their field, are aware of the underlying system of assumptions and guarantees that structure their thought. Thomas Kuhn's point about how normal science operates—with the mass of individual scientists blindly following a paradigm that none questions until a revolution overturns everything—is nothing compared to the conformity at the level of assumptions and practices one finds in the humanities. Whatever its defects and motives, we can all be thankful to the work of Stanley Fish for demonstrating the absurd extent to which shared beliefs that no one questions exercise total control over the most minute operations whereby literary critics have "perceptions" and constitute what the professional community counts as "correct interpretations." What we call our "experience" of *Paradise Lost* (say) is really a product of our socialization or professionalization to *read* texts following the current "party line." And Fish takes glee in adding an appropriately cynical corollary: a critique of critical theories is fruitless and powerless to change things, because *fashion* is the only reality. Critical discourse about literature is a self-contained enterprise determined by nothing but the will of the professional community to force its members to do whatever at a given time it finds "interesting"—for reasons that necessarily remain arbitrary. And what holds here, Fish argues, is true of all discourse communities—including law, politics, and philosophy. As we'll see, this conclusion is itself a convenient abstraction that bars inquiry into the more basic ideological assumptions that make Fish's position one predictable option in a predetermined game in which all the moves have already been mapped, so that only ideologically acceptable theoretical alternatives will be given a hearing and anything that breaks with the underlying assumptions will be dismissed out of hand.

A second observation is even more important to identifying the object of our inquiry. Without ever necessarily being aware of one another's work, thinkers in different fields contribute *essential planks* to the overarching ideological enterprise whereby work in one field completes that in others by providing the "answers" and supports it needs to resolve problems implicit in it. The result is a system of supporting discourses in which work in one field props up what is

done in others by providing the line of defense (or, more exactly, numerous lines of mutual defense) that can be called on should a threat to the hegemony of the underlying shared assumptions break out in a single field—an event which always carries with it the threat of spilling over to other fields, thereby creating a general ideological crisis. *Intervention*, the word invoked incessantly in academic circles the past 25 years (at conferences people no longer give papers or offer statements; they make interventions) is a self-aggrandizing myth propounded to deny the dominant reality: *supplementation*. And through the labor of reinforcing supplements the construction of an edifice that has all the characteristics of an impregnable fortress. Attack it at one point, it defends itself by shifting the discussion elsewhere, so that assumptions and guarantees that appear to falter at one place reveal their unshakeable solidity at another point, which becomes, by reason of that fact, the stunning consideration that solves the original problem. If, for example, philosophy becomes too skeptical, psychology or religion steps forth to remind us of those beliefs that human beings must sustain in order to go on living. Through such operations the underlying set of assumptions remains in force and crisis is perpetually deferred. A much cozier relationship obtains, of course, when things are functioning smoothly. Then ideology basks Fukuyama-like in the bliss of putting all doubts and conflicts to rest. Grand syntheses appear as natural as the rain from heaven. What philosophy establishes as true of reason, psychology reveals as true of identity formation. Both then find their views supported by what literature reveals about the universal needs and principles of response that are exemplified whenever we read or go to the theatre. Ethics thereby discovers that universal truths of moral conduct are exemplified in the most intimate affections of the human heart. The same values and motives, it turns out, explain the agents who make history as well as the dynamics that structure social interaction and collective behavior. This is, moreover, especially the case in "democratic" societies, where the proper political and economic arrangements assure the realization of the larger ideas and ideals. And thus out of the work and testimony of a number of disciplines comes fulfillment of the grandest dream: the possibility of understanding everything human beings think, feel, and do in terms of certain core principles that constitute the immutable characteristics of "human nature."

I've coined the term *Humanus, Inc.* to identify the system of assumptions and guarantees described above. As a result of the long

hegemony of humanism and Enlightenment rationalism, we are all in some way the servants and subjects of this system of assumptions and guarantees, which comes into play whenever we invoke "human nature" as a way of explaining phenomena in terms of the fixed, essential, and universal characteristics of human beings. Humanism defines the human being in terms of universal properties and qualities that it asserts cannot be lost. Enlightenment rationalism finds in reason the a priori source of an intelligibility that structures both the self and experience. An essential order thereby becomes the primary and ultimate object of thought, or, what amounts to the same thing, the haven of those beliefs and values that deliver us from the spectre of radical historical contingency. And something even more threatening: *existence*—that is, the recognition that one's very being is at issue and that one bears a total, terrifying responsibility for oneself, with no way to turn to a *nature* or system of essentialistic guarantees about human nature in order to gain deliverance from the anguish of that more primary self-reference. Perhaps that's the true motive fueling the idea of human nature—the desire to deny or limit one's responsibility for one's existence by positing unchanging principles of thought and behavior which confer a stable principle of identity formation and identity maintenance on the human subject, thereby guaranteeing us that we possess a "self" that can never be lost. Humanus, Inc. is a monument to that idea and its pathos.

The work of many thinkers in many disciplines is needed to provide Humanus, Inc. with the total economy of concepts required for this ideology to perfect itself. The resulting system can, however, be summarized as follows: good primary attachments create the bonds of love that issue in a stable self or identity that cannot be lost; and that develops the communicative and social competency through which an inherent rationality comes to fruition in creative engagement in the kind of meaningful activities that serve the betterment of societies dedicated to the nurturing of such agents who, as a result of that formation, live lives grounded in universal ethical, cultural, and religious values. (Who could quarrel with such a vision?) Or, to translate, this is why, though they may know nothing of each other, the following thinkers (to cite an abbreviated list) are essential to one another in realizing the *totalizing* project to which their work contributes by developing one of the essential planks required for the concrete realization of the founding assumptions: Habermas, Ricoeur and Gadamer in philosophy, Fonagy, Jessica Benjamin, Kohut and Erickson in psychoanalysis, Lifton and Hayden White in history,

Chomsky in linguistics, and in literary studies the many defenders of the humanistic tradition against the winds of deconstructive postmodernism. A priori rationality, communicative competence, pragmatic adaptability, attachment behavior, Cartesian linguistics, humanistic literary criticism—these are so many interlocking ways necessary to the realization of a single program. No disservice to these thinkers is implied in identifying them as servants of Humanus, Inc., since that is the grand goal to which their labors contribute.

That labor results in the realization of the two fundamental goals of the ideological enterprise. (1) A system of assumptions and concepts that will direct thought are set in place at so deep a level that their truth goes without saying. They constitute the conclusions we have either reached or toward which we inevitably find our inquiries moving. (2) These ideas are grounded in and satisfy even deeper emotional and psychological needs and desires that have become identical with belief in them. That identification is so deep, in fact, that the affirmation and defense of these ideas forms the very basis of both our self-identity and our sense that life has meaning and value. To lose faith in their truth would thus bring on a crisis threatening a general collapse of thought into chaos and the self into fragmentation and psychotic self-dissolution.

The above suggests why a piecemeal discussion of particular thinkers and disciplines is self-defeating. The task of ideological critique requires identifying the entire system of underlying assumptions. But not even philosophy provides that articulation. Especially not today when so much of it is dedicated to what are finally two minor ideological operations: (1) an explanation and justification of the methods and discoveries of science and (2) a defense of common sense against the speculative tendencies of philosophy. Anglo-American philosophy has succeeded in the ideological task of confining philosophy to the explanation and justification of knowledges that exist prior to and independently of it. The negative, critical function philosophy once performed is thereby contained.

Fortunately, however, there is one discipline that remains focused on understanding the core principles that make communication and agreement possible both within and across the full range of disciplines. That discipline is the science and art of rhetoric. It performs the ideological function par excellence. And it does so in the three ways that are essential: (1) by articulating the underlying principles that make thought and communication possible; (2) by identifying the larger social agreements and values that are thereby served; and (3)

by establishing the discursive (or rhetorical) practices that we must follow in order to be sensible human beings and maintain shared, meaningful goals. Rhetoric, in short, is about the glue that holds everything together. It is both student of and apologist for the system of assumptions and guarantees that controls virtually everything we think, feel, and do as social beings, i.e., as subjects *of* ideology. Its object: knowledge of the core assumptions and guarantees. Its purpose: to support and defend them.

Though rhetoric is a far-flung discipline, we are fortunate to have a thinker who is perfectly suited to our purpose, since his effort, over a series of books, has been to *articulate* and *celebrate* the underlying beliefs and discursive practices that make humanistic inquiry and debate possible. I refer, of course, to Wayne Booth, who attempts no less than this: to construct that single *legislative* framework that will *mediate* all disputes (judging the merits and contributions of all parties) because it articulates the *rhetorical* foundations whereby we determine what is reasonable and just, good, beautiful, and true. The *pluralistic* concept of *rhetorical rationality* Booth develops in carrying out this project offers us an unexampled insight into the core assumptions, beliefs and guarantees that shape traditional left-liberal thought. From Booth then we can gain a synoptic overview of the core principles that the left must *deracinate* in order to reconstitute itself.

It's time to lay all my cards on the table. My purpose here is to dramatize the roots of the problem that most of us on the left feel acutely today but don't know how to address. Namely, that there are two lefts—a liberal humanistic left and a more radical left. The two exist in an uneasy alliance—especially every four years in the United States, when many of us compromise our beliefs in order to support and vote for the lesser of two evils. In terms of philosophic principles and the *praxis* implicit in those principles the two lefts are, however, fundamentally incompatible. Moreover, the one based on liberal humanism and Enlightenment rationalism always wins out in the end and always by marginalizing and then extinguishing the possibilities of a more radical leftist thought. The assumptions and guarantees that thus remain in control of thought will continue to enjoy hegemony until this contradiction is confronted and the deracination required to replace Humanus, Inc. is carried out at all the foundational places where its rule is now guaranteed a priori. To dramatize this issue, the following chapter will take the form of a *system of contrasts* organized in order to lead the reader to the necessity of a choice; not on this or

that particular issue or problem but regarding the very bases of how one relates to everything—especially oneself.

Attaining freedom in thought is a laudable ideal whose pursuit is often defeated from the start by a force that is as powerful as the superego and may, indeed, be its intellectual realization. Most of us have little idea (1) how hard it is to break with the assumptions and beliefs that tie us to Humanus, Inc. or (2) how to sustain that break in the teeth of the repeated discovery that we've fallen back into one of the essential beliefs of Humanus, Inc.—or, failing that, feel ourselves lost in meaninglessness, threatened with despair. We don't realize, in short, how often and how deeply our processes of thought and feeling—even our very inwardness when it appears most self-conscious and Hamlet-like—are controlled by the very principles of *explanation* and *closure* that bind us to the system we wish to overturn. Like a magnet, the assumptions and guarantees draw back every effort to break free of their gravitational pull.

My purpose here is personal in two ways. First, to offer readers a chance to discover the extent to which they adhere to the credo of shared beliefs that Booth articulates. Few of us are aware of how deeply we are tied to this paradigm, how thoroughly it has colonized our thought on subjects we think of as separate matters (theatre and politics for example) and how strongly its cardinal premises affect all of our feelings, especially the ones we have toward ourselves. Our true paralysis is our failure to realize the profound control that this paradigm has over us. But my labor here is also personal in a second sense. I was fortunate to enjoy the benefit of a 40-years quarrel with Wayne Booth on these very issues. What I hope to do here is capture the essential issues of that debate in a way that will offer a wide readership the possibility of reexamining views that, thanks largely to the work of Wayne Booth, have become canonical for most of those who work in the humanities. This is not the place for a philosophically rigorous articulation of our differences.[1] What I hope to offer instead is a presentation that will give the reader a felt experience of the "shock of recognition" we both experienced so often in a debate that offered each of us insights into things we had not previously known, not only about our thought but about ourselves. That quarrel began a year before I met Wayne Booth. As overture, then, the following abbreviated narrative.

I was a senior at Marquette University where I'd struggled for four years to free myself from the religious, ethical, and aesthetic constraints of Thomistic philosophy. *The Rhetoric of Fiction*, which

had just appeared, was made the primary text for a senior seminar I took on modern fiction. Our assignment: choose a novel and apply Booth to it. The first part was easy: *The Sound and the Fury*, the novel I most loved then and have ever since. But as I read Booth, the second part of the assignment became a scrawl of rebuttals carved across the book's margins. Here was the return of the "worldview" I'd fought against. My undergraduate education had by then condensed itself into an axiom: replace the intellectual rigor of Thomism (especially natural law theory) with something equally rigorous and just as worthy of the claim to philosophic rationality. With the arrogance of youth I was already calling it Hegelian existential psychoanalysis, a term that embraced the thinkers who had made the deepest impression on me through their contribution to what I saw as the essential project of modernism: to replace the rationalism of the Enlightenment and the essentialistic theory of human nature it propounded with an understanding of the human subject as a being existentially engaged in a process of self-overcoming through a descent into the depths of the human psyche. Understanding "human nature" required going where the Enlightenment feared to tread. Moreover, the literature I loved was not simply a prop in the development of this worldview. Great artists, I believed, immerse themselves in the tragic dimensions of experience. By doing so they attain an understanding that transcends the limits of *conceptual* thought. My first quarrel, you see, was with Plato, and the grand project I'd already proposed to myself was to create a philosophic reply to his banishment of the poets by demonstrating how and why poetry is cognitively superior to philosophy. Writers like O'Neill and Beckett, Baudelaire and Rilke, Dostoyevsky, Joyce, Faulkner and, yes, the Shakespeare of the tragedies, were invaluable to me precisely because they offered the examples I needed in order to make that argument. And here was Booth, a disguised Platonist if ever there was one, imposing eighteenth-century rationalism and a severe moralism on literature. From the beginning, our debate was about far more than the rhetoric of fiction. For all its virtues, the fundamental thing wrong with Booth's book for me was his failure to understand that the experience modern writers had of the world made impossible the kind of (implied) authorial voice and framework of moral "values" that Booth proposed as the standard for judging all novels and all fictional techniques.

And then something happened that ended up being a turning point in my life. I told Professor Joseph Schwartz I couldn't complete

the assignment because of the severity of my disagreements with Booth. "Do your course paper on that," he replied. Three months later I was deep into McKeon, Crane, Olson, writing a long paper arguing against pluralism and the neo-Aristotelianism of the "Chicago critics." It was for me one of those golden times that makes the word *college* still move me the way a daffodil did Wordsworth; a time when everything drifted away except the impassioned pursuit of ideas I could formulate only by immersing myself in thinkers with whom I fundamentally disagreed, my mind sharpened by theirs through a process of mutual critique. By the time I finished there was nothing for it. I had to go to the University of Chicago, longing for what Blake calls "a day of intellectual battle." I soon learned that graduate education presents few occasions for such activities, but my disappointment with the process of professionalization was tempered by the conversation with Wayne Booth that began during those years.

## TWO HUMANISMS?

The question of humanism offers the most concrete way to begin. Booth saw our quarrel as one between two kinds of humanism while I viewed it as an attempt to oppose to humanism a way of thinking that breaks with and remains outside its ruling assumptions.

Wayne Booth represented all that is best in Enlightenment humanism and the essentialistic theory of human nature on which it is based. *Reason*, he argues, offers us a way to found an identity centered in the development of the ethical and aesthetic values that come from participating in the rhetorical communities that rational discussion makes possible. Such communities are open, flexible, and self-regulating because reason develops through an appreciation of all the different discourses—ranging from science to rhetoric—that reason makes possible in leading us to warranted conclusions regarding the different questions we ask. Reasoning together is an essential act because we are social beings formed through the process of communicating with one another. Identity (or the self) is a function of this process of communal interaction. Rhetoric is thus in one sense the most important discipline because its effort is to *preserve* the conditions required to make all the areas in which we communicate with one another as productive as possible. The liberal faith is in an informed citizenry dedicated to offering reasons for their views and willing to listen to and learn from the reasons offered by those who support opposing views. A humanistic education creates

the qualities of mind and feeling required for such activity. Central to such education—and thus one of the striking and distinctive things about Boothian humanism—is the study of literature and the other arts. Our response to literature is an essential part of our formation because, as Booth teaches, the kind of literary works we value and the ways we respond to them are the most important constituents in the formation of our moral character. Who could find anything wrong with such a view of things?

Virginia Woolf said that in 1910 human nature changed. I'd date the change earlier, in 1789. What makes a hyperrationalist like Hegel so exciting is his attempt to open reason to experiences that exceed it. His *Phenomenology of Spirit* is in many ways a philosophic meditation on the significance of the French Revolution. What makes Kierkegaard the truest descendent of that book is his attempt to reveal subjectivity as an impassioned engagement in existential questions that the traditional emphasis on rationality marginalizes all the better to then dismiss. What makes Nietzsche great is the will to redefine the very subject of the humanities thus: "spirit [i.e., reflective self-consciousness] is the life that cuts back into life; with its suffering it increases its knowledge." Self-overcoming through tragic experience thereby becomes the new standard that measures our humanity and that finds "reason" an ideological mask concealing desires and fears that need to be uncovered and subjected to critique. What makes Freud perhaps the most revolutionary figure in the history of thought is his discovery of all the ways that the *psyche* remains a stranger to itself and all the ways that a fixation on conscious, intentional, rational self-consciousness constitutes a defense against self-knowledge. Finally, what makes Sartre and the early Heidegger the philosophic realization of these developments is their attempt to ground philosophy in the awareness that there is no such thing as human nature. The human being is that being whose very being is *at issue* to it. Until we get to that register of experience, all our thought amounts to little more than a flight from an anxiety that has already tried us and found us wanting. In terms of this philosophic reorientation, Booth's focus on the social–rhetorical process and the identities it creates can thus be seen as an attempt to protect us from the burden of an existential subjectivity that we prove worthy of only by probing our psyche in depth while opening ourselves to the most exacting and tragic dimensions of experience. From Booth's perspective, however, my position gives an unearned privilege to

Freud and to the existential philosophers, and, thus, our differences here could never be resolved.

## THE DILEMMA OF "PLURALISM"

The opposed views of the human subject outlined in the previous section bear directly on the nature of Booth's pluralism and the question whether it actually does what it claims. I think it doesn't, and the reason why is so obvious that it can be simply stated. Booth's pluralistic openness rests on a repeated gesture composed of two distinct moments: (a) the willingness to grant anyone their question as long as (b) their answer is tested by the reasons they offer, as those reasons are themselves determined by the particular theory of rationality that Booth employs in *understanding* anyone he reads. As pluralist, Booth's effort is to provide the single framework of understanding that will include all other theories by creating the conditions for maximizing their ability to communicate with and make a place for one another. For Booth, dogmatism is the true enemy of critical thinking in the humanities. What is needed is the construction of a pluralistic framework that will welcome as many questions as we care to ask and as many approaches as are developed. Only one provision limits heaven's plenty. Any philosophic theory or critical discourse must offer reasons that satisfy Boothian rationality. When these reasons aren't immediately apparent, Booth is willing to work overtime to find them, but unless and until they are established there is no way to assess the claims of any discourse. But that's also the rub. What is so generously given with one hand is cleverly taken away with the other. Booth assumes that he possesses the universal criteria of rationality that constitute the neutral—and transcendental—court of appeal whereby all theoretical frameworks and any statements or theses they contain may be judged. Whether any such court exists, however, is a dubious and far from pluralistic assertion. To use an obvious example: there is no way that most of what Derrida says can make sense within the canons of Boothian rationality. Similarly, Derrida's demonstration of how the logocentric principles informing frameworks such as Booth's marginalize other ways of thinking which it can be shown disrupt logocentric thought from within undercuts the claims Booth makes for rationality as neutral court. The canons of intelligibility Booth would use to exclude Derrida or, what amounts to the same thing, reinterpret him in order to make him part of the commodious conversation Booth wants to construct, defeat the very

purpose those canons hope to secure. There is no one logic, no one criterion of rationality.

To put the matter in simpler terms, one cannot grant a thinker's question without also granting the *particular* kinds of reasons—and other forms of *evidence*—that thinker will have to develop in order to "answer" it. (Truth be told, one can't even grant the question, since its construing its meaning invariably involves reinterpreting the question in terms of the sense that it makes within one's own system.) The gesture on which Boothian pluralism is founded thus conceals and reveals the fundamental contradiction implicit within it. If we want to assert the truth of "rationality" and its right to judge all possibilities of thought then we should have the openness to admit that dogma and not hide the fact under the banner of pluralism when that pluralism is actually engaged at all times in the restriction of thought either by reinterpreting those we want to fit into the framework we command or by excluding—as irrational, relativistic, unfounded—whatever can't be made to conform to the procrustean limitations we necessarily impose on thinkers such as Marx, Nietzsche, and Freud. In short, there is a choice here, and we should not try to disguise the fact. If by our canons of rationality Freud is nonsensical or unintelligible, we should say so and not claim to find a place for him in our pluralism by denuding his thought of everything that makes it a fundamental challenge to the beliefs on which Booth's thought is based. Freud cannot be incorporated into Booth's framework because his thought both reveals and breaks with the assumptions on which that framework rests.

There is, however, another pluralism I argued whenever Wayne and I discussed this issue. And it points to a very different understanding of how conflicting theories relate and differ. Yes but, Booth would always reply, I welcome all of them into the conversation; that's what pluralism is—the recognition that Freud, Derrida, etc. have one set of truths, but not the Truth. But then neither do you, I'd retort, since Truth as you are now using the term is no longer a philosophic concept or even an unrealizable Kantian regulating idea, but a tautological counter in a purely rhetorical game.

## NOW DON'T TRY TO REASON WITH ME

The issue of pluralism turns on what we mean by reason. Though it would be rhetorically advantageous to Booth's position to frame our debate as one between reason and some principle opposed to

it (irrationalism, subjectivism, vitalism)—the actual issue turns on different concepts of rationality.

Reason as a concept has taken on many different meanings in the history of philosophy. That is in fact one way to describe that history. The safest generalization we can derive from that history is that there is no such thing as a transcendent reason or rationality that can be used as an independent standard to judge the range of discourses that feature the offering of reasons as an integral part of their procedure. A second perception follows. Though he champions its claims, Booth's concept of reason is not a particularly complicated one. Essentially it corresponds to what thinkers in the eighteenth century referred to as *common sense*, i.e., the pragmatic assumption that it's possible on reflection to discover reasons why we believe, feel, and act as we do about issues of common concern. Such reasons are rarely philosophically complex nor do we generally back them with strict philosophic proofs or tortured demonstrations of apodictic foundations. The barrier to reason as Booth conceives it is, in fact, skepticism and the celebration of doubt as the primary intellectual act. Indeed, Booth devoted what he regarded as his most important book, *Modern Dogma and the Rhetoric of Assent,* to the argument that reason works best when it acknowledges the prior existence of a wealth of commonly agreed upon attitudes, beliefs, and values that need not and should not be questioned. That is because they provide the prior ground of shared values and certainties that the exercise of "reason" depends on and verifies. Like everything else in Booth, reason is part of the rhetorical process. Moreover, that process and not the more sophisticated kind of philosophic reasoning that characterizes so much European literary theory is what we need to discuss the kind of questions that concern us. Is *Lolita* a good book? Is it morally objectionable? Will reading it cause ethical harm to the reader? If so, what judgments must we make about the "morality" of techniques such as the use of immoral first-person narrators and the deployment of "infinite ironic instabilities?" From the beginning, the question of artistic technique in Booth always comes trailing clouds of ethical concern. But the answers he develops do not cast our values and beliefs into doubt. Rather, they help us discover them. Reason, for Booth, is the act of reflection through which we discover the common-sense principles that have informed our experience. (As such, both reason and reflection in Booth are antithetical to what one finds in Hegel, for example, where every act of reflection instances and activates a critical negativity that continually leads us beyond

our previous understanding and the assumptions on which it rests.) Most people of course seldom bother to give reasons, relying instead on emotional prejudices. Booth's message to them is simple. There is no reason to fear reasoned discourse. Discovering one's reasons is a joyful process with the power to transform heated and often irrational debate into a process of genuine communication.

Several observations follow from the above description. The kind of reasons Booth is talking about are rarely the sort that would withstand philosophic scrutiny nor does Booth mean by reason anything like what we find in a Thomistic proof or the dialectical section of Kant's *Critique of Pure Reason*. In terms of Plato's divided line, Booth's concern is with *doxa* (opinion) and *pistis* (belief). Accordingly, his concept of rationality stays firmly rooted in the world of common sense. That's why in our discussions it was always easy for me to endorse it—and then go on to point out that it doesn't take us very far precisely because it conceals a nest of assumptions about thinking that must be objected to in the wake of thinkers such as Marx, Freud, Nietzsche, Sartre, Foucault, Lacan, and Derrida. To use common sense as a standard for adjudicating what these thinkers say and the kind of explanations they offer creates what the film *Cool Hand Luke* would call a massive "failure to communicate." Freud, for example, will never make much sense to common sense, and insisting that his "reasons" satisfy its criteria will only lead to those "refutations" that reveal little beyond the refusal of those who make them to open themselves to the possibility of exploring their psyches in depth. We confront here one of the dilemmas of understanding that a fixation on demanding explanations that satisfy common sense "solves" only in a narrow and dogmatic manner. What is required to "understand" Freud? Examining his reasons will never suffice, and it's the quickest—and most convenient—way to get side-tracked into pseudo-issues (such as, can there be unconscious ideas or fantasies?) that recede to the status of semantic quibbles once one makes contact with the *experience* that one must have in order to comprehend Freud, let alone agree or disagree with him. That experience: a self-examination that opens one to oneself in a radically new way, a way that calls into question common sense and all the motives it serves. Freud asks us to consider one possibility: how much we don't want to know about ourselves and those closest to us. Confining the anxiety attendant on that examination to questions of rationality is a convenient way to dodge what the *experience* of *reading* Freud makes possible. Or, to put it more

directly: that experience is not possible as long as one operates and lives within the terms and limits of Boothian understanding.

This example points to a concept of *rationality* that transcends the limits of Boothian pluralism. Whenever "the claim of reason" is made, a single question must be asked. What thoughts and experiences does this particular concept of rationality exclude? That question is a product of an invaluable lesson that Booth and I both learned from R.S. Crane. As Crane put it, "What would Aristotle have had to change in the *Poetics* had he seen *Macbeth?*" This principle has perhaps its most subversive implication in the following question: In what ways will your concept of reason be different if you let the thought of (say) Freud, Heidegger, or Derrida impinge on it? The first thing this question reveals is how often the claim of reason functions to rule out certain ways of thinking a priori. If, for example, one's concept of giving and testing reasons bars the ideological examination of ideas because such examination suggests that desires and motives determine our reasons rather than the other way around, then "reason" here is no more than the mask for a police action that needs to acknowledge its true agenda. If, similarly, psychoanalytic scrutiny of the motives behind one's reasons is *streng verboten*, the consequence is an arbitrary curtailment of communication rather than its pluralistic assurance. Ah, no, Wayne would reply: within pluralism the concept of rationality is itself plural and thus makes room for ways of thinking that challenge traditional concepts of rationality. What kind of room, I'd answer, when your reconstruction of what "makes sense" in Freud (say) ends up (1) denuding everything that makes his questioning radical while (2) turning rationality itself into something so vague and philosophically imprecise that all it really amounts to is the rhetorical gesture of granting yourself the right to make the limitations of your understanding the standard to which all other thinkers must finally conform.

### THE ART OF RHETORIC vs. THE CRITIQUE OF IDEOLOGY

Following Richard McKeon and Kenneth Burke, rhetoric for Booth is a discipline based on asserting the ontological primacy of the social process. Shared belief is the primary reality. In terms of "the human sciences" there is nothing prior to or beyond that foundation. We are what we are as a result of our participation in the communities we are born into or which we subsequently join. The beliefs, values, and ideas we hold are a function of the service we render them by

helping those communities maintain and enrich themselves. Rhetoric is the discipline that both proclaims and studies this subject matter. It rests on a primary perception: every rhetorical world is based on a number of shared agreements that must remain unchallenged for the system to operate. Those agreements thus render impossible another order of inquiry: the critique of ideology.

The critique of ideology is an attempt to get at the motives, forces, and desires that underlie our rhetorically based beliefs and affirmations. Marx's basic concept of ideology epiphanizes the fundamental reorientation that such an understanding brings. An ideology is the system of ideas that makes it impossible for a group of people to understand their historical situation. Ideological suspicion extends to any claim of rationality because restricting discussion to "reasons" is the most convenient way to deny other motives which retain control over discussion precisely because they can never be discussed. The only corrective to this common practice is, I think, the most radical one: an in-depth psychoanalytic examination of oneself in search of everything one doesn't want to know about oneself. One's "rational" and "rhetorical" attachment to certain ideas and values then starts to reveal itself in a new light, in terms of the fears and anxieties that are thereby displaced and the equally powerful defenses and desires that are thereby assured. Such an examination is, of course, a rare thing. And belief in the ultimate status of the rhetorical process and constant activity in that realm are the best ways to render it moot. For thereby we become persons of substance identified with institutional and professional imperatives that we serve through our repeated affirmation of a communal credo.

For Booth's system to operate, a number of rhetorical agreements must thus be in place and remain unchallenged. Being reasonable requires no less. And the quickest way to demonstrate that is to propose leaving the friendly confines of the social world of "consensual validations and reflected appraisals" for an existential and psychoanalytic inquiry into the nature of subjectivity. Perhaps rendering a traumatic experience of oneself unnecessary is the primary appeal of a rhetorical world. This is a question that can only be answered individually. The irony of my disagreement with Booth on this issue derives from our agreement that everything begins with our formation in rhetorical communities dripping with values and, I would add, hidden anxieties. Booth's effort was to preserve that way of being. Mine is to overturn it. The very values he sees as necessary to maintaining self-identity are for me the primary barriers

to psychological self-knowledge. The issue turns, of course, on the question of identity.

## EGO STABILITY WITH MULTIPLE SELVES
## vs. PSYCHE AS EXISTENTIALIZING PROCESS

Identity for Booth is a product of our formation by the communities in which we live. That process results in the system of beliefs and values on which we base our lives. The self is the *identity* one has as a result of one's *identification* with those beliefs and values through the communal activities one performs in order to earn and maintain the identity they confer. Once established, this structure remains relatively impermeable. The lesson Booth preaches repeatedly as the *ethics* and the *rhetoric* of fiction can be summarized thus: We read *from* and *to* the reaffirmation of a fixed identity. Literature expands it, but it cannot violate or overturn it. For Booth, when the latter happens a writer has gone too far. That is because identity for Booth is equivalent to what psychoanalysis identifies as *the defense ego,* a system designed to alert us to situations of anxiety so that we can avoid or escape them. This is the superordinate self that underlies one's participation in the multiple subject positions that are the preoccupation of our multicultural times. Booth welcomed this development—and wrote frequently in recent years about "the many selves of Wayne Booth"—because for him it did not threaten the fragmentation, dispersal, or, perish the thought, deconstruction of the self in a multiplicity of contradictory and often warring allegiances but was rather its maximum realization. The deliberate ambiguity and looseness that Booth must give all his key terms and categories in order to assure their pluralistic flexibility here plays havoc with the central issue that, as Kierkegaard shows, each of us faces as an existing being. Who am I? Can I achieve an authentic existential identity or am I forever dispersed in the multitude of social roles I am called on (or programmed) to play? Booth worked every side of every street on this issue without ever confronting the implications and contradictions of the positions he took. On the one hand, he is one of the last, great humanistic representatives of the notion that reason gives us our primary and fundamental identity. How else account for the role he gladly played in becoming the spokesperson for that position and its local habitation at the University of Chicago? On the other hand, the notion of plural selfhood that he also argued for is in one sense a confirmation of the rational "self;" for its solidity

alone is what enables us to function in so many different contexts without getting lost in the process. In another sense, however, Booth's particular understanding of "plural selfhood" reduces the problem of self and identity to another rhetorical game. Self is, for him, the term that covers the many very different things I do in living a richly variegated life. Booth was a disciplined cellist and this activity was vitally important to him. Karate serves the same function for me. But neither activity bears on the question of our self-identity in a way even remotely comparable to the fundamental intellectual commitments that have been our primary choice—and labor. That fact, moreover, returns us to the basic issue that all the currently popular talk about "plural selfhood" and multicultural identity conveniently displaces. Namely, the refusal to consider what I've called the basic lesson of psychoanalysis. Or, to put it more concretely: the kind of tragic interiority and in-depth psychological self-probing that we find in Dostoyevsky and Faulkner and Hegel and Nietzsche does not exist in a Boothian world nor can it without raising questions about his many concepts of selfhood that those concepts do not and cannot address. To which Booth always framed an equally powerful reply: possessing a strong central self, defined by a core of universal values, is precisely what enables us to perform the many roles we are called on to perform by the diversity of our situations and subject positions.

My quarrel with this view always began with the question of what it displaces. Is there a "self"—or better, a relationship of the subject to itself—that is more fundamental than any of the ones Booth champions? Is the defense ego pay dirt or must we open ourselves to what it defends against? Does the emphasis on multiple selves constitute perhaps a vast displacement that protects us from a more primary way of being that it represses? The basic lesson of psychoanalysis is simple: we are defined by traumatic experiences and conflicts that will continue to rule our lives until we assume them in the anxiety appropriate to that engagement. Doing so requires shattering one's defenses and learning to live within anxiety as that Keatsian "wakeful anguish of the soul" that attunes us to all that we've buried in ourselves. One of Freud's central achievements was to dissolve the line that most of us like to draw between neurosis and ("healthy") normalcy. Psychological disorder is condition general. Attempting to deny it about oneself is one of its primary forms. The first thing revealed to those who try to live out an anxious

self-reference is how nicely the Boothian view keeps that primary relationship to oneself at a distance.

In more abstract terms, our debate concerning self-identity recapitulates the difference between Kant and Hegel. For Booth, critical reflection on the self and its values leads to modification and thereby preservation of one's beliefs and values, whereas for me, it engages the effort to overcome the weight of repression and denial that is the actual truth of our social, familial origins. Reflection for Booth, as for Kant, produces that acquiescence in one's limitations that soon becomes their celebration, whereas for me, reflection, as dialectical negativity, inaugurates the process of self-overcoming. Let me add here the further suggestion that it is Freud who most fully concretizes this imperative. He does so by revealing the tragic burden that we all share as the principle that structures subjectivity and each subject's personal history. Human experience turns on a traumatic discovery: all that we do in an effort to flee our psyches carries a terrible cost to ourselves and to those on whom we project everything about ourselves that we refuse to face. In this sense most of us live a tragic story that remains untold, because we have successfully put off the day of recognition and the inner reversal that self-knowledge makes imperative. This condition, and not some single complex, is what makes all of us like Oedipus—and blind to that fact. To which I must add Booth's rejoinder whenever I suggested this idea: "Your vision of things, my friend, is far too dark. It imposes on human beings burdens that most are too weak to bear. It also suggests to me the possibility that everything you say is the projection of a private disorder." We thus again came to the fundamental opposition: Booth's humanistic defense of the rhetorical subject vs. the Kierkegaardian recognition that such an "identity" is impossible for "an existing human being." For inwardness grows only when we relate to ourselves in depth by embracing the problems and experiences from which Booth attempts to protect and deliver us.

To dramatize the contrast, I conclude this section with another example derived from Freud. What is sexuality and what is its function in the constitution and maintenance of the self or psyche? As you can imagine, Booth and I went round and round on this one. My argument: sexuality is the very source of psychological identity. Its conflicts are the informing center of everything we do. The only viable theory of the "self" is an erotics of experience. Booth's response: stark incredulity. Identity is a function of rationality and the social process. Sex is one of the areas in which we express an

identity that we have independent of it. Sexual experience does not involve a *crisis* for the subject nor is it a uniquely revealing instance of who we are. Reading and teaching literature, in any case, have little to do with it.

## A HUMANISTIC ETHIC OF RHETORICAL RATIONALITY
## vs. A TRAGIC ETHIC OF EXISTENCE

When the conversation turned to ethical questions our differences became sharp and often heated.

Ethics for Booth is the pre-eminent concern. The ethical realm is composed of a system of essential truths and moral values that are given an a priori status by reason and that thus serve as the regulators of experience. Sustaining such values is essential to maintaining the self and protecting its psychological coherence and integrity before the threat of experiences that may be labeled harmful or immoral. Without adherence to such values there is no basis for a healthy humanistic self nor any way to guide that self through the pitfalls of experience. The *from* and *to* of Boothian identity is the mediation of experience by ethical norms and judgments that are in no way dependent on the individual agent for their coming into being.

My contrasting position derives from an effort to break with the hegemony of what Nietzsche called "the moral interpretation of the world." Pursuing that effort essentially involves two things: (1) a critique of the ways in which a fixation on the ethical frequently involves repression, *ressentiment* and the desire to shrink the range of life's possibilities so that we are protected from certain experiences, and (2) intense engagement in those experiences in search of an entirely different way of being. Such an effort, I hasten to add, is not the abrogation of ethics. It is, rather, its grounding in a principle that is psychological rather than rationalistic and formalistic. To state it aphoristically: the crucible of one's most traumatic experiences is the only route to the discovery of an existential ethic that preserves the inherent complexity of experience against the reductions and abstractions that previous ethical theories have imposed on it. Booth's constant worry is that certain experiences will harm our ethical integrity. His concern as its spokesperson is to defend and protect an implied audience composed of those who want to defend the ego from those experiences that could shatter—or pervert—it. For me, in contrast, such experiences are precisely the spur and source of self-overcoming. The dependence of ethical values on the experience

of the individual agent is not an overture to relativism or willful subjectivism but a call to tragic engagement. Such an ethic depends on three principles that Booth cannot accept: one must (1) exceed the limits that the Enlightenment *ratio* imposes on experience; (2) sustain that break by immersing oneself in the experiences it proscribes; and (3) find in that activity a new way of *valuing* that will create what Nietzsche termed "values for the earth," i.e., for a situation where contingency and historicity are apprehended free of the metaphysical guarantees that previous thought has tried to impose on experience. The primary way this imposition is achieved is by positing "human nature" as the guarantee of ahistorical values. To *exist*, in contrast, is to think, value, and experience outside the framework of essentialistic and ontological *guarantees*.

## EMOTION: THE FLESH-AND-BLOOD READER
## vs. THE EXISTENTIALLY ENGAGED READER

To disagree for so long and find that a valuable experience, there had to be something we shared. We always thought we knew what it was. For both of us, literature was an experience with a profound and lasting impact in determining what we both called one's moral character. We both, in short, accorded the emotional life a far greater significance than it assumes in most philosophies. As rhetorician, Booth knew that often emotion is pay dirt: i.e., the real reason why someone accepts an argument or position. The theory of situated subjectivity I've developed rests on a comparable recognition: that disavowed and repressed psychological motives and conflicts are the primary force determining our intellectual commitments. What we refuse to feel about ourselves and what we insist on feeling in order to avoid that experience is the ultimate basis both of our thought and the resistance of that thought to critical examination.

Thus within our shared concern Booth and I once again discovered a world of difference, this time based on two radically opposed theories of emotion. For Booth, the most important thing is to cultivate an emotional life structured by rhetorical rationality. It gives us the emotional *control* over experience we would not otherwise have. The right emotions and emotional experiences must be cultivated, moreover, because *feeling* is the primary way in which we regulate and expand our ego-identity. The threat to the social–rhetorical self is the prejudicial force of those emotions that crave violent discharge against all discourse of reason. The corrective is the experience

provided pre-eminently by the reading of great literature, where moral judgment unites with our natural sympathies to produce experiences that reinforce and even have the power to shape our moral being. The ego is confirmed and enhanced by discovering the great order of feeling that it has within itself and how that order enables it to shape its deepest and most complex emotional experiences to the tune of complex moral judgments. By the same token, there are certain emotional experiences that must be judged ethically harmful because they unleash feelings that violate the order we must give to our emotional experience, i.e, to feelings that cannot be cathartically contained in keeping with the overarching necessity: that our primary need is to *resolve* painful experiences in a way that *relieves* us of traumatic and negative feelings by *restoring* our identity and the belief system on which it is based.[2]

In opposition to this view my effort is to probe and plunge the most exacting and "dangerous" emotions for what they reveal about what Faulkner called "the human heart in conflict with itself." To impose the emotional demands of the defense-ego upon writing and reading is to foreclose what make both activities a radical opening of the psyche to itself and to the claims of an order of feeling that goes far deeper than pity and fear in revealing the power of traumatic and tragic experiences to liberate the psyche from the tyranny of the ego. This theory rests on a distinction between what I term *primary* and *secondary* emotions.[3] Briefly: primary emotions (anxiety, envy, humiliation, love, depressive melancholy) burden the subject with an *agon* in which it finds its very being at issue and at risk. Defenses drop away. There is no longer any inner distance between what one feels and who one is. One is assaulted from within by the buried conflicts that form the "core" of the psyche. Existentially, one *is* what one here feels and nothing protects the psyche from becoming irreversibly the issue of that engagement. Secondary emotions (pity, fear, a general sense of well-being, the various ways we feel in order to maintain self-esteem), in contrast, constitute the most effective defenses that the ego has developed to displace and discharge anxiety. Through them the ego manages conflict in a way that distances and protects it from the threat of disruptive experiences. In effect, such emotions enable us to live our lives at a safe remove from ourselves, whether we do so through quiet desperation or noisy affirmation. Through the ministry of such emotions, the ego maintains an illusory identity based on the vigorous opposition to two things: experience and the inner world. Heidegger provides what will have to serve here

to exemplify the basic contrast. As he shows, fear dominates the life of most people precisely because it enables them to constantly displace the anxiety that underlies it.[4] As long as we worry about all sorts of things that could happen to us in the world we never have to confront the one that makes John Marcher's discovery at the end of Henry James' "The Beast in the Jungle" the common fate of most human beings.

Two important caveats are essential to sustaining this contrast. "The flesh-and-blood reader" that Booth and his followers so often claim to speak for is a clever rhetorical construct that tries to privilege one way of experiencing in order to eliminate another. There is no flesh-and-blood reader. There are only readers. Some, many no doubt, read in the ways Booth describes. Protecting oneself from painful experiences and fleeing anxiety—living in fealty to the defenses that protect one from oneself—are common practices, reinforced today by a general culture of obsessive affirmation. But there are also flesh-and-blood readers who read in search of books that will be radically disruptive. For them, a book remains relatively uninteresting unless it impinges on them in terms of the imperative that Kafka formulated: "A book must be an ice-axe to break the sea frozen inside us." Such flesh-and-blood readers do not read from and to a stable identity, but toward the possibility of opening their psyches to self-overcoming. This difference applies not only to the works that different readers will find most valuable: Austen, Dickens, Fielding and James for Booth; Beckett, Faulkner, Proust and Pynchon for me. It also applies—and in a far more telling and valuable way—to the understanding and evaluation of critical theories. Booth is indeed right. Whether explicitly or implicitly, we judge every critic we read in terms of ethical and psychological categories. The implication of that fact must be faced squarely. Thus, briefly and pointedly: for Booth, my *Get the Guests* is, finally, an immoral book because its effort is to ripen the psyche toward the experience of everything that makes it impossible ever to return to a Boothian world. For me, similarly, every page of *The Company We Keep* is dedicated to protecting readers from experience, by making Booth's ethic the standard that will control all reading experiences. And, implicitly, all friendships.

Retrospectively these differences imply a question that was at the center of our contrasting responses to modern writers and "the modern world." Is the kind of deeply unsettling exploration of experience that characterizes so many modern writers a good thing, or are such experiences precisely what we should be protected from

for our moral and emotional well-being? Booth frequently questioned the right of writers to inflict certain experiences on an audience. I was always equally quick to question the right of audiences to impose their defenses upon what artists can explore. This debate, too, was one that could never be resolved because it rested on opposed moral, psychological, emotional, and aesthetic imperatives. Booth argues that life is richest when we live in terms of the limits that rhetorical rationality puts on that to which we can be expected to open ourselves. My contrasting argument is that freeing oneself from illusions and knowing the most painful things about human experience is the highest value, the categorical imperative, if you will, of an ethic that will not, to put it in Nietzschean terms, "sin against life."

### LITERATURE: SAVING THE WORLD vs. GETTING THE GUESTS

To compare and contrast what Booth and I would say on a particular literary work (say *Lolita*) would require more space than this chapter allows. I think I know a quick way to take us to the fundamental contrast. Consider our views of literature as the theoretical equivalent of the distinct artistic purposes of two modern American dramatists— Arthur Miller and Eugene O'Neill.[5] Booth as literary critic performs a function similar to the one that informs Miller's plays. Profound and even tragic conflicts are dramatized, but Miller's plays always move to the reassertion of a humanistic vision that restores belief in eternal verities. The tragic for Miller is always contained within a framework that leaves the audience reassured about what is morally correct and what the consequences are of violating the moral law. That is what makes Miller's drama emotionally uplifting and reassuring. In his theatre of pity and fear the audience always feel that they are being protected from experiences that would plunge them into doubt or anxiety. We sympathize with Willy Loman while judging him from a moral perspective above and outside his struggle: his is indeed a tragedy of the common man but it is not written from that perspective. Miller always comprehends the *subject of representation* from a scheme of fixed humanistic ethical and aesthetic values.

In contrast to such an aesthetic, my aspiration as critical theorist is to create the equivalent of what O'Neill accomplishes, especially in his two greatest plays: metatheatrically in *The Iceman Cometh* and in the bosom of Miller's subject, the family, in *Long Day's Journey Into Night*. O'Neill's artistic purpose is to shatter illusions and thereby

create an anxiety from which he refuses to deliver his audience because the purpose of his drama is to lead them to a choice: either to take up the burden of existential self-discovery or to retreat back into what one now knows is a lie. For O'Neill, pity and fear become the emotional needs that are deracinated by plots that replace those emotions—and the ego-identities on which they depend—with the new order of feeling that emerges once one has developed an authentically tragic understanding of the psyche. A process of in-depth emotional transformation structures O'Neill's plays. The values and beliefs on which traditional humanism depends are thereby subjected to a critique that goes to the heart of the emotional needs on which that worldview depends. What Miller writes dramas in order to reaffirm, O'Neill writes dramas in order to overturn. There is accordingly no way to respond to or interpret his work in terms of Booth's framework without misreading it. O'Neill, in short, violates the ethic of friendship that Booth argues must inform any meaningful relationship—or friendship—between a reader and a writer. Wayne and I quarreled mightily on this issue without ever coming to grips with our basic difference. Wayne argued that O'Neill and Beckett (even Celine and Nabokov) were literary friends, ones far different than Arthur Miller and all the more valuable for that difference. And I know that he believed every word of this statement as he did, similarly, in his long and generous effort to understand the challenges my theories of tragic existence posed to his system. For all its openness and humanity, however, those efforts I think rest on a psychological and existential impossibility. To understand O'Neill and Beckett (say), one has to go in anxiety to that tragic place in the psyche where, in order to find ourselves, we must find ourselves at war with and in fundamental conflict with ourselves. Unless we "let" O'Neill and Beckett impinge on us there—and prove that friendship by sustaining an anxiety more exacting than all others—we aren't really making contact with them. This is, perhaps, the true condition of reading and of critical theory and interpretation. Our differences, finally, are not theoretical or philosophic. Those differences derive from and rest on something more basic: namely those fundamentally different *ways of being* that determine what Aristotle called our (ethical) character and what I speak of in terms of the fundamental existential and psychological choices that determine, in depth, *who* we are. These are differences that all the good intentions in the world cannot bridge.

Booth was keenly aware of something about his thought that has received insufficient attention. Namely, his model of humanistic reading (or friendship between author and audience) is the latest, and in some ways the cagiest, development in the long tradition of moral suspicion of literature inaugurated by Plato in the *Republic*. Serious moral concern always attends the discussion of literature in Booth. There is something dangerous about literature and certain ethical questions must be made foremost lest that danger escape the attention that must be paid it. A method must be found to protect us from works that will be harmful to us and also a way found to help us achieve the maximum benefit from those that are, as true friends, essential to our growth as persons. Here's the paradox of all self-identities not grounded in an in-depth psychoanalytic self-knowledge. They are intractable. No experience can overturn them. And yet they must be constantly on the defense, and thus constantly in danger of being overturned. However, the traumatic event that would bring about real inner change is, in most cases, forever delayed.

Plato's error is that he went too far. Booth, like Aristotle, finds a way to "humanize" his critique while preserving it as a standard fully operative in the (always secondary) world of *representations*. Literature is an essential prop in sustaining essential and immutable ethical truths. It expands our sympathies and our understanding in a way that proves necessary to the maintenance and expansion of an identity which is the constant need, for without it, for Booth, we'd be lost in the relativism of the modern world. Booth is thus a generous Platonist. He approves of any subject and any representation of human experience as long as the implied author brings to it a solid ethical vision that shapes our experience at the most basic level and moment by moment as we read. For it is by creating the continuity of an emotional experience that artists concretely realize their values. That is why for Booth friendship is the model for the relationship between author and audience. As in any friendship I am willing to open myself to anything my friend wants to share with me as long as I know she or he is not using that occasion, Iago-like, to harm or exploit me. For the same reason, the primary question I must ask of any literary work is whether the author is concerned with my well-being. Until an author passes this test—and sustains that passing grade—I must withhold the assent I long to give.

A stark formulation of my contrasting position is offered in the first sentence of an essay I wrote on *Death of a Salesman*: "Representation

exceeds intention." As Sartre showed, that's what makes authentic writing dangerous and *inaugural*. One enters the realm of experiences that exceed a priori values. An identity based on them is of no avail when we move within the medium of anxiety. Sustaining the project of representation requires a readiness to transcend all the personal and ideological limitations one had prior to writing. Conrad's "in the destructive element immerse" is the proper axiom because it is only by doing so that one discovers the fundamental terms and conflicts of human experience. That possibility is what Plato could not tolerate: the idea that art is an original and primary way of knowing precisely because it transcends the limits of the *ratio*. In doing so art offers us the possibility of moving beyond all the limits in which rhetorical souls so readily rest. To impose moral and emotional limits on such a possibility—to insist that literature not violate the needs and desires of the normal reader (i.e., the defense ego) is to violate the integrity of art. Literature is great insofar as it opens us to anxiety and forces us to probe our inner disorders and wounds in ways that make it impossible for us ever to return to the world of the ego and its defenses. Great literature's right and duty is to expose all the ways people lie to and hide from themselves. Great art is dangerous, even destructive. That is its *raison d'être*. Ego-identity and ideology is precisely what it strives to overturn. Protecting the audience from themselves is the temptation it must constantly overcome.

And so, pedagogically speaking, what did Wayne Booth and I teach each other? A lesson perhaps more valuable than any method or doctrine. The differences among critics are not primarily intellectual. They are existential. Disputes among critics derive from fundamentally different ways of being. And that's what's really at issue in our quarrels over *Lolita* and catharsis and the morality of impersonal narration, etc. We don't want to confront this condition, however, because it redefines "the knowledge most worth having." In choosing what authors we prefer and, more importantly, what theory (or theories) we prefer to employ in interpreting them, each of us faces an existential and moral choice that reveals far more about our psyches than most of us care to acknowledge. Indeed, our activity as critics entails and calls into question the entire system of choices that has made each of us the person we are. Whenever this issue works its way onto the agenda of literary theory there is resistance, anxiety—and the shimmering of possibility. We all wax eloquent when we urge the Delphic command to "know thyself" upon our students. What we seldom realize is that this command

haunts us our entire life. Isn't it time then that we put it at the center of criticism? I would, of course, utter a resounding Yes. Given his social–rhetorical commitments, Wayne would disagree. I miss him. And all the objections I know he'd make to the third part of this book. Having cleared the ground here, my purpose there will be to explore what we can know about ourselves and experience once we've truly broken with the humanist and rationalist paradigms. The tragic theory of psyche and experience developed there will have as its subtext the argument that this experience of subjectivity is where the left must begin if we are to evolve a politics that will address the fundamental realities that define the human psyche.

# Part III
# The Way out of the Cave

## Overture: "Happy Birthday, Sam!"

A cry so far inside your heart that even you can't hear it.
Alison Croggon, "Monologues for an Apocalypse"[1]

As I write these pages many are experiencing today as a special day. The day that marks the hundredth anniversary of the birth of Samuel Beckett. And thus a day that fills those of us who love and work in the theatre with feelings of immense gratitude, humility, and the uncanny sense of moving within the aura of what for those without God constitutes the sacred. Namely, the fact that a human being could have the courage and tenacity to take something deeply traumatic as his subject—the problem of "never having been born properly"—and see it through, true to wherever it led him, refusing to compromise the demands it placed upon him and thus able to reveal, as a result, something true not of his private but of our general condition. For purposes of the argument developed in this book we might think of Beckett as the antithesis of ideologically determined consciousness.

But if Beckett's work is radical and revolutionary it is because it is formally *sui generis*. There are, of course, precedents and influences, just as there were for Shakespeare when he sat down to write the most revolutionary play ever written, *Hamlet*—the play after which drama could never be the same without thereby confessing its "bad faith." Beckett understood the essential condition of the playwright. A novel understanding of one's world demands a novel dramatic form. In fact, there's one problem with this formulation. It separates what is inseparable. The way Beckett experienced the world was *already* the knowledge that extant theatrical forms were inadequate to the task of representation. The creation of new dramatic forms was thus precisely the act necessary to the development of a new awareness. Artistic form was for Beckett cognition in the most immediate and totalizing way. Beckett is one of the true examples of Croce's argument that

115

*intuition is expression*, i.e., that no idea exists apart from or prior to the *form* that it demands, indeed requires, in order to come into being. In terms of drama, Beckett radically pursued the essential problem: dramatic form is the very way in which a playwright's awareness or "thematic ideas" first articulate themselves—and the only way in which they can emerge and become concrete. This is the anguish of the act of writing and the problem it necessarily engages, since the constant danger is that one will lapse back into ideology, especially when things get rough. It is then that older dramatic forms seduce most playwrights back into older ways of thinking and feeling. Ideology and aesthetic form are opposite sides of the same coin. Seduction by one always results in being seduced by the other. It is a seduction that Beckett refused. Though the comparison is unfair in many ways, this refusal is what distinguishes his work from a liberal, humanist playwright such as Arthur Miller. Ideology, for Miller, is always there as the guide—to knowing what one wants to say, how those themes will be best conveyed, and how one organizes that representation so that all the humanistic values and guarantees become the through-line or teleology that runs through the entire play and is then asserted (often baldly) at the end, so that no one in the audience will leave the theatre in any doubt about who we are and what we feel and believe.

In one of the finest appreciations of Beckett published today, George Hunka states what is, I think, the center of Beckett's achievement. Beckett demonstrates that "the personal interior landscape of consciousness is…a worthy subject for theatre."[2] The power of Beckett's example is one of the reasons why *monologue* has today become a major presence in contemporary theatre; and why performance art and the long autobiographical monologues that so often characterize it has become an increasingly popular form of theatre. It is also why plays such as *The Vagina Monologues, The Exonerated* and *My Name Is Rachel Corrie* have reached such a large audience.

But that is also the problem in a nutshell. Is monologue in *The Vagina Monologues* even remotely what monologue is in *Hamlet* or Beckett or are there two radically different practices of monologue, one of which is the popular, theatricalized counterfeit of the real thing? Shakespeare took the monologue and revolutionized it from within by centering it in the drama of an inwardness engaged in a constant process of negation and self-overcoming. The result was *Hamlet*, a play which overturns every convention and tradition of what constitutes drama, because the act of reflection becomes in it

the principle of action that exposes all pseudo-action. (The common belief that Hamlet is unable to act is a monument to the misreading that characterizes virtually everything that's been written about this play, as if *Hamlet* were the Medusa and all critical theories the shields whereby we slay what we fear to look upon.) *Hamlet* dramatizes what happens when inwardness—the depth of human subjectivity, of a psyche in conflict with itself over its very being—becomes the subject of drama. Moreover, Hamlet haunts us because he remains the model of where an in-depth exploration of its interiority can lead a psyche. That is why his example founds a tradition that not only ruptures drama from within, but that spills out into other forms of art and culture, so that among the descendants of Hamlet we must number Hegel and Kierkegaard and Nietzsche and Heidegger and Sartre; Ivan Karamazov, Stephen Dedalus, Quentin Compson, Hans Castorp, Kafka's K, and Beckett's Unnameable; Wordsworth, Baudelaire, Rilke, and Wallace Stevens as well as Hickey and Blanche and the Tyrones and Hamm and Clov and Krapp and Winnie and the speakers of "Not I" and "Play" and "Rockaby."

What Hamlet suffers and does to himself—the action he performs on his own psyche—also begets questions that go beyond drama in another way. For his example asks each of us to question the nature of our own inwardness. That is, *to reflect on what happens when we speak within ourselves to ourselves about ourselves.* That dynamic (and the above formulation indicates that it always involves four dynamically interlocking moments) is always with us because it constitutes that force or deep current within the *stream of consciousness* that erupts at uncertain times throughout the day. In this we are all Leopold and Molly Bloom. And, whether we know it, Oedipus and Lear, Othello, Hedda Gabler and Blanche DuBois. That is so because the weight of self-consciousness denied is what comes back in full force upon us whenever traumatic events—of a personal or a national nature (9–11)—force us to reflect on our lives with thoughts beyond the reaches of our souls. When this happens *monologue* (like mourning) becomes us: we experience the depths to which human beings can be called by themselves or by the pressures of their world. One then finds oneself caught up in the kind of experience Rachel Corrie speaks of in that wonderful passage about the "shrug." That is, one finds oneself assaulted by that existential awareness that one finds only rarely in the play that bears her name, and then always quickly abbreviated in the move to more secure ideological ground.

But what if one refused that move? What if an entire play sustained the act of traumatized awareness; made that process the basis of its progression, the *law* of its form? That is, what would monologue be if it dramatized what happens when a psyche persists in *acting on itself* at the most traumatic and tragic registers of its experience, refusing to compromise that process no matter where it leads. Drama would then become a concrete illustration of the very process through which the psyche *existentializes* itself by *acting* on itself at the deepest register of its own anxiety. Or, to put it in even more challenging terms, such a drama would be a mirror held up to the darkest and deepest places within the psyche of each member of the audience—a mirror held up so that audiences could discover all that is fragmented and buried and wounded and struggling to be born in themselves and all that one must take up, accordingly, in order to answer the call of their own deepest experiences.

Part III offers three distinct ways to actualize these ideas. Three distinct efforts to show that the aesthetic, the cognitive, and the psychoanalytic are one. And that because that is so the person is the political and vice versa. So many on the left have for so long found it so easy to dismiss the dramatization of inner consciousness as irrelevant, bourgeois self-indulgence. What we've lost, as a result, is concrete experience when it is most revealing, when emotional and psychological courage strips away all the ideological guarantees and emotional needs that protect us from understanding the true, tragic exigencies of experience. The next three chapters attempt to restore our contact with this register of our psyches. As such they are not simply an effort to offer readers something they might think about; they're an attempt to exemplify something that each of us must do. For this is the deepest truth of *monologue:* we are always, in one way, in a room alone, fleeing ourselves or readying ourselves for the loneliest of acts. This is true also in that one public space dedicated to the impossible act: the staging before an audience of terrifying secrets—about themselves. Though we huddle and laugh and cry and applaud together we remain alone there too—alone together, knowing the thing we then collectively rush to deny. That all good plays are mousetraps. That the fourth wall is always broken. That we aren't looking at the play; it is looking at us.

# 6

# The Knot at the Center:
# The Tragic Structure of Experience

And for what, except for you, do I feel love?

Wallace Stevens, *Notes Toward a Supreme Fiction*

To reconstitute itself the left must recover the tragic. Faced with the nihilism of affirmative, Christian culture at the end of the nineteenth century, Nietzsche called for "a pessimism of strength" as the psychological imperative for those who would understand history. That pessimism is needed even more by those who would *act* in history.

What follows is the briefest of essays on the tragic. My hope is to outline a *structure of concepts* that I think has the power to free us from the ideologies to which we have now seen that we are bound, ideologies that make it impossible for us to confront the truth of our historical situation. Call them our own forms of a religious faith to which we kneel each time we insist on imposing ontological guarantees upon history because without the principle of hope, the belief in the proletariat, a left-Hegelian presence of reason in history, the necessary collapse of capitalism as the transition to a just world order, etc., we would find the world too difficult to bear. This is our own "bad faith" and it stems from a single condition—the need to exorcise the tragic. What we there lose, I'll argue here, is the very possibility of self-understanding and with it the possibility of understanding everything else.

Discussing this issue requires, however, something special from you as reader: a willingness to use the following discussion as an occasion for reflection on your life in a way that may bring unexpected discoveries. My purpose here is to address the hidden and buried places in the psyche, to offer each reader the possibility of the only kind of self-knowledge that's worthwhile—the kind that is hardest to get because it depends on overcoming all the barriers that we erect to protect ourselves from it.

There's an event that each of us fears because it would force us to confront all that we don't want to know about ourselves. Or what

amounts to the same thing, it would prove the truth of the thing about ourselves that we most want to deny. One person lives in fear of being found to be a coward; another from discovering an inability to love; a third from learning that one will sacrifice anyone or anything to advance one's career. The particular event is different for each of us. The power it has over us is the thing we all share. You know that situation. The one that leaves you overcome with anxiety, wringing your hands, pacing the floor in sleepless nights, feeling an inner paralysis inside and something even deeper that makes your blood run cold.

We organize our lives to avoid dealing with a conflict that for reasons we refuse to consider terrifies us. We construct a bright shining identity to put it to rest. And then at some point, as in economic *cycles,* a depression ensues, we feel the emptiness in our lives, or something happens and with a *crash* it all comes tumbling down like a house of cards. Or (and as we'll see this is the richest possibility and far more common than we realize) the thing we always feared happens and we discover that we've constructed the sequence of events that have brought it about. A deferred trauma then assaults us with the cumulative force of all that we've tried to escape and deny about ourselves.

In most cases, of course, all these occurrences are but passing moments in the recovery of one's "identity" and the stability of one's world. As in Woody Allen's masterpiece *Crimes and Misdemeanors,* the *crisis* passes. One reinvests one's capital in all the privileges that protect one from the bankruptcy one experienced only briefly. For after all one wasn't cut out for a tragic existence. One regains one's bearings; and yet this recovery, as the end of Allen's film suggests, is perhaps the saddest tale and the most chilling one. And one that as such gives birth to another: the inability of viewers of the film to know how much they resemble the central character. Judah Rosenthal's (Martin Landau) tragedy is that he managed to avert the tragic. It could only awaken in him for the briefest of times. He proved incapable of what it revealed to him about himself. Is that perhaps our common tragedy and the only form the tragic can take today? The postmodern condition redefined: that of a culture that has for so long alienated itself from the call of the tragic in us that we can only hear it now as a passing nostalgia, something that we can no longer constitute and so something that is as extinct historically as the other forms of life that are being sacrificed daily to sustain what has always been the deepest promise of the American dream—a final deliverance

from all the dark suspicions about "human nature" whereby the tragic once tweaked us into afterthought and forethought. No wonder the tragic has become the thing we shun as if the mere mention of it were enough to send any conversation scurrying toward a catechism of affirmative commonplaces as everyone goes on automatic pilot in the shared effort to expel the rude presence that has intruded itself into the room. Is the death of the tragic the irreversible event that defines us? Or is its recovery the only possibility that can reverse our situation?

So much for prologue. What follows is act. My effort will be to show that the tragic constitutes the inherent structure of experience. Each of us, accordingly, can understand our lives in a new way by finding where we stand within the structure that is described here. Or, more pointedly, the degree to which one has realized oneself existentially is defined by the degree to which one has fulfilled the teleological principle or goal that unifies this structure. I hasten to add that the tragic as understood here is not about meaningless destruction or catastrophic accidents; nor is it about the flaws that separate certain people from us good, normal, healthy folk. It is about the inherent working of the psyche, about the principles that define it and the experiences through which those principles come to fruition. As such, the chapter constitutes an attempt to give the reader what I regard as the greatest gift: the structure of concepts that will lead you to yourself.

Three ideological operations are needed in order to undertake that journey. One must be willing to question Aristotle's *Poetics* and all the commonplaces that derive from its long hegemony—i.e., the belief in catharsis and resolution of conflict as the goal of tragedy; or, in popular terms the current overweening need for *closure* and deliverance from any painful feelings. One must also be willing to question the two stories of the "self" that together control contemporary American psychoanalysis: (1) the notion that the subject is composed of multiple identities each determined by the different social and personal contexts in which we exist; and (2) the equally comforting notion that thanks to the attachments we form in infancy we have a stable self that through the developmental process reaps the benefits of a healthy life of relationships founded in recognition and mutuality. These are the two stories we currently tell about ourselves, stories perfectly in keeping with the ideology of American capitalism, assuring us that we can function successfully in a multiplicity of contexts because we possess a secure, stable self.

These two views are, of course, descriptively accurate as far as they go. But the tragic tells another tale, one that we don't like to hear because it suggests that these stories constitute displacements and defenses against discovering the actual principles that inform the *development* of the psyche; i.e., of the deep discontents and desires that we sense stirring in us whenever our preoccupation with reassuring ourselves about our identity lapses. Gaining a healthy skepticism toward current paradigms is merely the conceptual side of our problem.

Regaining contact with the tragic requires something deeper: opening ourselves to the suspicion that we resist and fear the tragic because it whispers to us something we don't want to know about ourselves. Moreover, that it has the power to impose that knowledge on us in a way that makes it impossible for us any longer to escape taking up responsibility for our being.

What follows constitutes a series of propositions (arranged in a necessary order and numbered consecutively) outlining the basic moments that compose the tragic structure of experience. These propositions form a necessary, unified, and dialectical order. An essential caveat: each step in this structure marks a point where many subjects make the great refusal, choosing, in effect, non-tragic ways of being in the face of a tragic situation. That fact does not alter the ontological primacy of the tragic and its normative value. The fact that most subjects arrest the possibility that defines their humanity serves primarily to underscore the key pressure points in experience and the excellence of those who refuse to flee them. Freud said "the poets knew it [the unconscious] first." Here is the essential structure at the heart of that knowledge, the core of the tragic both as a literary genre and, of greater importance, as an experience.

## FROM AVOIDANCE TO THE TRAUMATIC EVENT

(1) Through a traumatic event, we learn something about our character that reveals that our life has been a lie. Of greater importance, we learn that we are the author of the events that have brought us to this situation. The second discovery is the crucial one. "The fault lies not in our stars but in us." I am the cause of my undoing. The traumatic event enables us to see this for the first time, to know that the tragic is the process of our actions catching up with us. All the lies we told ourselves about ourselves unravel. All the identities we thought we'd secured are referred back to the underlying conflicts they displaced.

(2) We experience the primary fact. Inner conflict is the reality that defines and haunts us. And it does so through the inexorable working of an implacable logic. Running away from ourselves is the way in which we eventually run into ourselves. *Experience* is not structured by the adaptational development of a unified and coherent self. It is structured by the movement of conflicts deferred to the point where they can no longer be denied. That is so because repression (avoidance, displacement, denial, etc.) does not put a conflict out of play. It empowers it as the organizer of our experience. Experience is thus defined by the movement to (and then from) the traumatic event that reveals all that we have tried to avoid and deny.

(3) Fleeing conflicts and anxieties empowers them, creating a progression that leads inevitably to a traumatic event in which the underlying "truth" of our life assaults us with the knowledge that we are the author of the situation that now brings the greatest suffering upon us. That is the power and significance of the traumatic event: it makes the underlying "logic" of our lives evident in a way that is personally mortifying. The recognition that we've done it to ourselves (though we don't know why) is the most painful one and the one that most people will do anything to deny. For it is one thing to suffer; another to know that one is the cause of that suffering and, knowing that, also to know that one doesn't know the reasons why because one is a stranger to oneself.

(4) It is precisely in the face of this recognition that some human beings make a radical discovery—or choice. They see the trauma as the thing we need and bring about, in fact as the only way human beings have, given our overweening mendacity, to call ourselves to account. Those who respond in this way to the traumatic event begin to understand why the following thesis is the key to the psyche. *The thing about ourselves that we most strive to escape and deny is also the thing that we are impelled to bring about.* That paradox defines the inner necessity that makes us tragic beings.

(5) All subjects who suffer a traumatic event experience what it means to have a "self" in a radically new way, even if the event only briefly whispers to them things about themselves they refuse to hear. For example, that psyche is defined by inner conflicts that beget an *agon* always in process of development. As subjects we are permanently *at issue*, existentially engaged in some effort either to escape or to confront our conflicts. There is no "nature" or substantial identity outside this process. All supposed stabilities of the "self" are attempts to arrest and deny our condition, to provide *guarantees* that

deliver us from it. The traumatic event is the eradication of all that. All defenses, displacements, and delays drop away. The psyche is assaulted by itself in its existential responsibility for itself.

(6) Because it is our own doing, the traumatic event makes possible a self-knowledge we could not have gained otherwise. That possibility is a comprehensive insight into all the ways one's life has been a lie. In more philosophic terms, the lie has a name: the ego and with it any self-consciousness based on the belief that *rationality* and *intentionality* account for our agency and our actions. Or to state it more directly: the recognition that the ideas, ideologies and commonplace beliefs about "human nature" derived from these principles constitute a massive defense against self-knowledge.

(7) A new concept of self-knowledge replaces them. Human beings are defined by this dynamic: *we bring about our own undoing because inner division defines us. In the traumatic event that self-division assaults us.*

(8) The traumatic event thus offers the subject an authentic experience of Freud's central idea. So little of our lives ever transpires at or enters the realm of self-consciousness or intentionality. We're too busy denying our conflicts to know that fact, too busy fleeing anxiety to see it as the underlying cause behind our strident effort to attach ourselves to a world that will deliver us from it. And so our lives are organized and take form behind our backs as it were. Our belief in the ego blinds us to ourselves. For the ego is essentially a structure defined by a vigorous denial of two things: denial of our inner world and denial of everything in the real world that makes us anxious. (Which turns out to be most everything.) All the defenses and adaptations that serve to strengthen the ego and attach it firmly to the world, all self-conscious claims to know who one is and to proclaim a secure, stable self are significant primarily as signs of the depth of our blindness to the actual principles that structure our lives. We are like Oedipus and Lear, and like them we carefully craft stories about ourselves to assure that we will never know that kinship.

(9) To summarize: as human beings we are in fundamental conflict with ourselves and conspire against ourselves to bring about its own destruction. Once a traumatic event brings us to this recognition, the tragic drama has begun.

## TRAUMA AS TURNING POINT

(10) The traumatic event ushers the subject into a new world. We are assaulted by something that has broken loose within the psyche

that resists all efforts to contain it. I inflict on myself a judgment on my life. That is the lesson that the traumatic event delivers. It is my whole life and not a single, isolated event that is awry. It is what has brought me to this pass. Everything I have done has somehow led to this and the totality of my life consequently is the burden I must assume. My whole life thus passes before me under the signs of loss, guilt, and self-contempt. I suffer a depressive turning back against myself that is defined by mortification and rage. I am myself the object of both emotions. As a result I now *exist* as an agent defined by a burden: *the agon-izing of one's being within the crucible of a suffering that must be sustained.*

(11) The traumatic event thus delivers us over to the world of primary emotion, dissolving all inner distance between who we are and what we feel. Primary emotion puts us in conflict with ourselves; with no self outside the emotion and thus no way to manage or discharge it. We must, instead, live out the *agon* that the emotion creates. To put it in the most exacting terms: *we can only engage the condition of a self in conflict with itself by sustaining the self-torment that it inflicts on itself.*

(12) The absence of any inner distance between what we feel and who we are defines the ethical burden of primary emotion. Primary emotion is *the imperative to take action within myself.* In existential terms, primary emotion delivers me over to myself as *who/why*: as a being without a stable identity who exists wholly delivered over to the agon that traumatic experience has imposed on it. Psyche is the struggle within the conflicted ways I feel toward myself when I am assaulted by everything within myself that I have tried to escape. Primary emotion thus engages the human being in that self-reference that is deeper than all others: *an affective self-reference* that has as its inherent dynamic an impassioned effort to engage the burden of all the locked-up feelings that the traumatic event has torn loose in the psyche. (The above articulates a dynamic of self-reference that cannot be comprehended within a logic of essentialistic or stable self-identity.)

(13) The traumatic event existentializes us utterly. All we did prior to it constitutes an attempt to protect ourselves from existence or soften its demands. Anything we do subsequently is authentic only if it sustains and maximizes the claims that existence now places upon us. The traumatic event transforms anxiety. What before was the motive for flight has become Keats' "wakeful anguish of the soul." Anxiety is now the signal not to flee or avoid, but to attend.

Sustaining anxiety is the way one deepens the awareness of our situation; and as such the inception of the effort to act in it. Rather than the force that always led us to sacrifice ourselves, anxiety is now the knowledge of how utterly our existence is *at issue* in those inner experiences that threaten the psyche with fragmentation and self-dissolution.

(14) That is so because the traumatized subject faces a choice that can no longer be refused: that between inner deadening if one returns to the way one was before the trauma or inner transformation as an effort that must be radical, comprehensive, and unremitting in its demands.

(15) To summarize: primary emotion inaugurates a drama defined by the fundamental tragic truth. The possibility of in-depth self-knowledge and of genuine change are grounded in the most intense inner suffering.

### RECOGNITION: SUFFERING WHO ONE IS

(16) The traumatic event creates the situation that will measure our humanity. For what we now do will determine the kind of integrity and value we have as existing beings. Our projections have come home to roost. The only viable choice is to refuse them. But the only way to do so is by confronting all that one has refused to face about oneself.

(17) That is why the trauma must not be resolved. It must be deepened. Doing so is what distinguishes the tragic response to suffering from what Rilke calls "the bitter duration," the attitude of those who wait passively for unhappiness to run its course because they don't think there is anything else one can do with it. Refusing that response inaugurates the possibility of *active reversal.*

(18) That process, which defines the tragic subject, involves the attempt (a) to get to the core of one's disorder and (b) to reverse the relationship one has lived to it. That movement has a simple but unprecedented emotional beginning: it comes when *in suffering the deepest passivity—of an inner torment one would do anything to end—one experiences the upsurge of something in us that exists only through its radical opposition to that passivity.* The depth of one's abjection has become the opportunity for a transformation of the way one relates to oneself and to experience.

(19) Schematically, constituting this possibility involves internalizing three recognitions that must be sustained as suffering.

(a)   I am now locked in a fundamental conflict with myself that must be engaged against all attempts to soften or resolve it.

(b)   Doing so activates the agon at the heart of my subjectivity: the discovery that *there is something in me that seeks, even demands, my destruction* and the equally compelling discovery that *there is something in me that exists and develops only through its opposition to that power.* To put it in more abstract terms: the battle between the destructive superego and the existential self has finally been joined.

(c)   Nothing will suffice, however, but a total reversal of the condition that constitutes the structure of my inner world. Change and the possibility of change depend on engaging an agon that involves far more than thought—and goes far deeper. It depends on acting *upon* and *within* myself by meeting persecutory anxiety with existential defiance, i.e., a defiance that only earns itself through the effort to change the very ways I have felt and feel toward myself because of the power of the destructive superego in my inner constitution.

(20) The superego says no to anything that would alter its control over the psyche. It is that in us which *absolutely resists change.* We exist as tragic subjects insofar as we combat that force by engaging, in its full vehemence, the one commandment it teaches in so many different ways, the promise of winning its love being its most seductive ploy. The command: Obey me or die. That is the message that the superego rains down upon our psyche the moment we attempt a genuine break with it. That effort: *to take the action it forbids in the primary area where it is empowered.* Core conflicts, by definition, are those areas of life where the power of the superego absolutely prohibited an action we wanted to perform. The agon of tragic action within ourselves is the effort to reverse that condition. The minute we try, we discover the true force of the superego and all that we must tear out of our heart in order to overcome its reign. The only way to do so, we discover, is by reclaiming the force of a desire that persisted despite its continued defeat. This is the lesson that the core conflicts defining the psyche harbor as a gift. *Our whole life has been structured by the relationship we have adopted to our core conflicts.* We now have the key to self-knowledge. But in opening the door we confront with mortifying clarity the extent of the violation that we have done to ourselves.

## ACTIVE REVERSAL: THROUGH AGON TO CRISIS

Self-knowledge has now become something dangerous and utterly necessary. The central task after trauma is to comprehend one's entire life as a unified drama in terms of the core conflict that has structured it and the central events through which that conflict has progressed, with rigorous necessity, from its initial form to its traumatic issue. This is the story one must tell, a story that reveals the irrelevance of the other stories we incessantly tell about ourselves. Its telling, however, is but the prelude to what must issue from the telling: the effort to find a new way to *act* in the agon of one's core conflict—and thereby reverse oneself. (As we'll see, that drama also has a rigorous agonistic structure leading to what I term the *crisis*, an event analogous to the founding trauma but of far greater significance in the tragic maturation of the psyche.)

For analytic purposes, we can distinguish the effort to reconstruct the past from the drama to which that effort gives birth. Concretely, the two are parts of a single dialectical process in which often the action one finally finds the courage to take reveals the past one failed to deal with or even to remember until one's action in the present brings it rushing back as astonished memory. Knowing, however, is always but the prelude to doing. Existentially the task of tragic self-transformation is always the same: to act in a new way within the area of one's core conflict and thereby advance the effort to bring about a complete change in the structure of one's psyche.

### The structure of one's life: the past

(21) The traumatic event unearths the buried truth of the past, revealing the hidden structure of one's life as a history of conflicts deferred, displaced, denied. Such, ironically, is the process whereby things ripen to their traumatic issue. The task of memory is thus to recover one's core conflicts and comprehend the sequence of actions they have generated in giving one's life its essential structure as a necessary progression to the traumatic event which brings the underlying pattern to fulfillment as a long-delayed catastrophe. Attaining such an understanding of how one's core conflicts have structured one's life is the essential step toward living a new relationship to them. Otherwise one is destined to repetition, though often disguised in the bright colors of something new. Initially, tragic memory is the effort to trace the course of an enormous failure. Reconstruction of the truth about oneself is the tearing open of the buried secrets

that in the totality of their progression reveal the hidden history of one's heart.

(22) That history, one learns, begins in childhood. Childhood not as in a Disney movie, but as a traumatic origin defined by an inescapable event, which overturns the antipsychological assumptions on which attachment theory rests. *Parents project their conscious and unconscious conflicts into their children.* That act is the birth, or origin, of the psyche. Internalizing parental desires and conflicts creates the first self-reference: *our readiness to do anything to ourselves in order to preserve the love of our original love objects.* Our self-division is the product of this founding act.

(23) The self-division of the subject is the principle that organizes experience. The result: the attempt to fulfill incompatible demands— to remain true to the bond with the parent(s) or to become true to oneself. The first is necessarily self-destructive since it requires sacrificing everything in oneself that doesn't serve the demands of the parental program. The second can come into being, accordingly, only by overcoming the first. That battle informs the development of those experiences that matter because they engage one's core conflicts. *Experience* is what happens when the core conflict is *primed* by the emergence of something that challenges or threatens to shatter the dominance of the destructive principle. As Freud knew, the history of the psyche is the history of its loves; or more precisely, the history of how the conflicts of one's first love lives on in the loves through which one attempts to repeat it, replace it, or do both simultaneously and thereby heal the wound at the heart of one's psyche. Such are the various ways whereby failure—the impossibility of satisfying opposed imperatives—brings us to the traumatic event.

(24) One may successfully forestall it for a long time—often indeed for a lifetime, through avoidance, compromise and the various substitute formations that make up neurotic living—but its necessity is assured in principle. For the psyche is defined by a knot at its center. One has invested the deepest sources of one's being in the tie to a relationship that is destructive of one's own spontaneity and autonomy.

(25) The traumatic event is the best outcome because it foregrounds the self-destructiveness at the center of one's life as no longer tolerable. In it, the course of one's experience completes the downward path in a way that makes reversal both possible and necessary. Any action one takes after the traumatic event is legitimate only insofar as it strives to sever the destructive bond. Traumatic memory has revealed the past

in its truth. The past is all that one refused to feel and therefore failed to do. There is another name, accordingly, for the past recaptured: *memory*—that which opens one to the future in the effort to find a new way *to act* in what one now knows are the core conflicts that define one's being.

## The structure of one's life: the future

(26) Traumatic breakdown is not the end of the tragic process but its true beginning. The tragic is not about destruction, self-waste, or meaningless suffering. It's about *the logic of self-mediation* that a subject exerts upon itself within the crucible of suffering.

(27) The traumatic event brings to fruition one's inability to overcome the destructive force. That recognition begets the need for a total responsibility: the complete reversal of that condition. Each of us creates a trauma that is ours alone. For we each hollow out an area of human experience into which we pour all our disorders and discontents. After the traumatic event, however, there is only one course open to us. It follows an inexorable agonistic logic. Either inner death or the struggle to *act* in a new way within the register of our core conflicts.

(28) The fundamental truth now reveals the other side or dynamic of its dialectic. *Action is the being of the subject.* The self or psyche is conflict and nothing but conflict. We are from the beginning caught in the toils of an immanent process from which there is no exit. We aren't guaranteed an identity in the order of mind or reason, nor are we given the comfort of simply adapting ourselves to the prevailing social winds. We *are* what we *do* in mediating the conflicts that define us. Aristotle got this one right. Character is action. *Who* we are is a result of what we do in those situations that engage the conflicts that define us. There has never been any escape from this fact. After the traumatic event, however, we know our task is to reverse the relationship we have lived to ourselves.

(29) Thanks to the traumatic event, action is now raised to a new level, defined by a new relationship of the subject to itself. We have always lived under the shadow and dictates of the other. The way we feel toward ourselves has been defined by that fact. But after the traumatic event one lives *infected* by it. One suffers a clash of primary emotions that flood a psyche bereft of defenses. Anything one now does bears on and must attempt to mediate this condition. One is now, in effect, in the situation that defined Hamlet. *Inner action* is now the attempt to effect a radical change in the order of one's feelings

toward the self-division that defines one's psyche. *External action* is the attempt to see if one can sustain that effort through a concrete project that will embody a new relationship to one's core conflicts. This effort is full of surprises and the collapse of many a project that seemed certain of achievement when it was simply a matter of imagining all the things one can do by simply asserting one's will and desires. Action reveals the true coefficient of adversity—the barriers one discovers in oneself when one tries to turn one's fantasies and projects into deeds.

(30) But for all its fits and starts, false leads and blind alleys, action now has a clear logic and direction. Any action is legitimate only insofar as it attempts to break with the destructive force. Each effort to do so, however, necessarily unleashes an inner assault. A new form of drama ensues. Each action that furthers its development makes the self-division of the subject more intense. This is the test one suffers at each step of the tragic process. A subject who concretely sustains its opposition to the destructive superego gives birth to a progressively more complex series of actions that move with necessity to the one action that must be taken. It comes when one attempts *to take the action that would sever the very source of the bond that the superego insists cannot be broken.* Once that happens the tragic subject has moved from trauma to crisis.

## THE CRISIS: THE DRAMATISTIC LOGIC OF CHANGE

(31) The traumatic event is the moment of *inevitability* in the structure of experience. Crisis is the moment of *irreversibility*.

(32) The crisis arrives when one attempts to take the action that would sever the superego's power. That action activates in reply the most virulent expression of that power. The fate of the psyche lies in the balance, in a struggle to the death. The crisis is the essential moment in the tragic maturation of the psyche because it brings forth the truth of the superego by activating a threat to the underlying condition from which its power derives. As Freud knew, "nothing can be slain in absentia or in effigy." That is why to overcome the superego one must first discover the truth of it. That truth can be stated thus: *The superego is an erotic bond that has become a self-punitive one.*

(33) The only cure, accordingly, is the investing of one's being in a love that will prove stronger than one's bond with the superego. Let me draw out the implications of this proposition. For the crisis to occur one must love something or someone that violates the

fundamental commandment or demand of the superego. And one must be willing to stake one's life on this love; or what amounts to the same thing, suffer that loss that is greater than the loss of one's life if one fails. Failure here will entail a loss from which one will never recover. Success, in turn, will depend on no less than deracinating the superego by annihilating one's deepest investments in it. We have reached the heart of the tragic, the fundamental condition from which it derives. *Tragic action* is the attempt to free oneself from something in oneself that one has valued more than oneself. Out of our love for our parents we have internalized their desires, conflicts and prohibitions so deeply that they have become ours. And yet the only way we can live free of them is by finding a solution that they failed to find and forbid our pursuing.

(34) Getting to the point where one engages this issue is the logic behind the sequence of actions that constitute success precisely because they bring one to the crisis. It also has a precise definition: it is the mirror image of the traumatic event. Whereas the trauma was the event that resulted from serving the demands of the destructive superego, the crisis is the result of the attempt within the area of one's core conflicts to take the actions that it forbids. Talking about crisis in these terms, however, is a pale reflection in the medium of concepts of what that event unleashes within the psyche. For it is there, in the medium and agon of primary emotions, that the real action takes place.

(35) Crisis activates a murderous attack of the superego on the subject's very ability to go on being. Resistance requires an equally violent effort on the part of the subject to defy and then destroy that power. To put it in more concrete terms, the crisis comes when a subject feels the force of inner death waging a direct assault on the psyche itself; when *thanatos* presses down on one's being in an inner torment that threatens psychic fragmentation and self-dissolution. It is in the teeth of that assault that a defiance must be sustained, no matter how much suffering it brings down upon the psyche. The tragic measure of us is our ability to sustain this situation and find a way to act on ourselves within it. For once this battle is joined one *exists* wholly within the crucible of *primary emotions with nothing left to interfere with that process, no matter where it leads*. All the defenses and operations that protect the psyche have been cleared away. The battle to the death has begun.

(36) The crisis is defined by the possibility of that loss that would be deeper than all others: the loss of the relationship more important

than one's life—that which gives it value. Such must be the depth of our investment in the object of our love if love is to engage the possibility of curing us of our malady rather than being, as it is in most cases, the rat's nest we crawl into for mutual safety. To actualize the possibility it engages, however, our love must prove stronger than what one now experiences, in its pure vindictiveness, as the force of the destructive other in one's psyche. All previous experience has revealed one thing: the bond that ties us to this force is deeper in us than anything else—deeper than we are to ourselves. Change is thus the requirement for a reversal in which one must tear one's heart free from its deepest internalizations and identifications. Many internalizations require modification, but some must be destroyed. Yet nothing dies without putting up the cumulative fury of a final fight. Once experience moves within this register, the condition of radical change in the psyche is finally joined. That condition is the clash of primary emotions warring on one another *in an agon that takes place at the core of the self-division that defines the subject.* That's what Sethe goes through once she and Beloved find themselves alone together in a room they cannot leave; what Lear goes through in his madness; what Hamlet's suffering raises to the level of a self-consciousness; what Oedipus knows at the moment he blinds himself; and what the four members of the Tyrone family live through during their long day's journey into night.

(37) The kind of change I'm trying to describe here is radically different from all others. Change here is the effort to act within and upon oneself by engaging one's being in a process that *pits one primary emotional self-reference against another.* The depth of one's tie to the destructive superego wars against the depth of one's attempt to existentialize oneself by freeing oneself from it. The crisis arrives when everything else has been cleared away, when all half-measures and defenses have been eradicated. This is the situation to which all great tragic dramas move. Freud was fond of saying that in any conflict the stronger emotion wins. That is precisely what is here at stake in the deepest experience we will ever have of what it means to be an emotional being. As Rilke said, "you want the change, embrace the flame." Because a tragic logic structures the psyche, that is the necessity that rules in us. We must suffer the full weight of all that we've been in the agony of the effort to become something new.

(38) To summarize in more formulaic terms, crisis is an effort, in the white heat of primary emotion, to effect the following condition: *where destructive superego was, deracinating subjectivity must come to be.*

The rest of one's life can now be given over to that effort and all that it opens up in us as we ripen to it.

Most people, of course, congratulate themselves in proclaiming that the structure discussed in this chapter has nothing to do with their lives. They are happy to feel that their life has no discernible structure other than an ad hoc pragmatism—the ability to maintain their ego-identity by adapting themselves to the many roles they must play as they flow with the flow of things. Indeed, most people will readily confess that they don't have the slightest idea what their "core conflicts" might be, as if their celebration of this great gap in consciousness were an argument against the theory outlined here rather than its most trivial confirmation. What they thereby save themselves from is the knowledge that avoidance and denial are, sadly, the way they participate in the tragic, protected by their defenses and the bright shining surface of their lives from their one chance to attain the knowledge most worth having. Tragic change is the effort to unlock the sleeping beauty in us. It is the call of that which is existential in us and which, accordingly, can only come into being through the true and concrete labor of the negative: the effort to know oneself in depth and the courage to undertake the actions that such knowledge mandates.

### EPILOGUE: TOWARD A PSYCHOANALYTIC POLITICS

One purpose of the foregoing discussion is to pose a question for politics. Can nations, like individuals, have tragic histories? Can the tragic be the reality they keep trying to deny in the only way they can: by projecting their inner conflicts onto other nations, evacuating through aggression what they refuse to face? And to bring it all home: Is the only end to this process global apocalyptic aggression? Or is it possible that a traumatic event can force a nation to confront the repressed and festering condition beneath the ideological glitter of official, hagiographic histories? Can a traumatic event give birth to a counter-movement that might prevail against all the forces that would silence it? Can authentic historical knowledge bring about recognition and reversal? To speak in more practical terms, what kind of *revolution* in the social fabric will such knowledge require? What dearly held beliefs and practices of the sort we've examined in previous chapters (including ones to which the left is deeply committed) must be deracinated if the new direction required is not to be foredoomed to a repetition of the same old story?

Marx set the true agenda for a radical politics when he said something that most on the left have found it convenient to forget. "To be radical is to go to the roots. But the root is man himself." This statement obviously does not for Marx signal the collapse of political thought in bourgeois psychologism. It points, rather, to the *mediation* of the depth-psychological and the sociopolitical that we must recover if we are to understand contemporary history. The banishment of psychoanalytic categories in favor of more scientistic and rationalistic ones has merely left us unable to understand Bush and the forces he represents. Marx's statement identifies the synthesis that will alone give us the concrete universal: the most radical psychoanalytic knowledge as the way to pry open the truth of the social, economic and political orders.

The questions raised above identify the historical condition that defines America today. A tragic denial creeps on apace toward ever more deadly realizations. To resist it we must understand it from the inside. That is why an understanding of *the structure of tragic experience* is what the left needs most today if it would overcome its own resistance to knowing both the situation we face and "what is to be done."

The tragic is the highest form of artistic cognition, the deepest probing of the darkest truths of the human heart or psyche and of history. Aesthetic education is political education in the deepest sense because it is the deracination of everything in us that blinds us to our historical situation. That is why the deracination practiced in radical theatre attempts is the same deracination that must be effected in the sociopolitical order. Or, to revert to the confused and ideologically contentious situation that gave birth to this book, theatre isn't the popular prop that presents pre-existing political dogmas and programs in a way that makes them palatable to a mass audience. Theatre is, rather, the very beginning and heart of political engagement; the attempt to cleanse the doors of perception by taking the psyche into the heart of its own individual and collective darkness in order to perform there the truly radical act: the destruction of every ideological illusion and phoney emotional comfort in order to maximize a suffering that must be sustained because it is the very force and flame of radical change. The final two chapters dramatize instances of that process.

# 7

# An Evening with JonBenét Ramsey[1]

TIME: 2025

PLACE: A room

AT RISE: Voices heard in the dark, continuing as light comes up on the face of a woman seated center stage, reading a book, which drops to her lap as the pressure of inner voices builds.

MOTHER'S VOICE   No no no no no no no No. You're getting it all wrong. Again. From the top. (*Sings following line*) "I want to be a cowboy's sweetheart, I—"

GRANDMOTHER'S VOICE   Sing out, JonBenét, sing out! You want to be Miss America someday it begins here missy.

FATHER'S VOICE   That's what you are baby, Daddy's girl.

GRANDMOTHER'S VOICE   Oh, law, she carries her body like a sack of wood. Keep going, nobody told you to stop.

FATHER'S VOICE   You don't have to tell me it hurts. It has to hurt for a while.

MOTHER'S VOICE   Speak up! What have you got to say for yourself? Nothing. Good. Here's what nothing gets you. (*Loud noise of slap. As light comes up on stage brief image of child being strangled by mother projected as shadow on back wall.*)

(Light now full on the young woman seated center stage. Next to her a side table with lamp: on table her purse, an ashtray, cigarettes, bottled water, a glass. She is JonBenét Ramsey, age 35, smartly dressed in a grey business-like suit. Hair short and brushed back. Glasses. The light that rises on her must appear to come directly from the audience and should be played in a way that suggests she is under an increasingly intense spotlight of curiosity and interrogation. She reaches for cigarette but begins speaking before lighting it. Her speech moves in two directions. The fourth wall is broken often in direct addresses to the audience—and often to particular individuals in the audience—directly, anticipating their unvoiced questions. At other times she enters the privacy of an inner consciousness in which she speaks only to herself.)

—I read most of the night. When it's cold and dark and silent. That's when its best. Time slowed to the hush in the heart. Nothing but

the little light behind my head and the page. Nothing to distract me from the only thing that's ever mattered.

You see—after—I have to be alone after. That's the kind of thing you want to know about, isn't it? No, I was never without someone—when I wanted. But I always made them leave—after. To be alone and read, with the night like a solitude all around you. I know. I know. It's so trite. When I was emptied out, then words came alive. But it wasn't like that. It's the distractions. They're everywhere. But late at night they fade away. Words too crumble away til there's nothing left but this, (*tapping forehead, a gesture repeated often*) alone, seeking the single sentence. A sentence where everything stops. To read—for me that's always been the most violent act.

Okay, okay I lied. Sometimes they stayed, slept the night. It's too much trouble otherwise. You never know what someone will think he's entitled to because you fucked him. Well 3 a.m. scenes aren't my style. Better to be alone together.

Yes you bet goddamn right the reading was often best then. To know I hadn't been touched. Beside me one of the biologically blessed—a body at peace, dumb. I beside it more awake than ever—in my body, a body alert, alive to its own knowledge. (*Brief nervous laugh*) You bet, give me a good book and I'm your perfect partner for the comedy of the morning after. You know, the one where kindness is the language of evasion. Hell yes a good read and I'll say whatever you need to hear as complement to your fucking.

(Holds throat, effort to catch breath before continuing: this action to occur at other times during monologue)

I'm sorry. I couldn't breathe there for a minute. Hot black coffee, cigarettes, a book, and night folded in on itself. To lie there like that and come upon a sentence that bites into you like a judgment—that's what reading is.

Yes sometimes yes when I found nothing but words then yes it all gave way to nights of a different kind, when the whole thing circled in on itself in a vertigo. Only I was falling in words, out of myself, away from myself, reading the trap I threw myself into with greater effort page after empty page.

(Pause)

It was one of those times when there was nothing but what you call anxiety. When anxiety drew a curtain between me and the world. I'd wake in a panic. Consciousness was nothing but images flashing,

voices I couldn't silence, feelings broken loose inside me. And the craziest thing, with all this going on *I functioned*. I went to work and had long conversations in which I didn't hear a single word, afraid that any moment it would all tumble out and the only thing left when they came to get me would be a weeping I could no longer stop. That's how I lived—for months—in a general insurrection that could only end with one thing: the extinction of *this*. (*Taps forehead*)

You talk about a death drive. Death for me was then a pressure lived in the nerves. And something else—finally: an uncanny pleasure. "They don't see it," I said, "any of it. I can go on like this, indefinitely." The whole arrangement—what you call the world—it requires so slight an investment. Master a few moves, words, gestures and you're free. For this. (*Taps forehead*) For what beats here. Every waking moment can be given to it. No need to stop. Nothing out there to get in the way.

That's how far I'd gone—that time. Only one thing held me back. Every day, after work, I'd go to the University Library, to the stacks where they keep the psychology books. I'd walk among them, touch them, whisper the titles. "One. One holds the key. Tonight." Because there was a wager here too, a pact. I could take only one book. Each day. And I had to read it—all of it—that night.

That's how I found it. The sentence. I don't remember the name of the book—a collection of essays by an analyst named Bion. I'm a lousy scholar. Never time to get anything in order. So what I do is write down sentences on scraps of paper. I keep them with me here.

(Opens purse and takes out a few from among many crumpled pages. She holds these pages gently, touching them with love, opening one with care, which she then reads.)

"*Inquiry begins when love is doubted.*" Some sentences, Christ, you read them and know your life will never be the same. That someone could know that. Write a sentence like that. That others could come together in little rooms dedicated to the violence of it. That some day, maybe...I too could be a... The book fell away. Something broke inside me.

I remember everything about that night. The acrid smell of the room; the slant of light; the heft of it, the book; the chill in my fingers, and the hot feeling here. (*Indicating chest*). I lay there with my eyes shut tight so I could feel the words detach themselves and hang above me, the letters like stencils carved in the ceiling. I lay there like that as dark turned to dawn. It was only when I felt the light on my

eyelids that I realized I was crying—the tears gentle and warm down my face. I held myself tight then because then I was afraid I couldn't stop. "They'll find me like this, here...beyond reclaiming." And so I rocked myself and wrestled it down. But I remember—I'll never forget it—my face in the mirror when I was finally able to get up. You know how sometimes you catch your face—your real face—when you've forgotten to compose it before you look. My face: it was all on fire. My eyes—they're green—but then they were like emeralds. The points of my hair—where it rats out in the night—were all ablaze with sparks of light. And my mouth, it was open in a big O, with my hand holding it, like this, almost caressing it.

Then, before the mirror (*shifting into mother's voice*)—"Makeup first, JonBenét, before anything else"—it faded. My face faded. But I could see it still receding and then the hot tears broke in me again and I felt it—Joy in me—that I'd found it, finally, something I could love. Something I want.

(Pause)

Do you have any idea how terrifying it is for me to want anything?

(Pause. Removes makeup from purse which she will use to put on her face during what follows.)

I wore my face at school one day. Eighth grade: Patsy'd transferred me to a Catholic school. Gotten it into her head the nuns were the finishing touch I needed. Eighth grade. Remember: when every boy at his desk rides a hard-on and every girl fidgets in a confused anticipation.

Morning recess. I hide in a stall then sit before the mirror. I rat my hair then pencil the eyebrows so that they slant...like this. Then darken them all around with eye shadow and color my lips the richest red and full...like this. Last I hollow the cheeks. This is the hardest part, to get it just right, the shadows that give it that hungry look they love.

I already had my costume on. All I had to do was pull the skirt a little higher under the belt and tighten it. For myself alone: I'd worn the garter belt and now I draw the nylons up slow, waiting for that moment when I feel them together: where the nylon ends cool, flesh begins warm. I linger touching my inner thighs. Then smooth down the skirt and sit. Like this. Until I'm ready.

Back in class I walk to my desk with my head down, my fingers scratching at my scalp, and bury my face in a book. Only when

I'm ready, then I look up. At Sister Inez. She gives no sign at first. Just a blank look like something interrupted her train of thought for a moment but now she's flicked it off, the way you brush off a mosquito. I almost cry then. But then I see the change. The blank look was just the shock of it. Because now she gets that tight smile in the lips and that fixed look in the eyes that comes whenever she lectures us on her subjects—and you'll like this, this happens all the time—about nuns being Christ's bride, the body a "temple of the holy ghost," Saint Juliana "virgin and martyr" and all the others we pray to daily, who embraced death to save their virginity. The eyes are slits now, boring into me. The fingers snap, summoning me forward. We stand before them, facing each other. I wait for the slap I can already feel sharp and hot on my face. I wait proud but it doesn't come. "Face the class," she commands, turning me around at the shoulders. A hush. No one moves. I can see it in their faces. They're spellbound. The whole year has been building toward this and they know it.

Her voice, I hear it still, rising in pitch, almost remember them exactly, the words. "See what I mean. Can't wait, can you? To be like this..." Then, to me. "Think I wouldn't find out. That you've been sneaking around in cars with high school boys. Puffing yourself up so big, don't you, that now you dare flaunt it here, in my face." She stopped. I don't know what she expected. Tears. Some broken plea. A struggle to escape. 'Cause I could feel it now, her fingers pressing down here (*touches collarbone and neck*) turning me back to her. I got to hand it to her though, she had a sense of theatre. It was like she was positioning me so I wouldn't upstage myself, so we'd be face to face in profile before them. But the hands wouldn't obey. I could feel them tightening, moving up, toward my throat. But there was still pride in me—and something else. This was the moment I'd been waiting for too. So I held my pose and milked the pause. Then I did it. Slow, deliberate, defiant and proud—I smiled. I looked her right in the eyes—and smiled.

There was something different in them too now, something I'd never seen before. A panic, like an animal caught in the headlights of a car at night. Then outrage. I felt it, her fingers at my cheeks, then sharp and deep as they raked down the length of my face—

(Holds fingers forward toward audience and mimics cat-claw scratch during previous line.)

—and with it a sound, a keening at first then a long howl like a fire-engine across the night.

You know how a cat scratch at first all you see is the long thin line of the cut, clear, abrupt, and clean. Then how little spots of blood pop up, isolated, before they come together and flow. That's what it must have been like to them. There was a long still moment lifted out of time and held there pure so they could look at the long lines cut down my face. Then it all ran together and I saw it, the blood in drops hitting the wooden floor. No one moved. None of those wanton boys, who bragged all the time about how tough they were, their pants chafing, whimpered a single word. Not even when I started to shake all over.

(Pause. Takes drink of water.)

Ah, the poor thing, you'll say, never to have known anything different. Never to have known love when it's innocent and tender, when trust leads two people down each tentative step as their bodies bloom together. Well, that's where you're wrong. There was a boy. Once. He was different. It was different with him. Like an island with him. The first time we talked, at a school picnic, the thing I'll never forget, that I'll always treasure, he acted like there was nothing different about me. We sat together under a great elm and just talked, that golden afternoon, about books, music, our plans for college, and the great leap toward freedom that haloed that word. And I remember that night lying awake in bed—after—thinking how easy it would be to slide into your world, to Lethe myself on the lotus of his tenderness. Because he was gentle. He tried to be gentle. There was nothing unkind about him. I could see that, even if he couldn't. Men can't you know, especially when they're young. There was a tenderness in the way he was with me. Everything was slow, like a warm bath easing me into him. And so when we finally made love it was...it felt to me...like the first time. I trusted him—the way trust is when something in you goes out into the other person, something you know you can never call back. Yes, I loved...loved him. And so I told him, as much as I could, about Patsy and John.... No, he didn't. He held me and I was even able to cry for a while. No, nothing was different at first. I'm sorry, that's not true. I could feel it already, something different in the way he touched me. The tenderness had turned into a kind of sadness. When he touched me now it was like he was witnessing, testifying to some generalized sympathy for life's victims. My body had become something about himself he needed

to prove as much as the other boys had to prove how cruel they could be…. No of course there was no way I could get him to talk about it. We were kids. Briefly, in our confusion, we made a haven that turned into a prison. For me, for me it was like his fingers were choking me—inside—cutting off everything in here (*moves hands on body from breast downward*) that could breathe and flow outward toward him. Until it got so that I wanted to run screaming or rake my hands across his face: "Fuck me, fuck me for christsake, here like this let me get on top and ride myself down into you." That's how it ended. I protected him from himself. His hand never took back from my flesh the change in it. He felt what he needed to feel. I felt his need free me back into mine.

(Pause. Lights cigarette. Deep drag before continuing.)

The mind is a razor—it cuts sharp and deep and final. There's a world within the world. Mind ripens there, feeding on touch. The only language is touch: and touch betrays us—into what we dare not know and can't forget. But *you* don't want to hear about that, do you? You want the affairs—my "sex-history" as you call it. A quick rut through college and its humiliations. Then the grand tour—my adventures with the country club set, an adultery or two thrown in to whet your appetite for the image you long for, me pinioned on the deck of some yacht, writhing backward, part of the new crop of international whores. Or, better, this: a last look at my bloated body, the face pasty and colorless, as they wheel me out to final curtain.

(She stops abruptly, confused. Eyes dart about as if she doesn't know where she is. Struggles for breath. Then begins again. Moves skirt up slightly above knee in what follows.)

Or what if I show them to you, the cuts here (*indicating arms*) and here (*inside shoulder, just above breast*) or if I slide the skirt to the thigh so you can see the ones there—a savage hieroglyphic, written on the body, the fine scars a razor carves into flesh to memorize an impossible awareness. Isn't that what you want—to hear how we cut ourselves? How it takes a world of wounds to seal over what bleeds here (*tapping forehead*) yet must remain unspoken? That's what you want, isn't it? Victims, in a long queue, Coriolanus'd, a pageant competing for the milk of human kindness you can't wait to offer—as long as we come to you empty and broken.

(Smoothes down skirt.)

Sorry. I have none. (*Tapping forehead*) For me it all goes here. Here that the real cuts are made.

I'm sorry. I know this isn't what you want. It can't be. You want to know about love. What we learn from our experiences—even the worst. Okay, what if I told you I learned how little there is to learn. And how far we all go to deny that knowledge. About all the times I told myself—like you?—"this, this will be different, he won't be like the others..." Only to say soon "this...now I will have done this... gone through this...now this won't eat on me anymore..."

You see I've been on stage since I was five and learned early about roles and audiences, how perfectly suited they are to each other. And so it didn't take me long to learn that to "fall in love" there's only one condition that must be met—but its an absolute one. You have to find someone whose disorder matches yours. That's love—perfect symmetry. (*Snaps fingers*) CLICK.

(At the snap of her fingers she points to an imaginary screen that is lit by bright lights cast on the back wall of the upper stage. She steps to its side and delivers what follows as if she is giving an imaginary lecture complete with slides that are projected on a screen behind her. The screen, however, remains blank.)

Click. The narcissist aloof in his superiority. You know them, ladies, the strong, silent ones, whose recognition is sought but never gained. What a challenge! He's never found that one special woman who'll give him the courage to express his inner feelings. There must be treasures buried there, waiting to bloom at the touch of a real woman's love. What a victory: to be the one he opens himself to. To be there the day it all blossoms in the full flower of its emptiness.

Not to your taste? How's this? Click. The romantic, drunk with the need to draw you into the whirl of his self-destruction. What drama!— to be the latest in the long line of the seduced and abandoned. Center-stage at last, free to play the hysteric to his exits and entrances, then savor the delights of your abjection. What poetry!

Or this? Click. The man we start to talk about in our thirties— don't we, ladies?—the kind, tender, sensitive men. They're out there waiting—for you. For someone just like you. A real woman. Different from all the others. And now that you've finally found each other you can wash away all the bad experiences. Because you're ready to learn what real acting is: as you discover the little murders he must enact daily to hide his failure to be the kind of man he secretly admires. The one who gets to fuck the bad girl's brains out. Who you must never be. Remember, that's all in the past, ladies. Your little secret.

Your role—and damn right you better play it to chilly perfection in the sack—is to be the good girl whose job is to keep his little allegory of love insulated from reality.

Click. Click. Click. I was a true catholic in my loving. I visited all the nostalgias. These just a few hits from a life lived among shadows. Love: the extent to which we'll go to convince ourselves that we exist. That in our romantic life we're creatures of passion and not puppets aping predetermined roles in comedies we repeat incessantly—as if all of this had anything to do with love.

(Pause. Returns to chair. Sits. Appears momentarily lost in thought.)

A wolf caught in a trap will gnaw off its own leg in order to be free. They travel the greatest distances—alone, in a world of ice and snow, then kill—at the throat—in a necessity free of pity. You can never tame them. Sometimes they will come close and look at us but every motion is always approach and backing away. The paws poised above the earth tentative, already redolent with withdrawal; the limbs on guard, flexed, but never in flight—in freedom free. And when you look in their eyes you know it: that what they see they never forget. Their eyes look straight through us. And what they see becomes a ruthless will: to raise one's voice in the torchlight of dusk and dawn, to summon, if only oneself, for the insistent plunge beyond all why and what for.

You want to talk about love? Okay. Love, like a knife, rends the curtain. The roles collapse. The stage is bare. The words empty. The only language is touch—and touch betrays us. Something happened to me before I could develop what you call defenses and so I live a sort of peril in a world defined by touch. That screen of indifference you interpose between yourself and the world—you know, that contact barrier that gets you through the day. I've never been able to build one. You inhabit the world. I live in the world within the world. A world where everything is touching—and where touch never lies.

You see a dog chained, all fang, leaping forth and torn back, at the neck; then leaping again in renewed fury to attack what is always behind it, at its throat, wrenching it back, the noose tightening. You see it—as I saw it yesterday. On TV. At the start of a commercial for—for god knows what. You see it and you feel—what? Fear? Pity? Or the brief stirring between your legs of an insatiable cruelty? You see...feel...may even form a concept, a fleeting protest. Then the whole thing dies within you and you move on.

I see nothing. A suffering erupts in me and I have no way to stop it. That dog's violation and its dumb terror becomes mine. It enters me and rushes down to wed with all the other images waiting to receive it—here (*indicating womb*)—in the place where touch never dies.

(During what follows the lights come up in the house so that the audience members become aware of one another.)

Men, the long line, saying you love me while your hand at my breast is like fingers at my throat draining life from me. Your hand, it speaks your fear, your loathing, your need to take possession of a trophy or coerce a testimony to deny something about yourself that you know is true. Touch: all the ways we ooze betrayal. Touch: what the body knows and must sustain—or die. The way you touch me tells me everything. What I am for you. Who you are. Everything we invent words in a vain effort to conceal. Touch knows. It is the future in the instant.

My body's the seismograph of your self-deceit. And you wanna know something, fellas, it's not really a subtle science. To know when your tongue in my mouth is like a bullet in my brain. When your cock is a battering ram and how you loved it when I was tight and dry, like a virgin, submitted to the conqueror's right. My cry—of pain goddammit—the turn-on you need. Or when your mouth smells and pecks at me in the brief affirmation of my sex—oh yeh you guys love to eat pussy allright—the prelude, I can feel it already, my head forced down so I can suck long on my self-abasement. Or your eyes, invading me, spying me out, waiting for it, my face abandoned to you in that look you love (*she here mimics the commodified look of the woman in rapture*), a face in surrender to your "O baby let me masturbate you. I love to see your face when you cum"—your fingers like sandpaper rubbing at my soul.

Yes, but while I complied with your need, my soul took in knowledge. Not just of you. But the bitterest knowledge: that how we are touched becomes the way we touch ourselves. And that this is how the soul dies—

Dies into lust—the battle to deliver the wound that goes to the quick. Whattya think, ladies? They're big boys now, should we let them in on the secret? How there's always triumph from below. How a woman can make her body a corpse that kills. Or how a sharp twist and a howling in the hips can unman as surely as this deft reply to a casual but insistent question, "How good was it?—I'd give it about a B-minus." Better yet the quick trip right after to the bathroom. To

wash. Followed by the stupor sleep that ends all conversation save the one that plays on as he sits and smokes alone…. Remember that strange satisfaction the first night he couldn't get it up? And all the ways you found to sustain what became "the problem" so you could watch confusion, frustration, then despair churn in him til he grabbed his cock, shook it like a sausage, and sweated it into a brief stand? Or the times you told him "I'm not in the mood tonight, but you can if you want. It's like a mashed potato anyway, after the first push or two." Better yet the "please, please wait, I'm almost there. No, not like that. I told you, if you just wouldn't move like that when I'm almost there…. Try again? I can't. You know that. Not tonight."

Take your pick. All roads lead to the crowning moment when he's high above you, pounding away, and you can hear it, the words, shouted or in the silence, the "here bitch, I'll give it to you, the way you want it, you bitches all got some alley cat in you." The ceremony of the dead attained at last, bone to bone, socketed together, up and down, two hollowed out skulls, rubbing away at each other.

All that I was prepared to learn, given my upbringing, but nothing prepared me for what I learned when I tried—Christ how I tried, believe me, tried, to make it work, to embrace the great institution of marriage and say yes, if this is all there is then yes we can build a haven and nurture one another, slowly, carefully—only to find the worst: to feel touch die into normalcy and normalcy into contentment. It was then that I thought I was truly mad—suffocating in an unspeakable cruelty.

(Pause. Long stare at audience before continuing.)

I know, I know, this isn't what you want, not the history you envisioned for me. You want me all dolled up in the latest symptoms—the affectless stare, the deadened body drooping like this, the head hanging lifeless, walking the dull round of its drift toward death. And on the inner screen too a sleepwalker moving like lead across a blank stage where nothing remains, no memory, except at times some after-image already fading then banished by an incessant flight from knowledge. As if I too must conform to the one belief that defines your world. Well, I tried. Believe me. Tried. But for me it never worked. Memory always stayed alive, avid—as image.

I remember in high school. I'd lie awake—after—rigid but my mind racing, unable to halt the rush of images that projected themselves on the ceiling above me like pictures on a screen, a home movie superimposed on the idiot wallpaper Patsy'd chosen for my room—a

collage of Disneyfied monkeys, ducks, and mice grinning. It was like I was exploding out onto the ceiling, thrown from myself then coming back at myself in a whirl of images. But then as dark shifted to shadow and became dawn I'd slow it down until there was a single image, a snapshot preserved, refined, and stored here (*tapping head*) as a tablet against forgetting.

Oh I know the desire to forget, to shut down what beats here. (*Tapping forehead*) I tried, too—like you?—believe me I tried, to find my way to a deadened body and a life devoid of emotion. But I couldn't. Rage always supervened. And I knew that if I lost it, the rage, I'd lose myself. There'd be no me to open my hand in solidarity to all the others—like me—but broken by experiences I must believe were a thousand times worse than mine. Yes okay yes the fear that if I ever lose it…the rage…if this (*Tapping forehead*) ever stops, then I truly will go mad. So okay yes I choose it: choose to remain without the thing I never had a chance to develop—a nice tight system of defenses. Choose it: to be no more than one whom experience enters utterly— my body its permanent record. For me memory can have nothing to do with forgetting—with bleaching things out and working them through. I am memory come alive—as act.

I'm sorry. You want events—don't you?—to round the story off to a fitting close. Me on the hook perhaps: "How better express her hatred of men." Or in porn: "Look, look what she turned fucking into!" pure gymnastics; the geometry of safety, the body like a piston, the face expressionless, stiffening your prick's itch for the shower of cum to anoint me with your disgust. Okay. Okay. No more Sally Rand. The feathers drop away. I stand before you—the woman–child—in that pose you dote on. You know the one. Picasso invented it, Hefner perfected it. The buttocks full now and thrust out toward you, two orbs, plump and inviting. The shoulder turned so you can see the other at the same time—the left breast ripe, riding high, the nipple erect, waiting for the diddle of your thumb. The head spun around atop the body, holding itself there in that dumb, insipid look you can't get enough of: the idiot grin that says come, fuck me, any way you want me, I live just to please you. Okay. Picture this. The statue comes to life and turns on its axis so that at last she faces you. Courbet was a rank amateur. Finally. You get to see it. What you long for. A grown woman with the cunt of a little girl, shaven, open for your inspection so you can gape as long as you want—at the image of your fascination, your horror, your obscure object of desire. Daddy was a true Cartesian—all he wanted was a little knowledge.

(Lights in house that have been on, making the audience visible to one another now go out again. Lights on stage dim—isolating JonBenét, who stares out at audience.)

And you. What of you? 'Cause it's all theatre, isn't it? Health, identity, the bonds of love? I should know, I've been on stage since I was four. Oh, I know the great spirit of renewal that reigns here. The remarkable cures fashioned on this little O. The pity and fear you so readily extend. Your courage. Your desire to confront essential things. No violent emotion you won't applaud, no horror you won't bless—as long as it all leaves you purged when you leave, identity and world restored, "calm of mind, all passion spent." I know. But I know something else: what a life under the bright lights taught me. That the art of acting begins on the other side of all that. And it's really simple—the art of acting. It can be condensed into an aphorism. *Something must break within you with each line.* Because acting was shoved down my throat I had only one choice. To make it a portal of discovery. To take every role you offer me and find its hollowness. And then to play it—from here (*touches heart*)—so that you can feel it too. If you want to. But for that to happen, something in you too must break within with each line.

Everything you desire is visible to you here, save the one thing you can't see. Except when something I do arrests you for a moment and your world totters. That's when I get to look—for a change—and see dread in your eyes, as we meet, briefly, in that place inside you that you never visit, that stage where all roles dissolve, for they are nothing but dry straw (*snaps fingers*) consumed in an instant by what beats here. (*Tapping head*)

(Pause. Deep inside herself. All lights now out but one on her face, a light that seems to be boring into her. Then speaks, at first as if utterly alone.)

In the dream it always happens after I've lived a long and honorable life. That's when they come to get me. The evidence has finally been unearthed, the body. I am a murderer and yes of course the victim is always someone young, someone horribly violated. I buried the body in a field...deep...where no one could find it. But now they've dug it up and everyone knows.

The terrible thing about this dream: there's nothing surreal, dream-like about it. This is not a vivid dream. The authorities who come to get me are ordinary in every way. The scene is blank. White. Fading. All I see now is myself in a room alone awaiting an interrogation

that has already taken place, begging the same empty room with a plea that I know has already been rejected, unheard.

What's terrible about this dream is its lack of color. It has the absolute certainty of fact. And that knowledge is so unassailable that whenever the dream happens I spend the next day trying to convince myself it isn't true. The day becomes a dream—everything real recedes and I walk through life like one trying vainly to come back, to reattach myself to the world. I always succeed—eventually. The dream fades. I forget again and live—until. Then I'm in a room alone again knowing that nothing else is.

That's it, isn't it? This dream. It's the stage, the backdrop to all my other dreams, the motive for their intense imaginings. But this dream needs no fireworks. It's more powerful than any other dream because it's true. And I can never convince myself it isn't, because I know it is.

The feeling tone of it, you ask? Unremitting. Yes of course I know what the dream means. No inquiry is needed there.

(She breaks down in a sobbing that lasts through the following lines.)

That I did it—to myself. The pageants. To myself, ten cents a dance. That I would do anything—to win your love. That you let me do it. Saw I was doing it and couldn't stop yourselves. I was a child, how could you let me do that to myself—

(Now directly, to the audience.)

Yeh yeh yeh yeh yeh yeh yeh. I know. I know. A child can't understand things this way. Can't be held responsible. That would be too cruel, wouldn't it? Besides, it's only a dream. Who would dare suggest that we are responsible for our dreams? Because if that's true, children are the only ones who know how precious life is—know it at the very moment they sacrifice it.

(She returns to chair. Sits. Takes up book. Begins reading—avidly.)

*NO CURTAIN*

# 8
# Between Two Deaths: Life on the Row

And I have told you this to make you grieve.
Dante, *Inferno*, Canto 24

## TOMORROW AND TOMORROW AND TOMORROW

(As lights rise the following chronology will appear on a screen placed across the center of the stage. Text to run like a scroll on that screen.)

1936 Both parents born. During childhood mother of inmate physically abused by her mother. Tied up and left in basement for long periods of time. Father sexually molested her beginning at age 11. Inmate's father grew up in impoverished and abusive alcoholic family. At age 7 he was sodomized by a man who then shared him sexually with other men until he was 12.

1962 Inmate born. Has older brother and sister, born respectively in 1960 and 1961.

1964 Inmate's mother makes two attempts to drown him. Brother also attempts to smother him in crib.

1965 Inmate swallows bottle of baby aspirin and goes into convulsions.

1967 Inmate prescribed Ritalin.

1969 Inmate begins suffering *grand mal* seizures.

1973 Inmate begins sniffing glue.

1979 Inmate first arrested. For burglary involving assault on elderly couple.

1980 Inmate and friend rape and sodomize a 13-year-old girl. Inmate then takes her to his home and repeats these acts. Then gives girl a bath. Then puts bag over her head and pushes her head under water. Convicted of a number of violent sexual offences. Given indeterminate sentence at Vacaville.

December 18, 1986 Paroled from Vacaville.

February 26, 1987 Following confrontation with 19-year-old daughter of father's live-in girlfriend, inmate ingests "speed" (metamphetamine) at home of friend, Carla James. Later, driving Carla's friend Denise home, inmate pulls off road and forces her to

strip. Later that night and in the following days inmate makes sporadic attempts to get his parole revoked.

March 2, 1987 Inmate meets Rosalie Romans in Wild Peacock Bar in Barstow.

March 3, 1987, 9:30 a.m. Body of Rosalie Romans found near local beach.

February 14, 1988 Inmate found guilty of first degree murder with special circumstances (rape committed during murder).

May 1, 1988 Inmate given death sentence.

2005 Having exhausted state appeals, inmates appeal of death sentence is now at the Federal level.[1]

(Screen is now raised revealing the condemned man sitting in a booth behind a Plexiglas window with phone in his hand. The minute spotlight hits his face his monologue begins. Rest of stage remains shrouded in darkness. Only the man's head is visible, through a glass partition that forms the upper half of the booth. When he leans forward his face is brightly illumined, as if under a spotlight. But when he leans back his face can only be seen partially, in shadows, and when he leans back far enough his face becomes invisible. Additionally, the glass is smudged and dirty in many places making the face often resemble a painting by Francis Bacon. However, whenever the man draws his head forward his eyes stare clearly and directly into the eyes of the audience.)

I fell off the edge of the world. That's what it felt like, the moment the bars clanged shut. My life over. Nothing now but waiting, without hope, for something that'll come someday, it doesn't matter when, because time is nothing now but this wall in front of me and her eyes coming out of it, following me all day, closest at night when I fight to keep mine open against sleep, knowing it will come again the way it does whenever I sleep, from as long as I can remember: I see myself under water looking up at Mother's face all twisted, her hands like claws, forcing me down, my eyes pleading, dying—then breaking the surface gasping in a shriek toward air. Only now it's other eyes I meet in dreams, and not darting wildly about but how they got just before I felt her body stiffen and release itself. She wasn't looking at me anymore but at it as it moved down upon her. Death. What it's like right before the end when there's nothing but death and consciousness arrested and forever alone looks into the brute finality of it. Everything goes into the eyes then—into the impossible No. They're looking at me that way now: coming at me out of sleep, pursuing me down every corridor of sleep—until I wake screaming but with no sound coming out of my mouth, only the knowing, that

I have to begin again, trembling in the cold of night, see it all again, live it all again, my life, but like a film running backwards, faster and faster, until all the images loop into one another and only one remains—her eyes, looking at me, asking me, why?...

Even when I was a kid, I always wanted to understand why I was so agitated all the time and why I did the things I did. Remorse too. I always felt it right away. Hell, remorse was part of the agitation spasming me from one deed to another. This was different. I was calm, for the first time in my life, if you can call it that, with something cold and unmoving in the center of me where before there'd been the blind effort to outrun what was always out ahead of me—waiting. But now there was no escape, no matter how often I told her how sorry I was. She knew better, knew that when death comes nothing remains of the fitful fever we call life. Nothing but what must have rushed through her in those last few seconds, her whole life in its furious passage...The same passage I repeat every night, drawing across time what she saw in an instant.

Life on the Row was different back then. After they collected the trays from breakfast they'd open the cell doors so we could come and go almost like we were free, walk down the hall to a dayroom where there were tables with chessboards and chairs in semicircles so men could sit and smoke and talk. That's how I got to know some of the older guys. I can't remember their names or even their faces because then I looked at everything with fish eyes that registered nothing. But what they said reverberated in some empty place inside me, about how there was nothing for a man in here but the journey and the books I should read to get started.

It's funny, I started doing burglaries when I was 12, but whenever I was in a house that had a library this strange feeling would come over me looking at the books—that they were what I really wanted to steal, all of them...*If there were just some quiet place where I could go and be alone and read*... I'd stop then, though my ears kept listening, run my fingers slowly across some of the titles, whispering them and the author's names, take one down and turn a page or two, getting that empty feeling in the pit of my stomach and something dreamy coming over me like Momma when she'd be cooking popcorn and we'd find her over in a corner or in the bedroom staring at the wall with the smell of burnt popcorn everywhere...

That's how I got caught. I must have been standing there I don't know how long, reading page after page. It was like I was reading something that had been written only for me. Turning each page was like turning back layers of myself. Reading about how, when it was children who were made to suffer cruelty, to see God's purpose in that offended everything decent in us. And how there's a hell in the heart of every man—and that's where crime begins...I couldn't stop, not even to turn back and get the title or the author's name, and that's how I lost it...Though I've been searching for it ever since, in every book I've read, hoping to find it again, knowing that if I could find that book and read those pages again it'd be for me something like what you call peace.

He was on me before I heard a thing, like a bear, forcing me into a corner, clawing at my pants. That must be how he got my wallet and ID. I brought the book down on his head, once, twice, felt his arms go limp and sprung free. There was just her then, a red-faced old woman cackling and hopping in front of me like it was her turn and she was going to take a stab at tackling me too. I moved her to the side. Almost gentle. But she went down right away, crumbled in upon herself, like she was all straw inside. I ran—knowing the fucking cops would be waiting for me when I got home.

A book has to pass a pretty stiff test to make it in here. The ones that do is where you can see the writing comes out of an urgency, where a life is at stake and every page a fight with something that can destroy you. Like in Melville and *Native Son*, Shakespeare in the tragedies, and Sophocles too, Beckett, Mailer sometimes, Freud and Sartre. Almost anything in philosophy because there's something about it that's different...like Socrates said, it's about learning to die and the only thing worthwhile then is thought that is clean and hard...

Soon I was reading all the time—the way I'd always wanted to—all day, one book after another, each book leading into another, forming an iron chain in pursuit of a single goal. Christ, sometimes whole days went by and I never left the cell, filling the yellow pads with notes, questions, quotes I had to write down to memorize later so I could make them a permanent part of the thing I was trying to create in myself. I was so caught up in it that soon I didn't have to work to screen out the noise—that din of despair that's the one constant here. I was living in the hush of a silence that drowned out everything else. I lived that way for six years, six timeless years,

reading, questioning, teaching myself how to think, with everything driven by the one necessity.

Because I had it all now, all the pieces that made up my life, but strewn about the way chessmen lay on a board after the game is over, or pieces of a giant jigsaw puzzle... But if I could fit it together I'd see myself for the first time in a mirror and not how my life had been, one long spasm trying to outrun something I never forgot. Not memory the way it is for you, but something deeper, something I couldn't forget because I felt it moving in me all the time, at school, in church, whenever things got quiet and I could hear myself breathing...There'd be this pop, right in the pit of the stomach and I'd feel all the air go out of me. As if life is breath like Homer says, and mine had gone leaving nothing but the struggle to hide the panic building inside me...Because I could see it now—flashing in front of me—a blanket pressed down over my face, my mother's hands holding me down under the water, my eyes looking up at her, pleading, the whole thing whirling around inside me...—until there was nothing but rage, blind rage, to explode out of myself—as if bringing my fist down upon the world was the only way I could breathe.

That's what they tried to give me. A way to breathe. Mother, Father, Regina—I loved them so, the way they came forth to plead for my life at the trial. Only Kevin wouldn't. They let themselves be known—utterly. All the family secrets. Like they were offering their lives to me so that I could try to piece it all together here...Only like the way it is in a dream—a dream in which you walk through yourself becoming the thing you behold. Mother weeping all day, every day tied up down in that basement, the rats scurrying across her toes; my father waiting in that shack, trembling, the long processional of men like it was all one day, a summer afternoon, just a little boy, but holding his jaw out stiff the way it always got just before he'd start hitting my mother; Regina holding her jaw the same way, refusing to cry, telling the court what father forced her to do—what my mother's father did to her—what I did to that poor little girl, fucking her that way then forcing her head down into the bathtub.

I could see us now, the family, like branches of a poison tree, a tree that could only grow downward, clawing its way into the earth, latching onto whatever it could take hold of to root itself deeper, water itself with our tears, reach out and claw like Mother's fingernails, twine round itself like tendrils choking off anything that could grow upward and break free, dragging everything back down

into the one knot at the center. Only now when I woke sobbing it was my mother I heard crying, not me; my father that time I heard him in the kitchen when he thought no one was home, Sis huddling in the corner of the closet when we hid from Momma, whimpering like that but saying "no, no don't you touch me!" her face like granite locked in its impenetrable stare.

I'd lay there every night feeling the images bleed into and out of one another but distinct now too until it got to where I could grind the projector to a halt, snip off one image and hold it still in front of me—though something in me kept racing like kids in a movie house banging their feet and hooting "start the show! start the show!" … One image. Then another. Individual but also linked like circles cutting into one another. *This is that* I said. Came from that. Led to that. I am my father and my mother, what happened to them is who I am, what I did. My face under the water is my mother sobbing all day tied up in that basement, the hot wheel tracks lashing our backs are the ropes binding her. My father with Regina in the camper is me, my voice guttural like his muttering curses in that poor little girl's ear—"whore, bitch, cunt"—because she looked so weak and submissive whimpering when I slipped the bag over her head so I wouldn't see her face—their faces, mine, all jammed together, rushing up at me out of the bag when it ripped—a single face howling as it broke the water with me hugging her and sobbing "O my god my god forgive me please what have I done?"

Only it was too late—*too late already the day I got paroled, I could feel it starting to unravel driving home when Mom told me she'd lied, Kevin was still living there, with his wife and daughters, drunk every night bullying everyone and beating on them just like my Dad did…. I could see it already, my knuckles whitening over the steering wheel, feel the car spinning out of control on the gravel, my fist crashing into her jaw before it stopped whirling: "Take off your clothes, bitch" … It had already happened, I just didn't know it yet, running around in circles for two weeks like a chicken with its fucking head cut off, hopping back and forth from Mom's to Dad's, where he was living with Mildred and her daughters, Jenny and good old Vicki…. I was acting an absurd role in a comedy of my own invention: "Trying to make a family"—and feeling it slipping away all the time, knowing Vicki'd be the one to betray me. Even after I brought her a new present every day when she was in the hospital—a stuffed monkey with cymbals that clang together when you wind him up, a book of poems, a flower pot with a single sunflower… But no I told myself,*

*the first time, it must be a mistake, she wouldn't do it, lock me out of my father's house after telling me the door would be open; pretended it was a mistake the second time, though I could see it wasn't from that taunting look she gave me when they got back late and found me waiting on the front steps.... I felt it beginning then, rage breaking loose in me, in my fist banging on the door, the third time, when I heard them inside laughing at me. "Go ahead," she said, opening the door, "do something why don't you, get yourself put back in there where you belong." I followed her out to the kitchen—bitch—hearing the voice like his coming out of me "Lie to me will ya, slut, huhhh, you're all a bunch of lying fucking whores," saw the disrespect in her eyes as she brushed by me to the bedroom. Another locked door. I'll show you—cunt—my fist crashing through it like it was plywood, her face like mother's now when she'd chase us around the house with the spike end of her shoes... "You're history buster. The cops. I called them. They'll be here any minute." Only she couldn't stop taunting me even then, sitting there in the driveway, revving the engine to make it sound like it was laughing at me, blowing smoke rings at me through the window while I kept kicking, kicking, kicking at the door, banging my fist down on the hood, cursing and crying. Then I ran—*

*But it was too late. I could feel it spinning out of control all night at Carla's... the drugs only made it run faster. Spinning faster the moment Denise slid into the truck next to me, spinning on the gravel when I turned off the road toward a field, spinning like a whirlpool, sucking everything down into the voice screaming "take your clothes off, bitch"—into the voice weeping, "O my god no please forgive me what did I do?" But it was still spinning, even after I took her home and told her mother everything..."Call the police," I cried. Called them myself the next morning, begged her "Sis, please, get Branch. Tell him to revoke my parole. Have them pick me up soon please"... Because now I couldn't stop it, driving around town all day in circles waiting for them to arrest me, then out into the desert, late into the night, feeling the headlights of the oncoming cars like spikes shooting into my eyes, driving out and away, searching for some place quiet under a tree or hidden in a field high with weeds so I could sleep.*

*Only it never slept... I'd feel it the moment my eyes snapped open. It was already racing as if sleep had only increased its energy and sapped mine. Like I was still spinning on the gravel, going round and round faster and faster sinking deeper and deeper, trying to keep my head from going under, driving each day a wider circle out into the desert, feeling the heat of it coming down on me, rising up from the pavement toward me—and rage hot all over me, trying to outrun the rage but knowing it would bring me back, each circle wider and narrower, all leading to a single point, a*

*point of infinite density, my heart, like the inside of a black hole: and in it another little town, a truck stop, a bar, staring hard at all of them now, seeing Vicki in every one one of them, telling myself this'll be the one, knowing it was going to happen and fighting against it, against that haughty smile she gave me when we were done playing darts. "Wait for me outside," she whispered.*

*It was in a vial she carried in a chain around her neck and it was good, the kind of speed that takes you out in one great rush clear to the edge of the world where you can see the stars dancing... it'll be all right, I said, maybe we can take a blanket lie out under the night sky and talk there's no rush take it slow and easy... But it all spilled out of me the moment I entered her...and there it was building again in me, right away, the need to do it again... "Whoah cowboy," she laughed, "Take it slow this time okay?"— and I felt it all rush back on me the way speed gets when everything rushes away but the rage, rage raging in me, in my fists hitting at her, my hands tightening around her throat forcing her down...—so I get to see it in her face for a change—fear, panic, terror—how do you like it mother?—the full weight of my body over her pressing down on her windpipe... cursing and crying (he emits a terrifying sound)*—only it was too late: there was nothing but her eyes staring at me with that look that came into them right before the end, staring at me like that forever.

I had it all now all right, my life, the whole picture, I held it in the palm of my hand, complete in its necessity, random in its cruelty, meaningless in its horror. And I could feel it rush right through me like a thunderbolt, my own hand dashing the cyanide pellet to the ground, my lungs gulping the poisoned air, sucking on death, feeling my whole life rush headlong through me to its pointless and inevitable end.

I'd put it all together, sitting alone in my cell, and what I knew drove me back out into the hall again, only not like before but now like a dead man walking, shuffling my feet along the floor, the same ten steps one way and then back, eyes fixed on the floor, the arms hanging limp, the shoulders stooped like an old man's and what must have been on my face the look of a corpse because everyone stayed clear of me. Everyone except Reverend John. He was from one of Colson's prison ministries and would walk freely among us every day, taking men aside, one by one, whispering to them, opening the book and pointing at it with his insistent finger...

And I guess he knew right away I was one of the ones who'd read the parts in red, over and over, long into the night when the only

light left was from the moon, and feel the tidal pull of a compassion so inconceivable that soon I couldn't wait to tell him "yes yes I accept Jesus Christ as my Lord and Savior," weeping and saying it over and over while he held me in the thick embrace of his bear-like arms. And I tried, tried to hold onto Jesus later when I felt him slipping away, no matter how hard I tried to feel his love, tried to hold onto the Reverend too even after I saw that it was all about power for him. He wasn't interested in the questions I was asking now, only in what came later when the beckoning of his sad eyes told me it was time to confess again and sob how thankful I was to him and Jesus for forgiving me, again and again. No, goddammit! I couldn't forgive myself and didn't want to. I'd done the most terrible thing a human being can do. "Forgive yourself," he said "even as your heavenly Father forgives you." Only that doesn't bring back a life. The dead are the only ones who have a right to forgive—and they can't. Their eyes say something else. That death is a horror in which there's no comfort or forgiveness. Only nothingness, pitiless and final—and as your life slips from you the last thing you see is that nothingness, triumphing over every hope and illusion. Besides, the afterlife and the great banquet of forgiveness. It undoes everything. As if all the evil and suffering we do doesn't matter finally. Life's a shell game to amuse something vindictive in us that wants to call itself God.

It got so I couldn't stand to see him coming down the hall with that sad look in his eyes. I didn't want his fucking pity. I wanted judgment, judgment pure like hammer strokes...

And I knew there was only one way to get it. Back into the cell, into the books, the ones that had been the hardest to crack. Books with a finality that cut away everything but what I could use to forge a hammer I could bring down upon my life the way you crack a walnut so that all the pieces shatter and nothing is left but what's at the center. I was reading again, all day, but now like I wanted to finish something not start it and so needed only the few books, the ones I'd struggled against that had defeated me the first time. Like Spinoza. Not because he was difficult but because he's pure. For weeks I read the opening sentences, over and over, paralyzed by their clarity. And then step by step the great movement of thought that follows. But I had to understand each sentence—understand it from the inside—before I could read the next one. I'd hold a sentence in front of me, days at a time, until I grasped the inevitability of it. One sentence after another, for I don't know how many months,

with all existence purged away except the iron march of thought toward total clarity. Pure concepts in a pure order—from bondage to freedom—and then as I raced to the breathless close of it, I felt it, what everyone says, how he becomes a wind, a great wind blowing through your whole life, scattering the dross like leaves in autumn, leaving nothing but the truth apprehended in its perfect symmetry, each individual piece known in its necessary connection to every other, what happened to my mother and my father, the things I did, each piece infinite in depth and complexity yet bound to every other in an intelligibility total, unchanging—and thus beyond rage. Forever beyond rage.

And so I waited in the purity of that knowledge for what I sought to happen. And nothing did. I saw my life, that's all, like dirty bathwater whirling down a drain, taking everything with it into that terrible sucking sound it makes at the end.

It'd stay this way forever. I'd know it all—in perfect comprehension—and nothing would change. Ever. I looked up one day and I'd been on the Row for nine years. It would have stayed like that, another decade or more, mere time, if it hadn't been for the black man.

I could feel him staring at me through the back of my head long before I saw his eyes black with rage burning into me, saying "This is how it'll come down, any day now motherfucker. And you won't see me...There'll be just the shiv in the spine—and then I'm the last thing you'll see, my eyes, watching you die."

It was like Shakespeare says somewhere, I was distilled into a jelly with the act of fear. It was in my legs every time I tried to stand and walk, in my hands shaking like a junkie in need of an angry fix. In me and outside me, lurking in the cell, even after it was locked... "I know how he gets in! He doesn't need the guards to open the doors. It's a key, he's got it hidden in that gold tooth that gleams at me when he smiles. Tonight, that's when he'll come, after I can't help it anymore and fall into sleep. I'll wake, my throat already slit, the blood starting to gurgle, his great hands around my ears almost like he's going to kiss me—and his eyes like huge suns on fire with hate." It got to where all I could do was lay in my cell, balled up in a fetal position, trembling and crying like a baby. So I did it—the one thing you can never do here. I dropped a kite. On myself.... I'm sorry, a kite, that's what we call it when you slip a note to a guard ratting on somebody. "Save me. He's everywhere now, his dreadlocks like snakes with eyes at the end—eyes like fangs."

They took me to the white room. That's when it really got bad. When I was safe. After they strapped me down on a bed like I asked them to—and I was free, free to rave. I didn't need him anymore. It was all back inside me, but torn loose from all the ways I'd tried to contain it. I could feel it, something ravenous, scooping out chunks of my heart, devouring them: like that passage in the *Bhagavad Gita* when all mankind rushes into Krishna's mouth to be chewed to pieces, the crushed heads stuck between his teeth, all creation, moths to the flame, rushing headlong to the one sea, burning, burning in Krishna's flaming jaws. "No," I screamed, when they told me they were going to medicate me. "No motherfuckers you can't, not without my permission. I know my rights, even here." Somehow in my raving I knew that this is what had to happen. What I had to go into wherever it took me. The only thing I had to hold onto—my madness. The only thing left that was mine. Mine—even when they put me down in the hole.

That's where it happened, what I'd always sought, deserved… Everything drifted away—even the images. I was left with only the one thing. *Emotion.* That's what we are. All we are. Something happens and an emotion is formed. Later something triggers it and it returns—in all its fury. Then it's like what Spinoza said—an emotion can only be replaced by another emotion and the strongest always wins. Hate, fear, love, rage—each the pure product of pure and brutal experiences—warring with each other. Emotion—the thing that tears us apart. And so we try to blow it out into the world. Inflict it on someone else to get some relief. But it always returns to its source. Life nothing but the process of being blown with restless violence from one emotion to another. But always in the end rage, only rage…

Let it come, I said, feeling the sweat of it pouring over me…rocking myself back and forth in it…making my body a cradle for it. For rage so pure it'd consume me, rage raging in me until it burst into remorse—remorse becoming love—a terrible love, ripping me apart… Then again nothing but the panic of feeling myself—what you'd call my soul—dying within. Then reborn, reborn in rage. I felt it claw at me: *not I, it*, I said like that play of Beckett's, only I knew it was I and I…I felt myself vanish into it…until there was nothing but one emotion after another searing my flesh. Time went away and space. The room went away. I was utterly alone, with nothing left between me and what I was.

Most of the time it felt like I'd never come back. That rage would claim me so complete and entire that I'd run and dash my brains

out against the padded wall. Or that I'd dissolve in a love that was nothing but pity, pity for a loss so deep that one morning they'd find me gone in a weeping that could never end. Or that the panic would seize me…*"yes that's how it'll end crying out against myself for the meds, begging for them, pleading with them please please I'll do anything just take the pain away."* Or fear, the worst fear, that I'd become my deed—but without remorse—my deed and nothing but a monster raving kill kill kill, living only for horror, wanting it, more of it, unable to get enough of it, hurt and hatred and revenge.

I felt each emotion blow down white hot all over me. Burning itself up in me. Renewing itself through me. And in the brief interim, when the whole thing would pause and turn on itself like a ferris wheel about to run backwards—dread—the cold sweat of dread all over me, knowing this might never end yet knowing I had to sustain it because otherwise I was truly lost. *Do it to yourself*, I cried. Be it, rage, hate, terror, despair. Assault yourself with yourself. Make each emotion a spike driven through the brain straight into the heart. *That's the only way*, I cried, and in that cry I became a young girl in Nepal sold into prostitution, raped and beaten by two men; a woman in New York bleeding to death in an alley ten feet from home, the neighbors gawking through closed windows; then little girls, dozens of them, sexually abused children crying out of me for it to "stop."… Stop! …And that's when it began, what had to happen, though I had no way to know it then, all the emotions bleeding into one another, out of their clash refining themselves into something else that I no longer felt would crush or swallow me but out of which something new might come to be.

I lay there like a corpse feeling the whole process moving across me the way a rat down here sometimes crawls across your chest in the night, slow and tentative, almost delicate, like it was your companion and didn't want to wake you. *Don't move*, I said. Hold yourself still in the still of this. Wait. Wait. And then I felt it, my whole life, coming back to me, all the images, every event, but like there was finally room in me for them. Like I'd created a womb in myself and something was being born there. All I'd felt, done, suffered, all the violence of my passage through life, was being transmuted into something else. Like I was giving birth to myself. Out of myself. Feeling in myself something I'd never felt before. Not pity or remorse but grief, a grieving for my life and out of that grieving a new way of being beginning in me. Only I couldn't reach out and grab it like the brass ring, but had to wait, wait for it to open in me. I wept then,

but in a way I never had before. There was no desperation in it. The tears were warm and slow—streaming down my cheeks—and full of what I can only call gladness. But grief too, real grief. A grief for her deeper than any I'd felt before when the panic to deny who I was got all mixed up in it. No, this was real grief. Grief for someone I never knew—someone who never had a chance like mine to know herself. For a life that never was. Unforgivable—to take that from someone. And so for the first time I could really say it—to her: "I'm sorry, sorry for your loss…for taking from you the chance to discover who you were." (*Breaks down and weeps.*)

And that's when I felt it, love spreading out from me like spokes of some great wheel, blood red spokes running across a wheel as big as the sun, turning, turning in love for all of them, for my mother just a little girl all all alone down in that basement and my father all alone, forever alone, in that room full of men. And Sis, the beautiful one, who somehow knew from the start that there's one commandment we must live by—the refusal to pass it on.

Something like what you'd call peace descended on me. Not forgiveness, but something else. A feeling—I don't know how to put it any other way—that I was ready to resume my life. That I'd carry it all, but in a new way…

I lay there feeling it moving across me like that last breeze of night that comes just before dawn when we collect ourselves silently in the beckoning of day. Because I was in time again and knew it, time like the first step toward the prospect of a distant mountain capped with snow. And I was ready to start on that journey, ready to rejoin the world of men. But I waited, waited in the hush of it for what must have been at least two more months. When I left the hole, the guards told me I'd been down there over three years.

Everything since has been one day, man. And I want to live it to the full. In the now. Like I told you before, I got way beyond the religious stuff. I don't need what it promises. But I believe with all my breath that there's a spiritual dimension and that it defines us. You can scoff at that if you want to, but without it we're all dead long before they drop the pellet.

The journey. It's all that matters and the only way to make it is to live purely with nothing between you and who you are. For some, it takes all their time here just to get started—but that's enough. A life begun. I was lucky, I always had remorse. I didn't have to waste years trying to crack the hard nut of denial. Aaahh, and there's so

many ways to get lost, to turn the journey into something else. Some guys here become lawyers and get so stuck in a battle to outsmart the state that they forget their deed. That even happened to one as great as Chessman, I'm told, until he became the shadow of himself. No, I tell my lawyer, no no no no no, I don't want to know what's happening in my case. Appeals—the interminable process of what will come.

The innocent ones, the ones who are here unjustly, it's all different for them. Like those souls at the beginning of Dante who weep forever but not over anything they've done and yet without hope of ever leaving this place. They make their journey, but I have no idea what it is. Maybe I don't want to know because it would undo me. We pass, in silence, and like we're always moving in opposite directions and have to keep moving that way because if we turned and faced one another there'd only be the questions burning in each other's eyes. Can they forgive us? Has injustice become in them the desire to kill us? Before them will all our work crumble to dust in a guilt that can't be expiated?

I can't say I'm thankful for my life. That would be obscene. And yet I'm one of the fortunate men. I found a way, in this place, to do what few people can do.... Rehabilitated? I don't know what that means. After a time any man in here isn't the same man he was when he got here. Because there are only two choices. To finish it—become the thing one was trying to be on the outside. Murder. Rape. Terror. Revenge. Or to somehow find a way to live life to the full every day, knowing it isn't life, can't ever be life. Life is what I took. Like what Patricia Krenwinkel said, how she wakes every day knowing she's a taker of life and deserves to wake each day to that knowledge. That's what I try to live too, knowing that every breath I draw comes after she, the woman I killed, Rosalie, Rosalie Romans, drew her last...That's how she lives in me. She is all I denied her and all she could have been—a pure possibility that must become cleaner with each year.

I've been trying to think of an example so you'd see how what I call the spiritual isn't anything grand but simple. And then I remembered a day in the yard last week. They only let us out a few at a time. And there I saw one standing alone, his fingers curled like claws through the chain link fence, looking out at the Bay.... He was unmaking himself.... And so when it was time to go back in I worked my way along the fence, toward him, leaning out with my head to catch his

eye so he'd hear me whisper to him as I passed "Hold on, brother, you can carry it. Hold on now." I don't know who he was and I'll probably never see him again. Christ, there's over 600 of us on the Row now. But maybe letting him know I knew what he was going through lightened his load. And mine.... It's there, you can feel it in your chest sometimes, a love that's got nothing to do with anything in here...but life, life the way it was meant to be lived, even by those of us who've lost it.

(Bright lights, we see the man's face in ghostly illumination. He brings his fist forward and closes it against the glass, the traditional way in which prisoners share fellowship with those who visit them. Lights then fade slowly until only the fist is visible. Then fade to darkness.)

# Notes

## PREFACE

1. *Dramatists Sourcebook*, 23rd edition (New York: Theatre Communications Group, 2004), p. 71.
2. Walter A. Davis, *Deracination: Historicity, Hiroshima and the Tragic Imperative* (Albany: State University of New York Press, 2001).
3. Walter A. Davis, *Death's Dream Kingdom: The American Psyche Since 9–11* (London: Pluto Press, 2006).

## CHAPTER 1

1. Walter A. Davis, *Get the Guests: Psychoanalysis, Modern American Drama and the Audience* (Madison: University of Wisconsin Press, 1994).
2. For Mr. Nicola's statements, see, in the following order: http://www.nytimes.com/2006/02/28/theater/newsandfeatures/28thea.html; http://www.dailykos.com/storyonly/2006/3/2/131554/4510; http://www.playbill.com/news/article/98213.html. For ongoing coverage of and commentary on all of this, see: http://playgoer.blogspot.com.

## CHAPTER 2

1. See Preface, endnote 1.
2. On the historical background of the Israeli–Palestinian conflict in its specific bearings on this play, see the article by Philip Weiss in the April 3 issue of *The Nation*.
3. *My Name Is Rachel Corrie*, the writings of Rachel Corrie, edited by Alan Rickman and Katharine Viner (London: Nick Hern Books, 2005). I should also point out here that the situations described in this article are not confined to the New York theatre scene. For the almost uniformly positive reviews of the London production of the play see: http://www.royalcourttheatre.com/archive_reviews.asp?play=401. Even as difficult a critic as Michael Billington viewed the play in highly positive terms.
4. See the *Guardian* arts section, April 8, 2005. Available at http://arts.guardian.co.uk/features/story/0,,1454963,00.html.
5. Frances Goodrich and Albert Hackett, *The Diary of Anne Frank* (New York: Random House, 1954).
6. In the aforementioned article from the *Guardian*.
7. Jerry Rubin, the 60s radical later turned successful Wall Street stockbroker and not Deep Throat, deserves the credit for first having formulated this principle. It remains sage advice.
8. See http://www.nyc.gov/portal/index.jsp?epi_menuItemID=c0935b9a57—see also the NYTW website, www.nytw.org.

9.  For a listing of the members of the board of the NYTW and major contributors, see DailyKos.com/storyonly/2006/3/2/131554/4510.
10. For a full report of the meeting, see the entire section titled *Last Night's (non-)Panel* on Garrett Eisler's *Playgoer.blogspot.com*. See also the invaluable discussion of the Corrie controversy on the following blogs: George Hunka, http://www.ghunka.com and Jason Grote, jasongrote.blogspot.
11. This statement by Tony Kushner is in the aforementioned article in *The Nation* by Philip Weiss.
12. A confession. I am the unnamed Michigan author who sent his copy of the play to Philip Weiss when he found it virtually impossible to find a copy of it in New York. But then everybody was too busy knowing a priori what they thought about all this to bother to read the play. The academic world isn't the only one where no one has time to read anything except what supports what they already believe.
13. This quotation comes from the section of the novel titled "The Story of Byron the Bulb," pp. 647–55. *Gravity's Rainbow* is hard going (like most good things) but this section can be read independently as a clear and concise parable of the fate of the Enlightenment and those who try today to sustain its effort.

## CHAPTER 4

1.  See Tom Hayden's recent "New Port Huron Statement," which begins with Rachel Corrie as an example of how we might recover the political inspiration of the sixties: http://truthdig.com/report/item/20060328_hayden_port_huron.
2.  Jeff here reverts to "Mac," the name all my friends call me and which he used on all our earlier communications.
3.  With respect to the one issue in Jeff's letter I don't discuss—that of Mr. and Mrs. Corrie's feelings and the pain that my book might give them—I can only say that my focus here is solely on the issues involved in the dramatization of their daughter's life. Regarding their unspeakable loss, I can only join others in offering my deepest sympathies.
4.  For a discussion of Marx on ideology and the history of the development of that concept within Marxism, see Walter A. Davis, *Inwardness and Existence: Subjectivity in/and Hegel, Heidegger, Marx, and Freud* (Madison: University of Wisconsin Press, 1989), pp. 146–60.
5.  See, for example, Father Richard Neuhaus, *Catholic Matters: Confusion, Controversy and the Splendor of Truth* (New York: Basic Books, 2006). Father Neuhaus is, of course, the good friend and counselor to Dubya and the philosophic leader of the new right.
6.  I want here to acknowledge my own Catholic origins and my great debt to my undergraduate Jesuit education at Marquette University for instructing me as to the final philosophic touches in that ideological determination to combat "modernism."
7.  James Green, *Death in the Haymarket* (New York: Pantheon Books, 2006) and Jean-Paul Sartre, *Critique de la raison dialectique*, 2 vols (Paris: Editions Gallimard, 1985).

8. For their announcement of these meetings, see the NYTW website, http://www.nytw.org/special_event.asp.

9. Daniel Dennett, *Darwin's Dangerous Idea* (New York: Simon and Schuster, 1995); Stephen Pinker, *How the Mind Works* (New York: Norton, 1999); Sam Harris, *The End of Faith* (New York: Norton, 2005).

10. Daniel Dennett, *Consciousness Explained* (New York: Little, Brown, 1991).

11. A note on the genetic fallacy: i.e., the idea that one cannot account for the developed state of a thing by accounting for the elements that went into its origin. This principle, well established by the scholastics, has been banished in order to underwrite a philosophic paradigm based on the notion that the primary facts of evolution will and must account for everything. The upsurge of existential self-consciousness can provide no exception to the reductive rules.

12. For all their carping about neuroscience, Dennett, Harris, and Pinker hold no place for psychoanalysis in their work, despite the impressive work done by Schore, Solms and others to renew Freud's 1895 project and thereby show ways in which neouroscience supports the findings of psychoanalysis. The banishment of psychoanalysis: that's the infallible sign that what we have in Dennett, Pinker, Harris, and others is an ideology masking as a pure science.

13. See Sartre, *Being and Nothingness* (New York: Philosophical Library, 1956), pp. 36–413.

14. *In Inwardness and Existence* I construct a far more complex theory of subjectivity, in which psychoanalysis is only one component. But my purpose here is simply to offer a primer that will get us thinking in a new way.

15. Adolf Grunbaum has offered the most strenuous arguments of this view.

16. For a rethinking of the concept of *thanatos*, see Walter A. Davis, *Deracination: Historicity, Hiroshima and the Tragic Imperative* (Albany: State University of New York Press, 2001), pp. 133–50. For its application, see Walter A. Davis, *Death's Dream Kingdom: The American Psyche Since 9–11* (London: Pluto Press, 2006).

17. Robin Wood, *Sexual Politics and Narrative Film* (New York: Columbia University Press, 1998), p.16.

18. For the development of such a theory of evil see Chapter 8 of *Death's Dream Kingdom*.

19. For the development of this theory of history and the writing of history, see *Deracination*, pp. 9–15, 25–40.

20. Hayden White, *The Content of the Form: Narrative Discourse and Historical Representation* (Baltimore: Johns Hopkins University Press, 1987), p. 181.

21. On this, see the theory of the image developed in Chapter 6 of *Deracination*.

22. Dwight MacDonald, *Politics*, October 1946.

23. For an extended discussion of group psychology as the subject of *The Iceman Cometh*, see Chapter 1 of Walter A. Davis, *Get the Guests: Psycho-*

*analysis, Modern American Drama and the Audience* (Madison: University of Wisconsin Press, 1994).

## CHAPTER 5

1. Those who wish to pursue the full dimensions of our debate should consider the following books, as we often did, as paired opposites: Booth's *The Company We Keep* (Berkeley: University of California Press, 1988) vs. my *Get the Guests* (Madison: University of Wisconsin Press, 1994); his *Modern Dogma and the Rhetoric of Assent* (Chicago: University of Chicago Press, 1974) vs. my *Inwardness and Existence* (Madison: University of Wisconsin Press, 1989); *The Rhetoric of Fiction* (Chicago: University of Chicago Press, 1961) vs. *Deracination* (Albany: State University of New York Press, 2001); and *Critical Understanding* (Chicago: University of Chicago Press, 1979) vs. *The Act of Interpretation* (Chicago: University of Chicago Press, 1978). For the quickest take on the debate, see Booth, *Critical Understanding*, pp. 369–70.
2. For a critique of the concept of *catharsis* and the rationalistic framework of guarantees that it serves, see *Deracination*, pp. 185–91.
3. For my attempt to formulate such a theory of emotion, see Walter A. Davis, *An Evening with JonBenét Ramsey* (Nebraska: iUniverse, 2004), pp. 160–2; and *Deracination*, pp. 185–8, 196–8.
4. See Martin Heidegger, *Being and Time* (New York: Harper & Row, 1962), pp. 179–82, 228–35. The concept of *existence* derives from the primacy of *anxiety* in the constitution of the psyche. The importance that most people accord to *fear* is the ways it offers to displace anxiety.
5. I summarize here interpretations of Miller and O'Neill developed at length in *Get the Guests*.

## OVERTURE TO PART III

1. Alison Croggon, *Attempts at Being* (Western Australia: Salt, 2002).
2. George Hunka, *Superfluities,* entry for Beckett's birthday.

## CHAPTER 7

1. JonBenét Ramsey is now, of course, largely forgotten. Thereby we cast aside any chance to understand two epidemics that in many ways define American society: (1) that of the sexual abuse of children and the fact that most of this takes places within the family; and (2) the institution called child beauty pageants, which now in the United States number eight times as many as took place the year JonBenét died. In this case, those who refuse to understand the past are condemned to perpetuating it on the young. For a full discussion of the Ramsey case, its treatment by the media and the legal institution as well as the full version of the play from which the present chapter is derived, see *An Evening with JonBenét Ramsey* (Nebraska: iUniverse, 2004).

## CHAPTER 8

1. The monologue is based on two meetings I had in May of 2005 with a man who's been on death row in San Quentin for the past 15 years. The meetings (one lasting 75 minutes; the other two hours) were face to face in booths over a telephone with a Plexiglas partition between us. I was not permitted to take either pencil and paper or a tape recorder to the meetings. Indeed, had the authorities known I planned to write this work I would not have been permitted inside San Quentin. Additionally, I met with the lawyer who represented the inmate in the appeals process for 10 years, a private investigator who does field work interviewing family, acquaintances, medical personnel and others in connection with the appeals process, and an attorney who has done extensive work documenting conditions within California's prisons. I also read the court transcripts of the inmate's original trial and penalty phase trial as well as a number of secondary sources. The inmate's appeal of the death sentence is now at the Federal level. For that reason I have been advised by attorneys not to use his name and to take other steps to disguise his identity. Within the terms of that restriction what follows is a factually complete document. There are, of course, over 600 inmates currently on death row in San Quentin.

# Further Reading

Alter, R. and Kermode, F. (eds), *The Literary Guide to the Bible* (Cambridge, Mass.: Harvard University Press, 1987)

Booth, W., *The Rhetoric of Fiction* (Chicago: University of Chicago Press, 1961)

—— *Modern Dogma and the Rhetoric of Assent* (Chicago: University of Chicago Press, 1974)

—— *Critical Understanding* (Chicago: University of Chicago Press, 1979)

—— *The Company We Keep* (Berkeley: University of California Press, 1988)

Croggon, A., *Attempts at Being* (Western Australia: Salt, 2002)

Davis, W., *The Act of Interpretation* (Chicago: University of Chicago Press, 1978)

—— *Inwardness and Existence: Subjectivity in/and Hegel, Heidegger, Marx, and Freud* (Madison: University of Wisconsin Press, 1989)

—— *Get the Guests: Psychoanalysis, Modern American Drama and the Audience* (Madison: University of Wisconsin Press, 1994)

—— *Deracination: Historicity, Hiroshima and the Tragic Imperative* (Albany, N.Y.: State University of New York Press, 2001)

—— *An Evening with JonBenét Ramsey* (Nebraska: iUniverse, 2004)

—— *Death's Dream Kingdom: The American Psyche since 9–11* (London: Pluto Press, 2005)

Dennett, D., *Consciousness Explained* (New York: Little, Brown, 1991)

—— *Darwin's Dangerous Idea* (New York: Simon & Schuster, 1995)

*Dramatists Sourcebook*, 23rd edn. (New York: Theatre Communications Group, 2004)

Fisk, R., *The Great War for Civilisation* (New York: Knopf, 2006)

Green, J., *Death in the Haymarket* (New York: Pantheon and London: New Left Books, 2006)

Pinker, S., *How the Mind Works* (New York: Norton, 1999)

Pynchon, T., *Gravity's Rainbow* (New York: Viking, 1973[1956])

Resnais, A., *Night and Fog* (New York: The Criterion Collection, 2003[1955])

Rickman, A. and Viner, K (eds), *My Name Is Rachel Corrie* (London: Nick Hern Books, 2005)

Rilke, R.M., *Letters to a Young Poet* (Boston: Shambhala, 1993)

Sartre, J-P., *Being and Nothingness*, trans. Hazel E. Barnes (New York: Philosophical Library, 1956)

—— *Critique of Dialectical Reason, vol. 1*, trans. Alan Sheridan-Smith (New York: Verso, 1976)

—— *Critique of Dialectical Reason, vol. 2*, trans. Quintin Hoare (New York: Verso, 1991)

Shlaim, A., *The Iron Wall* (New York: Norton, 2000)

White, H., *The Content of the Form: Narrative Discourse and Historical Representation* (Baltimore: Johns Hopkins University Press, 1987)

Wood, R., *Sexual Politics and Narrative Film* (New York: Columbia University Press, 1998)

# Index